DRAWING FOR
OLDER CHILDREN AND TEENS

DRAWING FOR OLDER CHILDREN AND TEENS

*A Creative Method That Works
for Adult Beginners, Too*

MONA BROOKES

JEREMY P. TARCHER, INC.
Los Angeles

Library of Congress Cataloging-in-Publication Data

Brookes, Mona.
 Drawing for older children and teens / Mona Brookes.—1st ed.
 p. cm.
 Includes bibliographical references and index.
 ISBN 0-87477-660-0 ISBN 0-87477-661-9 (pbk.)
 1. Drawing—Technique. I. Title.
NC730.B657 1991
741.2—dc20 91-24864
 CIP

Jeremy P. Tarcher, Inc.
5858 Wilshire Blvd., Suite 200
Los Angeles, CA 90036

Distributed by St. Martin's Press, New York

Design by Tanya Maiboroda
Photographs on pages 123, 126, 129, and 130 are by Eleanor Monroe.

Manufactured in the United States of America
10 9 8 7 6 5 4 3 2 1

First Edition

With love and appreciation to Elliott Day,
for the never-ending friendship
and inspiration he gives me
to follow my dreams.

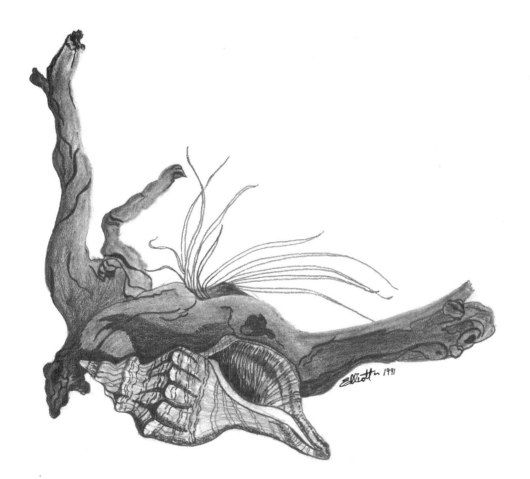

CONTENTS

PART I

DRAWING: THE BIG PICTURE

ACKNOWLEDGMENTS

Thanks to so many:

To my aunt, Beverly Bender, for showing me how to draw when I was a little girl.

To my son, Mark Hall, for his loyal support and appreciation during the rough times as well as the wonderful ones.

To my mother, Mary Boles, for giving me an appreciation for education and a passion for truth.

To Noah Purifoy, Gertrude Dietz, Ann Lewin, Geraldine Schwartz, Marilyn Ferguson, Bill Cheshier, John Davis, Alice Fine, Paula Greenstein, Lucia Capacchione, Susan Grode, Annette Polan, Gabriele Rico, John Solom, Barbara White, Ray Gottlieb, Ruth Strassberg, Catherine Veritos, Sue Miller-Hurst, Cindy Kingston, Sharon Lord, René Lamkey, Dorine Little, and Barry Brukoff, for their encouragement, friendly advice, and expertise.

To Jeremy Tarcher for his belief in me and support of my work.

To Rick Benzel, Michael Dougherty, Robert Welsch, Lisa Chadwick, Connie Zweig, and all of the Tarcher staff for their help and warm reception.

To my private students, and the local students from the Ojai, Santa Paula, Camarillo, Ventura, and Oakgrove School Districts for their contributions of illustrations.

To Sandy Lane and her students from the Sanoma Community Center for their illustrations.

And with much love, to my franchise family of Licensed Monart Drawing School Owners:
Dottie Russell from Encino/San Fernando Valley Monart
Karen Jackson from Santa Monica Monart
Janice Purnell from Santa Monica Monart
Nancy Reese from Huntington Beach/Irvine Monart
Bonnie Allen from San Francisco Bay Area Monart
Janice Hand from Los Osos/San Luis Obispo Monart
Vanessa Hall from Taft/Bakersfield Monart
Karen Kelly from Denver Colorado Monart
and to their students for the illustrations they contributed.

A NOTE TO EDUCATORS AND PARENTS

As human children grow, they learn from trial and play, with voice and hand, to communicate. Words in the native language of the speaker are modeled, and as children's efforts to copy are selectively reinforced, their sounds, gestures, and facial expressions become language. In the same way, the marks they make with their hands become drawing, and later, writing, as the written language of the culture is modeled by the teachers. At the same time they learn, also by copying what is important to learn, and the response of their elders to their trying teaches them about the quality of their own performance as learners. These teachings, ingrained at the deepest level of mind and heart, become part of the very nature of the person.

It is at this same time in our own culture that we learn to value language in its oral and written form and to undervalue drawing as child's play, thus losing a method of communication potentially rich in expression of both thought and emotion. In this way, we set aside the natural human ability to draw. Untutored and undeveloped beyond the simplest primary explorations of children, this ability is discarded by most of us along with play in favor of the more serious, adult, valued study of language. Our schools reflect this in their curriculum by allowing art for pleasure in the primary grades, where it is mostly untutored, unstructured, and without discipline. They do this on the false assumption that the truly talented will somehow discover the techniques for themselves and that by teaching them how to draw, we interfere in the creative process. Further, we forbid in the name of the same creative process copying and modeling, which is the key method by which we learn everything else.

Can you imagine a mother saying to a young child trying to make a sound that approximates *mama*, "Don't copy me, kid, . . . make up your own language," or a teacher complaining as a child tries to approximate her letters so that he can write his name, saying, "Make up your own script"?

By the time children are ten, drawing—even for pleasure—is often relegated to the last hour of Friday afternoon, when students and teachers are too tired to do anything else. By high school it is an elective subject, and the only students who get real lessons are those whose pleasure and talent are so outstanding that they have nurtured this ability in themselves by learning to value a skill others have not dared to value. The rest of us, with the voice of judgment shouting in our heart, compare a skill cut off in childhood with those who have spent a lifetime learning to draw and say with childhood innocence, as if it did not matter, "Oh, me—draw? I can't even draw a straight line."

Mona Brookes uncovers this problem when she asks people to scribble and they resist, lest their scribbling not measure up. It is only when she compares the scribble and the doodle to works of great artists that they relax and begin to unblock, and thus to learn. By returning to the essence of the way humans learn, by giving permission to copy and model, Mona frees up both children and adults to use their formidable skill as imitators to learn the basics and thus proceed the way all natural creativity does, from the known to combining and synthesizing the known in new ways, and finally to using the known as a platform or catalyst for the completely new and original. Exploring richly with color, form, and texture, she frees her students to communicate in another medium that gladdens the heart of both the producer and consumer, just as song enriches both the singer and listener.

There is another, even more important, issue at the heart of all this. The human mind works by generalizing its lessons from the specific instances to the larger ones. As the child learns that he or she is an incompetent drawer, that child internalizes and generalizes this to mean that he or she is an incompetent performer more generally. There is no human anxiety greater than performance anxiety, across all fields of human endeavor. From the kindergartens to the board rooms of the nation, the fear of looking ridiculous and incompetent reduces our willingness to try new things and subjects us all to a pathology of limitations in which we attend much more seriously to what we can't do, and to what can't be done, than to what we would do if we tried, practiced, learned, and improved.

Here, too, Mona makes an important and serious contribution by building competence in a climate of safety, which honors diversity of style

and sees beauty and value in many different products. She provides the student the opportunity to experience the joy of accomplishment. The resulting work becomes one of worth and its creator worthy of esteem. This esteem is generalized across performance in general and the person grows in confidence and willingness to explore and experiment in drawing and many other endeavors.

I have seen the truth of this over and over again at the Vancouver Learning Centre during the five years we have been teaching Monart to improve visual perception and visual spatial organization in students with learning disabilities and brain injury. As we praise the drawings posted all over the Centre, students glow with pride. It is no surprise to us that this contributes to their improvement in reading and writing, as they learn to pay better attention to visual detail, and in mathematics, as they learn to understand the organization of objects in space.

As we move toward the twenty-first century our world, exploding with change, diversity, and complexity, becomes increasingly different. We no longer know what today's students will need to know to succeed in their future. In such a world, the ability to learn in creative ways, to communicate richly and work with confidence in our own competence, are the only qualities of real, enduring value. Mona Brookes, through the teaching of drawing begun in her first book, *Drawing With Children*, and expanded and extended in many excellent ways in this one, makes a major contribution that reaches well beyond the scope of this little volume. The wisdom in this book, both in its method and its underlying message, is important for every educator and parent of our time who wants to raise children to be successful twenty-first-century citizens. It is of special value to those scientists interested in the nature of learning and to scientist-practitioners looking for ways to improve learning to empower learners.

Five years ago in this note, I wondered what would happen if the skill of drawing were nourished and nurtured in all children. Today, I can say with certainty that this *should* happen for every kid, teen, and adult.

Mona Brookes's second book shows how this might be done.

Geraldine Schwartz, Ph.D.
President
Vancouver Learning Centre

LOOKING BACK AND STEPPING FORWARD

Mona — age 7
From a party favor, watercolor.

When I was a little girl, drawing was my passion in life. Paradise was staying with Aunt Beverly, where art materials and projects were all around the house. Aunt Beverly's hands were always busy, doing Swedish embroidery, drawing pictures, cutting linoleum wood blocks, or making magical things. I got to watch her create her art and she spent a lot of time helping me create mine. She would provide me with materials and show me how to use them, teach me how to choose projects, and get me started with basic instructions and a lot of encouragement. Drawing was the main thing I wanted to do. I loved drawing animals, and people kissing, and characters from stories and movies. I remember making paper dolls, with fully proportioned bodies and a variety of clothes, by the time I was seven. I don't ever remember feeling that I couldn't draw. In about fifth grade I finally noticed I was the only child in school who was drawing the way I did, but I never thought about it much or believed it was anything unusual. Becoming the high school artist and eventually going off to art school was what everyone had always expected.

Now that I have observed the drawings of so many children and have studied the subject in such depth, it is eerie to look back on my childhood drawings that Aunt Beverly saved. I had no real appreciation of their technical maturity or uniqueness back then. I never questioned how I achieved them, but remember feeling strange that I didn't know how I did it. I guess I just accepted the opinions of the adults in my world, who said I had been born with a gift. I got the message that I somehow ended up with a particular set of genes, as if it were simply a matter of chance. All my life people would admire my drawings amd then immediately tell me about how they couldn't draw. They seemed to have none of the kind of embarrassment that would have accompanied similar statements about not being able to read or

write. They would announce it loudly, for all to hear, seemingly accepting that those illusive genes must have escaped their makeup.

The Expanding of My Passion

After leaving college I pursued my dual occupations as an artist and a social-service worker, but I was never drawn to teaching art. Twenty years later, an opportunity arose that threw me into the world of teaching others to draw. In 1979 a director at a private nursery school, who knew I was an artist, asked me to develop a drawing program for one hundred preschool children. I didn't plan to develop a system or even to stay in the job very long; I just thought it would be a fun adventure during an exciting transition in my life. I never imagined that this little job would give birth to a drawing method with such far-reaching results. Within a year the California Arts Council funded a three-year grant for field study. Suddenly I was inundated with parents seeking private lessons for their children and entire school districts wanting to incorporate the method into their curriculum. The results led to a chain of licensed drawing schools, called Monart, a national in-service training program for school districts, and the publication in several countries of my first book, *Drawing With Children*. I became obsessed with the world of education and drawing and never returned to my former work. I watched the individuality and creativity of the students grow by quantum leaps and the method expand to a fully integrated drawing program.

Two years or so after the book was published I was besieged again by the parents and teachers who had been using it. They were thrilled with the results they were getting from the basics. However, they also said that many of the children in the program were ready for advancement and that they wanted to expand their own skills to more mature levels. The same need for expansion began surfacing at the Monart Schools. This forced the teachers and me to deal with the situation in a practical way. Hundreds of students who had started at ages four to ten were now twelve to sixteen years old. They had mastered the basics, were asking for more complexity, and were ready to be challenged further. Their older siblings and even their parents had been enrolling in the classes, and we found our children's drawing curriculum expanding into teenage and adult classes.

I began exposing these young but experienced students and our beginner adults to the kind of projects I had in art school. I always knew they would make the transition into more sophisticated work, but the ease with

Mona — age 10
From a photograph, watercolor.

Mona — age 14
Portrait of a classmate,
watercolor.

Mona — age 17
Inspired by Japanese prints,
gouache.

which it happened astounded even me. I suddenly found myself watching ten- to fourteen-year-old long-term students, as well as brand-new teens and beginner adults, drawing live models and moving animals at a level that I had never seen before.

We weaned the youngsters away from the step-by-step instructions they had grown up on and simply said, "O.K., you're ready to fly on your own now," and they did. The teens and adults walked into an environment where drawing was modeled as being possible and they simply did it. If you give yourself permission, you too can experience that kind of independence and ease.

If you question how much you can develop your drawing ability, I would like to encourage you to join the endless number of people who are surprising themselves.

The Unfolding of a Methodology

When I first took on the task of teaching young children to draw, I still didn't know how I did it myself, let alone how I was going to teach others. Since I was an artist, and not an art educator, I didn't know anything about the art methods used in the school system. I was unaware that there was an existing philosophy that would have told me I shouldn't show a child how to draw. I didn't know that Aunt Beverly might have been judged for giving me instruction when I was a child.

To figure out my methods, I talked for hours about art with my next-door neighbor and musician pal, Elliott Day. We slowly analyzed how I drew, broke it down into a simple language, designed an alphabet of shape with which to see, and planned a curriculum of inspirational subjects. When *all* one hundred children in the preschool were successful, I realized the myth of the gene theory. I began to appreciate the importance of the gift Aunt Beverly had given me.

The elements of the system are as simple as a noncompetitive environment, a lot of exposure, detailed instruction on how to use art materials, guidance on how to pick projects, permission to draw from pictures and photos as well as live objects, and the freedom to explore any style one wants. It suddenly made sense to me why none of my classmates in school could draw. They feared judgmental remarks from instructors or competitive classmates; they were trying to use equipment without instructions; they thought that looking at pictures or photos of things for inspiration

wasn't acceptable; and they believed there was a "right" way to draw and were afraid of making "mistakes."

Now I watch whole school districts of children drawing with technically mature and unique styles, with teachers who were afraid they couldn't draw themselves. It's wonderful to see all the children in a class proud of and satisfied with their drawings, without dreading a critique. Year after year, it is equally gratifying to see teenagers and adults easily get over artist's block and watch them enjoy their natural ability.

After twelve years of watching thousands of nondrawers achieve satisfaction, I have concluded there are two major factors that make this drawing method so successful.

Mona — student at age 19
From still life objects, oil pastel.

1. A noncompetitive and nonjudgmental environment, with no implication of a *right, wrong,* or *real* way to draw. When you feel safe, you are willing to risk exploration. When you can explore, you can develop your skills and your creativity.

2. Enough structure to ensure accomplishment and enough freedom to allow for individuality and creative expression. This method teaches you how to see through an alphabet of shape, but the structure is so loose you can interpret the information in an endless variety of ways.

If you think you can't draw, whatever your age, the lessons in this book may be your dream come true. They give you the opportunity to start like the four-year-old for whom the method was designed and to safely understand the basics. Then you can quickly move on to the mature drawings you secretly wished you could do. You get to experience the freedom to work without being told which method is good or bad. You can explore all methods, trying many established styles, plus any new ones you can imagine, and develop a sense of what *you like*. In short, you will enjoy the freedom of learning to *draw for yourself*, instead of following a preconceived idea of what you thought was a right way.

If you are a parent, teacher, or professional, you can learn how to bring drawing into your world and share its many benefits with others. Along with the sheer pleasure your children or students will get while drawing, there are a wealth of skills that are naturally developed during the process. Educators, brain researchers, and other professionals give me continual feedback about the added values that this drawing method promotes. For example, preschoolers show increases in reading-readiness and visual-perception skills; older students and teens show vast improvement in concentration levels, problem-solving abilities, and critical-thinking skills; and adults report in-

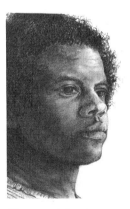

Mona — adult
Portrait of Elliott Day, pencil.

creased appreciation for the environment, stress reduction, and calming meditativelike experiences. For all three groups, the self-esteem that comes from such successful experiences also carries over into a multitude of other aspects of life.

I truly believe drawing is a teachable subject and that everyone can learn to draw. No matter how reluctant you are, I assure you that drawing is a natural ability you possess. You simple need some basic information and a bit of inspiration. If you are an older child or a teenager, you can use this book by yourself, without waiting for others to help you. If you are an adult, there is a child artist inside of you, waiting to be unleashed. If you are a teacher, you can help others draw regardless of your background. I hope you have a wonderful experience drawing with me. I encourage you to give it a try and join the fun.

Mona — adult
Portrait of live model, recent
work, pastel pencil.

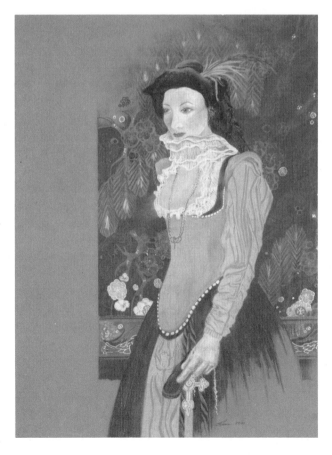

HOW TO USE THIS BOOK

This book is written so that it can be used by anyone over eight years old and still be appropriate for the adult beginner. I have been teaching this information to groups of mixed ages for years. Since beginners of any age need the same basic information, they can enjoy learning together. Because the method includes a noncompetitive environment, people of all ages are comfortable about learning the basics together. Since freedom of interpretation is encouraged, older students simply achieve more sophisticated results from the same basic information and projects.

The drawings that you see in the book were achieved by students who either were terrified they couldn't draw at all, were drawing like the average kid when he or she first started lessons, or had never drawn the kind of subjects or in the styles that they ended up achieving. In fact, many of the drawings were collected from people who weren't even drawing students and reluctantly agreed to do me a favor and contribute an illustration to the book.

As deadlines drew near and I didn't have time to travel to the schools, I began to pounce on anyone who was in my life. For example, Tom Lupica, a photographer who came to my studio, said he would try to produce an illustration, even though he felt he had no ability to draw. After a brief lesson in perspective he accomplished the skillful drawing of the corner of my living room that you see in Figure 5.36. Another example is the lovely shaded drawing by Elliott Day on the page on which I dedicate the book to him. Elliott, a composer and musician friend, got involved in helping me with Monart because he thought understanding visuality would help him play his instrument more proficiently. He is sure that developing his inner vision transformed his ability to see the structure of music, and he achieved spontaneous improvisation on a level he had always dreamed of. He never intended to actually draw. When I asked him to do a shaded drawing for the dedication page, he couldn't imagine accomplishing the results he ended up with. In one evening I walked him through the steps on shading and volume that I teach in Chapter 5 and his sophisticated drawing of the shell and drift-

wood unfolded. He said he was stunned for days afterward at how easily he had achieved something he felt would take months of study to accomplish. There is no reason you can't achieve similar kinds of results.

Notes to Older Children from 8 to 12 Years Old

There is little in this book that you won't be able to understand or accomplish. You will simply need more encouragement and support from your parents or teacher to use the book and be given time in which to do it. Of course, you would probably love it if one of your parents or friends did the lessons with you, so speak up and try to arrange a time each week for you to get together. I personally find that when I treat you the same as adults, you find out you can do a lot more than you thought you could. If you use the book by yourself and have problems, don't hesitate to ask your parents or teacher for help. Even if they don't draw themselves, they will be able to understand the instructions and help you follow them.

Notes to Teens and Adult Beginners from Age 13 to Senior Citizens

If you are a teenager or adult beginner, you have the same kind of visual capacity and will learn at about the same rate. The material presents basic information that is appropriate and necessary for several age groups, but is open to a wide range of interpretation. You will find your own level of complexity and maturity to interpret the instructions and projects.

If you are a busy teenager or young adult, your biggest challenge will be finding the time to explore your drawing desires. Many people who want to draw find they have to enroll in a class to make the time available. I suggest that you set aside a scheduled time for your drawing sessions, just as if you had enrolled in a class. I also suggest that you find some spot in your home where you can leave your equipment out, so that you will work on drawings in spare moments. If you have to set up the equipment and clean up every time, you may never get to it.

If you are a senior citizen, you may have the luxury that the rest of us wish for—enough time to really submerge yourself in the experience. Drawing may provide you with the passion you miss from raising a family or your past career drives. It is never too late to learn to express yourself

through drawing. If you have any physical or motor-skills problems, don't let that stop you. I have watched many students with so-called physical handicaps develop unique styles of drawing with which they were very pleased. I have drawn with people who had no hands and held the tools with their mouth, partially blind people who put their eyes right next to the paper to create mature and skilled drawings, and palsied students who found a way to create loose and abstract styles of drawing that expressed great sensitivity and self-expression. Drawing can provide you with some outdoor activities and exercise when you take your sketch pad out on leisurely walks. If you can find some drawing buddies, you may draw more often.

Notes to Parents, Teachers, and Professionals

If you are going to use this book to teach others, whether it be at home, in a classroom, or with people you serve in your line of work, it is very important to read the whole book first. Read in a relaxed manner, studying all the examples, but without doing any of the projects. This will allow you to know the entire scope of the book and address your students with a comprehensive view from the start. Then you can slowly take a section at a time and decide how many lessons you want to use to cover the different kinds of material. Unless you are experienced in teaching drawing, it is strongly suggested that you do each lesson yourself, right before introducing it to others. I have also included a special section at the end of the book, "Notes to Teachers," in which you will find some suggestions on how to teach in a classroom or institutional setting, with hints for teaching different ages and types of students.

Notes for Everyone

The lessons in the book are designed to encourage you to *draw for yourself*. So put aside preconceived notions about how you thought drawing should be done and prior experiences in which you were told there was a particular way you had to draw. In fact, you needn't be bound by the suggestions in this book, either. Anytime you feel the desire to do something other than what the instructions say, take the liberty to follow your feelings. Try any idea you have, then come back to the instructions and try following them as well. The more independence you claim, the more you will please yourself in the end.

And the more variety you explore, the more experience you will have to draw upon.

Even though you may be tempted to skim through the text and quickly get involved in the drawing projects, I encourage you to quell the temptation. The information that will empower you to be successful is contained as much in the text as it is in the drawing projects.

If you have heard that structured information about drawing prevents creativity, you need an update on the latest findings. In the past there was a concern that a person's creativity could be stifled if he or she was exposed to any structure. It turns out that that is not true. After ten years of watching hundreds of people's creativity flourish, as they integrate structured information with freedom of interpretation, I have no doubts about the outcome. Structure only enhances a person's ability to be creative. All the other arts rely on learning the basic structure of the subject first. You are encouraged to experience music, dance, singing, writing, language, and theater by learning the basics of the craft. Then your creativity unfolds from your understanding of the subject and confidence in that knowledge. I find teaching drawing works the same way.

What the Book Includes

In Part I, I will give you an overall introduction to the subject of drawing. You will be introduced to many styles of drawing in Chapter 1, along with simple projects to do so you can experience each kind. Don't worry about achieving skilled results; it is more important for you to get an overview of the many options for drawing and learn to appreciate the differences. One of the first steps in getting over a drawing block is to put aside any comparative and judgmental opinions about one style of art being better than another. Focus on finding out what you like and on giving yourself permission to learn to draw in ways that will please yourself instead of others. In Chapter 2, I will show you some examples of what is possible and what you can achieve. People just like you will tell you about their own experiences and share their artwork with you. When you look at their drawings, don't fall into the trap of thinking you could never draw so well. Most of the students were as dubious about their abilities as you may be about yours. Their work is typical of what happens to most students, and there is no reason for you to be the exception.

In Part II, I will introduce you to the technicalities of drawing. Some material from *Drawing With Children* will be reviewed in Chapter 3, which will give you the basic steps of the drawing method. You will see how to set up a conducive environment and how to train your eyes to see through an alphabet of shapes in order to draw. That may be all you need to be successful. (If you find yourself dissatisfied with or critical of the results you are getting, I suggest you read *Drawing With Children* and work with the more complete exploration of the basics first. This book is written in a format that is appropriate for adult beginners as well as young children and has step-by-step guided instructions that will help you get through artist's block with ease.) Chapters 4 to 6 will further develop your skills and guide you through several projects to help you gain confidence. You will learn how to plan drawing projects and compositions; how to use the techniques of shading, positive and negative space, and perspective; and how to choose from an endless array of subjects. If you use the information as suggestions to explore, without being overly concerned about liking every drawing, you can't miss. You will find out that drawing is just like any other subject: when you are given the information on how it works and some hands-on experience in following the steps, you can learn to do it.

Using the Process

Read the Note to Educators and Parents and the Preface. Then skim through the rest of the book and look at all the pictures and types of projects you will be doing. This quick glance will help you start with the right attitude and give you an overview of the many kinds of experiences in store for you. Then collect the starting supplies that are recommended in this section and set up a drawing space for yourself. Slowly work your way through the book, section by section, until you reach the last one. While reading the last chapter, you can endlessly jump from subject to subject, depending on what inspires you for the day.

As you work through the book, there may be time lapses between active drawing sessions. It is recommended that you reread the checklists in "Starting with the Preliminaries" when you have had such a time lapse. This will help you remind yourself to establish the supportive environment and the eye-training information that will help you have consistent success.

Photocopy and Free-Use Permission Information

If you are employed as a schoolteacher or an institutional worker, you have permission from the publisher to photocopy materials for use in the classroom to accompany your verbal lessons.

If you are using the book to teach a college-level course, you have permission from the publisher to photocopy no more than ten to fifteen pages for handouts to your students. Beyond that amount, you need to write the publisher for permission or consider assigning the book as a textbook for the class.

Finally, if you wish to teach private art classes, it would not be appropriate to present yourself as a Monart teacher, solicit private art students based on this book, or photocopy materials from the book for such classes. The name Monart is a trademark, and it is illegal to use this name without written permission from the author.

The only certified Monart Drawing Schools in existence display a license signed by me and are operated by owners whom I have personally trained. The only people qualified to conduct in-service training seminars in the use of my methods are members of my personal staff. For futher information, write to me directly at P.O. Box 1630, Ojai, California 93024.

Getting Started

Before you begin Chapter 1, you will need to gather certain art supplies to work with. Here is a list of the basic materials that you will need to get started and an additional list of optional materials that will add to the variety of drawing experiences you can have.

BASIC MATERIALS

If you take this list to an art store, ask a clerk to help you. Different stores carry various brands, but an informed salesperson will be able to steer you to comparable materials.

DRAWING BOARD AND SEPARATE LARGE METAL CLIPS
Get at least an 18 × 24″ drawing board or heavy piece of cardboard and some large metal clips to hold your papers onto the board.

DRAWING MAT

Get at least an 11 × 14″ piece of white tag board or cardboard, to keep marker ink from bleeding through onto your drawing board or table and to test your colors on.

PENCILS

Get an H, a 2 or 3 B, and a 5 or 6 B.

PENCIL SHARPENER

Get a portable style, with both a large and small hole.

ERASERS

Get a Design kneaded rubber eraser and a Staedtler Mars (or other) plastic eraser, along with a box of household facial tissue.

SHADING STICKS

Get a stomp blending stick (gray paper rolled to a point) for shading.

PENS

The following are recommended:

One Flair (or other) regular-tipped *black* felt-tip marker

One Pilot (or other) metal-tipped *black* razor-tip pen

One Stabilo (or other) broad-tipped *black* felt-tip marker

Assorted Pentel fine-tipped *colored* felt-tip markers. If you can't find Pentel, test cheaper brands to avoid points that mash.

Assorted Berol Prismacolor double-tipped *colored* felt-tip markers. These are the only sophisticated markers on the nontoxic approved list. If you can't find them, watch out for streaking or dryness in cheaper brands.

OTHER

Get the following:

Two *brown-tone* Conté Crayon (or other) sticks

One *brown-tone* Conté à Paris (or other) pastel pencil

One box of assorted *colored* Koss (or other) pastel sticks

One box of assorted *gray and black* Koss (or other) pastel sticks

One soft and one hard *black* Berol (or other) charcoal pencil

PAPER

A ream of 8 ½ × 11″ photocopy paper

A 9 × 12″ or 11 × 14″ pad of heavy drawing paper

An 18 × 24″ pad of heavy drawing paper (recommended brands: Morilla or Strathmore)

An 18 × 24″ pad of cheap smooth newsprint paper (recommended brands: Morilla or Standard Brands)

OPTIONAL MATERIALS FOR MORE VARIETY

DRAWING TOOLS

Assorted *colored* (any brand) razor-tip pens

Assorted *colored and black* Marvy (or other) calligraphy pens

Assorted *colored and gray* Tombow double-tipped brush-point felt-tip pens

Assorted *colored* Pantone, AD, or Design broad-tip felt-tip markers
(These pens are not on the list of nontoxic materials for children.)

A box of Caran d'Ache or Berol Prismacolor *colored* pencils

A box of Schwan-Stabilo Othello *colored* pastel pencils
(These are great for colored portraits, since the sharp point gets fine detail.)

A box of Pentel or Cray-Pas *colored* oil pastels

An electric pencil sharpener
(This is not really a luxury if you plan to do detailed pencil drawings.)

PAPER

You will find drawing paper in pads of various standard sizes. When you are shopping it is not necessary to find an exact size, but look for sizes that are similar to the ones below:

Around 11 × 14″ and 18 × 24″ Bond Layout (recommended brand: Morilla)

Around 11 × 14″ Bristol Board with vellum or matte finish (recommended brands: Morilla or Seth Cole)

Around 18 × 24″ *white and colored* charcoal paper (recommended brand: Strathmore)

PART

DRAWING:
THE BIG PICTURE

1

Exploring
Different Styles

You will be doing some drawing as you read this chapter. However, all of the projects I have chosen are simple and do not call for a high level of ability. Later in the book you will receive guidance and help with your drawing skills, and the projects will progressively challenge you to develop more and more complexity. For now, relax and do the work with an attitude of exploration and fun. These projects are just an introduction to the different kinds of drawing that are possible for you to enjoy. Let yourself focus more on the process than the results.

There Is No Right Way:
Letting Go of Preconceptions

Most people think drawing is done in a particular way. When you ask them whether they can draw, they think of the kind of art they were taught to admire, compare their own work with that style, and then tell you they can't do it. They usually have strong opinions as to what is considered good and are sure there are certain paths one must follow to achieve it. For example, most people think flat, two-dimensional styles of drawing aren't as good as shaded, three-dimensional styles. They don't realize that many professional artists use such flat styles and are greatly admired. Most people also think that they can't look at photographs or other drawings for inspiration, unaware that Picasso and Michelangelo both spent the first years of their training in copying exercises.

Judgmental opinions and critical comparisons abound in the art world. Commercial art styles are judged by some fine artists as inferior and not

acceptable for museums. Some realistic artists sarcastically imply that abstract artists insult us, while abstract artists may patronizingly imply that realism is shallow and lacks creative expression. The two-dimensional styles of so-called primitive cultures may be judged as immature attempts by the so-called artistically educated. The world of children's art is eliminated by many from what is considered real art and is relegated to being pinned up on refrigerator doors. With such a critical atmosphere surrounding art, who can blame you for being hesitant to explore your own drawing ability?

The main reason for much of this negative judgment is a lack of understanding. Most people simply don't realize that different types of drawing don't lend themselves to comparison and that they exist for completely different purposes or ways of communicating. Imagine trying to compare the skill of a famous jazz musician with that of a celebrated sculptor, or expecting ballet dancers to use the same methods to arrive at body movements as tennis players. A similar confusion results when we compare master artists from different cultures with one another, or commercial artists with fine artists, or one style of drawing with another. Unless we become aware of these useless comparisons, we will continue to misunderstand the reason most people think they can't draw. Most people don't draw because they are too intimidated to risk the kind of confusion and critical judgment that I have been discussing.

If you have been conditioned to believe that one way of drawing is better than another, or that only certain techniques and methods of drawing are acceptable, you have limited your ability to enjoy the art of others and have restricted your own creative expression. All you have to do is visit the halls of the museums or listen to the endless debates of art critics to know that there is no right or wrong way to draw. If you expose yourself to as many styles as possible, learn to appreciate differences, and let go of expecting certain results, you will claim the natural ability you have to draw and help others do the same.

LEARNING THE DIFFERENCES: APPRECIATING MORE POSSIBILITIES

The following sections will discuss several major styles of drawing. Until you actually experience the process of drawing in these styles, it may be impossible for you to know which ones you like and what inspires you. There is

no exact cutoff point between one style and another. Using what you like from each style and mixing these elements together will serve you better than trying to limit yourself to one style. Learning about all the possible options will help you develop your own style.

ABSTRACT DRAWING: FROM TODDLERS' SCRIBBLES TO MODERN ART

There is a great deal of confusion in defining the term *abstract art*. Most of the problem comes from the different ways people use the words. Some people claim that the term *abstraction* means having no relationship to a realistic object, while others feel an abstraction depicts a recognizable object with some degree of deviation. We will study both types of abstract drawing, but I am going to separate them for now. In this section we will talk about abstract expression that comes purely from your feelings and your exploration of form. In the later section on flat styled drawing, I will address the type of abstraction that deals with drawing realistic objects with deviations.

When you create a drawing without any relationship to objects, you express yourself in line, pattern, feeling, texture, contrast, and color. The overall feeling of the piece sets a tone or an atmosphere that can range anywhere from balanced beauty to chaotic disharmony. Abstract drawing can give you a direct route to free expression of feeling. I encourage you to submerge yourself in the experience. Your style can be as loose as the scribbling of a child, as organized as complex professional designs, or as sophisticated as the patterns of form in an abstract modern painting. Start at the beginning of the drawing process, when you first learned to make marks on paper and learned that it was referred to as scribbling.

Scribbling

Dr. Howard Gardner, research psychologist and co-director of Harvard's Project Zero, has written extensively on psychology, intelligence, art, and child development. In his book *Artful Scribbles*, he states, "A society that valued the realistic drawings of an Ingres, a Millet, or a Constable would find little reason to cherish the seemingly careless scribbles of its children." He goes on to explain, however, that this viewpoint has changed with the

ABSTRACT DRAWING
From toddlers' scribbles to modern art

These four works show a style of abstraction that has no relationship to objects. The artists expressed themselves through line, pattern, and movement.

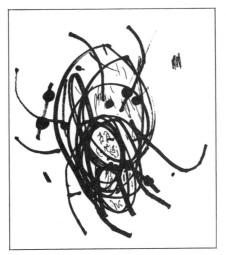

FIGURE I.I
Child's scribble.

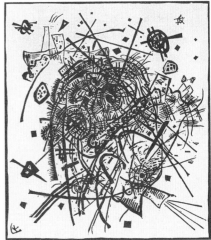

FIGURE I.2
Wassily Kandinsky, 1866–1944, Small World VIII, *1922. National Gallery of Art, Print Purchase Fund.*

FIGURE I.3
Adult scribble.

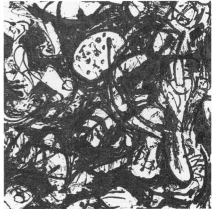

FIGURE I.4
Jackson Pollock, 1912–1956, Black and White Number 20, *1951. Los Angeles County Museum of Art, David Bright Bequest.*

development of modern art. He shows us children's art next to works by such master artists as Jackson Pollock, Pablo Picasso, Paul Klee, and Wassily Kandinsky to illustrate why a new appreciation for children's work has evolved. In figures 1.1 and 1.2 you will see the similarity in the work of a child's scribble and a woodcut by Kandinsky.

Most people, however, have a negative view of scribbling. For example, I have been giving drawing workshops to groups of fifty parents and teachers at a time for years. I begin these workshops by taking the participants through an activity that transforms them back into a four-year-old scribbler. After some exercises in eye relaxation and remembering what it is like to be a preschool child, they begin looking at me with peaceful, sweet faces. Then I suggest that they forget everything they thought they knew about drawing and tell them simply to scribble with many kinds and colors of markers, all the while listening to music. I have done this process with thousands of people, and each time I can count on several of them finding it hard to follow the instructions. They have a specific judgment about scribbling, and so they make structured designs on the paper. When I tell them to let go of the need to perform and to scribble on top of their designs, they laugh, their bodies sigh with relief, and they finally relax and let themselves really scribble. After about five minutes I tell them to stop and to watch every move I make. As I walk around the room looking at their papers, you can almost feel the thickness of performance anxiety hanging in the room. One would not expect such a strong reaction from a group of adults who had simply been scribbling. Then I suddenly take one of the papers that resembles a Jackson Pollock and throw it in the trash, telling the participants to make an exaggerated facial expression indicating the feelings they are experiencing. As I look around the room, I see embarrassment, pain, shock, and rage. Next, I take the scribble, such as the one in Figure 1.3, back out of the trash and show them its similarity to the famous works of Pollock, as exemplified in Figure 1.4.

Then we talk about how our attitudes about art are what block us from our creativity. Finally, the students' faces soften and they begin to regain the innocence of the four-year-old. As we talk about what happened, they are amazed at the amount of performance anxiety they felt and the investment they had in their scribbles. They gratefully adopt a more open-minded attitude and approach the rest of the day with more relaxation and concentration. They respectfully put away their scribble as the first completed drawing of the day. Keeping this story in mind, prepare yourself to experience the introduction to scribbling as a truly serious endeavor.

SCRIBBLE PROJECTS

Pick a quiet time of at least 30 to 45 minutes, when you won't be interrupted.

SUPPLIES

Your drawing mat (to keep ink off the drawing surface)

10 to 15 pieces of cheap photocopy paper

An assortment of thin- and broad-tipped colored markers

An assortment of pencils and oil or chalk pastels

An assortment of different kinds of music tapes, from peaceful to lively

INSTRUCTIONS

Put on some lively music and, using the markers, force yourself to scribble randomly all over a sheet of photocopy paper. Hold the pen in your whole fist instead of holding it the way you usually do; this will encourage the gross motor movements of the toddler. Try to avoid doing what you think will look good; instead, just get into the flow of the pen on the paper.

Now, change to peaceful music and do the same activity on a new piece of paper. Notice the differences in feeling and mood and the types of marks that occur. Keep changing music. Try some scribbles with pencil and pastel to experience the differences in media.

Doodling

How many times have you heard someone say, with a self-belittling tone of voice, "I can't really draw, I can only doodle"? If you decide to take doodling seriously and develop it into finished pieces, you will be working in a form of abstract drawing that can be very sophisticated.

One of the features that denotes doodling and distinguishes it from scribbling is that it has designed patterns instead of randomly placed marks. You build one line off another, until the drawing grows into larger and larger forms of designed patterns. Doodles can be as unstructured as figures 1.5

and 1.6, as elaborately structured as the freehand ones in figures 1.7–1.9, or as mechanically exact as those done with templates in figures 1.10 and 1.11. The main feeling you want to focus on when doodling is letting the drawing unfold by itself on the paper.

DOODLE PROJECTS

Set aside 1 hour of uninterrupted time for your first session, creating a quiet, relaxed atmosphere, perhaps with some soft music.

FIGURE 1.5
Elena Ramos — age 9

SUPPLIES

3 pieces of 9 × 12″ white drawing paper

An assortment of black and gray fine- to medium-tipped markers

A razor-tip or steel-tipped black pen

An assortment of soft to hard drawing pencils

Some plastic templates (circles, squares, diamonds, hexagons, or French curves). Templates are usually green plastic squares with different-sized holes cut in them (the kind used by architects or computer programmers). If you don't have templates you can use squares of cardboard, rulers, round objects such as plates or cups, or objects with unusual-shaped holes in them.

INSTRUCTIONS

1. Unstructured: Start anywhere you want on one sheet of paper and let the first line flow out of a feeling. Without planning, randomly let the next line grow out of what is already there, repeating this over and over, until your drawing takes on an overall look that you like and gives you a feeling of being finished. Change from one kind of pen or pencil to another, to give the drawing a variety of thick and thin line and some interesting textures.

2. Structured: Start anywhere you want on a new sheet of paper, with a single line that flows from your feelings. Then stop and do some loose planning. For instance, think in terms of whether you want mostly angular lines or curved ones, whether you want dotted, striped, or plaid textured areas,

FIGURE 1.6
Juli Diener — age 18

FIGURE I.7
Amy Schnapper — adult

FIGURE I.8
Michelle Richards — age 13

FIGURE I.9
Tomas Dessle — age 11

STRUCTURED DOODLES
In this style of free-hand doo-
dling you may start with some
general ideas or develop a
structured plan as you draw.

and whether you want a little or a lot of white space left over. Let your general ideas repeat themselves over and over in the piece; repetition is one of the things that will organize the overall look. You can repeat ideas in smaller or larger forms or with thicker or thinner line. However, keep the general plan loose enough that it allows for new ideas to grow out of the existing ones.

3. Using templates: Choose a shape from one of the templates and begin a line or shape anywhere you want, on a new piece of paper. You can use the edge of the template for a straightedge or any portion of a shape to create a line. Flipping the template shape over in various directions can give you a repetition of ideas in symmetrical patterns. Repeating a line by offsetting the template shape a little can give you tapered lines or shadowed effects. When the doodle grows to the point of completion, you might want to color portions of the spaces in with colored markers.

Abstracting

Prior to 1950 most drawings and paintings represented something real. They were of subjects like landscape, still life, animals, objects, or people.

In the 1950s, however, a new art movement introduced us to works of art that had no recognizable subject. Artists made paintings comprised of only shapes and colors, and sculptors made pieces that were simply combinations of general shapes and forms.

But abstract painters do not just slop paint in any random way they choose. Vicci Sperry, a contemporary abstract painter (whose work is seen in figure 1.12) goes into lengthy detail to explain the preparation, discipline, and inspiration she believes are necessary. In her book *The Art Experience*, she writes, "Prepare your attitude, but not the expression, for that is spontaneous. Have your mind and your materials ready. We must give wholehearted attention if we wish to receive full value from the experience. Contemplation releases the talent. The release is such that one feels as though one dances as one works."

Children have no problem making abstract drawings and paintings. Figure 1.13 is an example of the abstract work of a nine-year-old. Children have no preconceived notion as to what results are desirable and are simply feeling the joy of watching the colors and lines appear on the paper. As you do abstract drawing, it can help you to think or be like the child you once were.

FIGURE I.IO
Alicia James — age 16

FIGURE I.II
Jocelyn Greene — age 10

TEMPLATE DOODLES
In this style of doodling, you can use rulers, stencils, or templates.

ABSTRACT FORMS
In these works, the artists
expressed themselves through
form, pattern, texture, and
contrast.

FIGURE 1.12
Vicci Sperry, Child With Red
Face, *1966, oil.*

FIGURE 1.13
Jonathan Jung — age 9
Abstract drawing, markers.

ABSTRACTION PROJECTS

Play some music that will exaggerate a feeling you have now. Do at least 3 of the following free-expression drawings. It may first take 20 or 30 minutes of uninterrupted quiet time to leave your analytical mind behind and get into an intuitive state of mind. Since you are trying to tap into a spontaneous feeling, it is also more important than usual that you isolate yourself in this exercise for at least an hour.

SUPPLIES

Several sheets of large (at least 18 × 24″) drawing paper

Gray-tone and colored chalk pastels

A box of facial tissue (for cleaning your fingers between color changes)

INSTRUCTIONS

Begin with one sheet of paper and some chalk pastels. Use the chalks on their corner point to create solid lines, and turn them on their side to block in large areas of color. Use the pastel colors in their pure state or use your fin-

gers to mix and smear the colors together. Instead of letting the form build on itself, as you did in doodling, let the forms and lines move around in any direction your feeling takes you. Remember Vicci's attention to contemplation. Take time to stand back and look at the patterns you have created, then contemplate what feeling they give you. Try not to talk, and let your silence take you into the next burst of expression. Work only as long as the feeling carries you along; you will know when you are finished. Immediately go on to another paper and let a new drawing take its course.

SYMBOLIC DRAWING: FROM CHILDHOOD STICK FIGURES TO CAVE PAINTINGS

Symbolic or stick-figure drawing is like visual shorthand. Young children use abstract forms of an object to express themselves, possibly due in part to the lack of small motor coordination. The cave painters may have been forced to use simple symbolic styles due to the difficulty of cutting their drawings into rock. Modern artists, such as Joan Miró and Paul Klee, use images in their paintings that are reminiscent of the kind of stick figures and abstract forms that you see in rock art and children's drawings. In all of these cases the artist is using symbols to communicate ideas. Figures 1.14 to 1.17 show examples of symbolic art by these different groups.

If stick-figure symbolic drawing is discouraged, it will interfere with a child's development of language skills, ability to communicate, and expression of feelings. That is why it is so *important not to compare stick-figure drawing with realistic drawing and to encourage the development of both styles*.

If you thought you couldn't draw because you could draw only in stick-figure or symbolic forms, it is time to reevaluate that opinion. When modern artists such as Miró and Klee began to experiment with more variety than the traditional realistic styles, they began to reclaim the ability to express themselves through symbolism. You can learn how to communicate through symbols and abstractions and possibly develop a modern style of your own.

SYMBOLIC DRAWING PROJECTS

Each one of the following three projects may take from 45 minutes to 1 hour, depending on the depth of your involvement. You may want to do them at separate sittings or with long breaks in between.

SYMBOLIC DRAWING
From childhood stick figures to cave paintings

In these four works, artists use symbols to communicate. Many people try to compare symbolic styles with realistic ones, but they are completely different subjects. Just as you can learn to enjoy many kinds of music, you can enjoy expressing yourself in many ways of drawing.

FIGURE I.14
Child's stick figures.

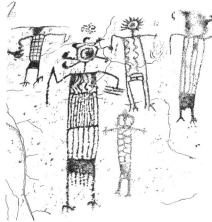

FIGURE I.15
Pecked petroglyphs, site INY-281, prehistoric rock art, University of California Press.

FIGURE I.16
Joan Miró, 1893–1948, Spanish, Figure and Birds, *1948, color lithograph. National Gallery of Art, gift of Mr. and Mrs. Burton Tremaine.*

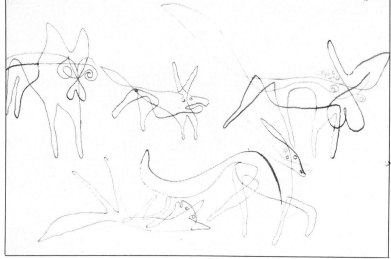

FIGURE I.17
Paul Klee, 1879–1940, Swiss, Gemischz, *1927, pen and gray ink over traces. National Gallery of Art, Ailsa Mellon Bruce Fund.*

SUPPLIES

A few pieces of lined writing paper

A writing pencil or pen

Several sheets of small (9 × 12″) to large (18 × 24″) drawing paper

A variety of colored markers and pastels

INSTRUCTIONS

1. Pictogram story. First, write out a simple story of just a few sentences. Use a lot of animals, objects, and people in the story. Then take a piece of drawing paper and with thin-tipped colored markers rewrite your story, using stick-figure or symbolic drawings instead of words, using a lined format as you did with the story. When you come to words such as *the, or,* or *and,* make up a symbol to represent it. Delete words that you feel you can't represent with pictures or make up other little symbols that represent those words. Do at least two or three of these stories. Now see whether you can read the stories from the pictures instead of the words.

2. Pictogram drawing from a story. Choose one of your stories, and incorporate its components into a fully developed drawing. Use any combination of the supplies you wish. Place the subjects and objects from the story anywhere on the paper in a manner that aesthetically pleases you, adding background colors, textures, and lines to pull the drawing together.

3. Symbolic drawing. Use the larger paper and the pastels. Decide on at least two subjects you wish to represent in your drawing. Freely and loosely draw these subjects on the paper in any placement that pleases you. Then begin to play off these main subjects wth line and texture and abstract forms.

FLAT-STYLED DRAWING: FROM CHILDREN'S WORK TO THAT OF WORKING ARTISTS

When an artist draws a recognizable object but deletes any reference to volume or depth, the drawing takes on a flat, two-dimensional or abstract quality. We can see this flat style in many powerful paintings from around the world, from the work of illustrators and graphic artists, and from that of children. Figures 1.18 to 1.21 show some examples of flat-styled drawings.

If you believed that drawing in three-dimensional shaded styles is a better way to draw, I encourage you to reconsider that position. There is no reason you can't learn to draw in many styles and enjoy different ways of expressing yourself. Most students I meet love to draw in flat design styles, and I have never seen it prevent them from learning to draw in realistic styles as well.

One of the most respected artists, Pablo Picasso, was able to paint in either realistic, abstract, or flat styles. He was accepted and admired for any style he chose to use. In her book *Picasso, Creator and Destroyer*, Arianna Stassinopoulos Huffington writes about how one of the main things that inspired him to branch off into the realm of modern art was collecting and studying African masks. You can borrow from other cultures the same way Picasso did, learning to appreciate the power and expression of two-dimensional and flat styles.

FLAT-STYLED DRAWING PROJECTS

Spend a few days and collect as many examples of flat-styled drawings as you can. You will find such images in books about art from other cultures, in magazine and book illustrations, in graphic designs on posters, greeting cards, and commercial products, and on fabrics and clothing. Study the way the artist simplifies the objects. Notice how he or she takes the basic lines of the subject, eliminates the detail, and chooses not to represent its three-dimensional quality. Sometimes the work is in black and white, but most often the piece is done in vibrant solid colors. The work can range from cute and immature images to very dramatic or sophisticated ones.

Allow at least 1 hour for each of the projects below. If you don't finish a project in one sitting, don't push yourself. Artists usually have several projects going at once and rotate from one to another as their interest and time constraints dictate.

SUPPLIES

A few sheets of scratch paper (for planning sketches)

2 sheets of 11 × 14″ drawing paper (option: bristol board)

An assortment of thin- to broad-tipped colored markers

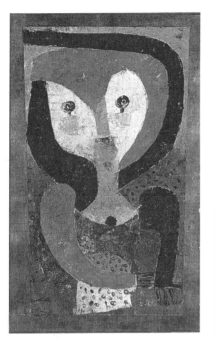

FIGURE I.18
Paul Klee, Maid of Saxony,
1922. Norton Simon Museum.

FIGURE I.19
Varnette P. Honeywood, Snuff
Dippers, *1982, acrylic on can-
vas, 36 x 48 inches.*

FLAT-STYLED DRAWING
*From childrens' work to working
artists*

*When artists draw or paint rec-
ognizable objects, without any
reference to volume or depth,
the work takes on a flat, two-
dimensional quality. This is
another of the many choices you
have in drawing and develop-
ing your own style.*

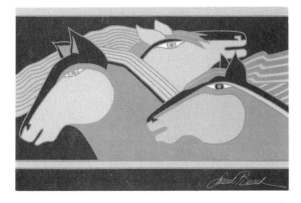

FIGURE I.20
Laurel Burch, Wild Stallions,
*1989. Laurel Burch Design,
San Francisco.*

FIGURE I.21
*Kristen Miglore — age 8
A child's flat-styled drawing.*

INSTRUCTIONS

1. Duplicate something you like. First, choose one of your favorite samples among those you collected. You will use it for inspiration. If you have heard it is cheating to copy, just remember that many of the most famous masters spent the first years of their apprenticeships copying. Use your scratch paper to test some of your ideas; then take a piece of drawing paper to begin your drawing. In order to give yourself a challenge, don't try to copy the sample exactly. Take a portion of the sample and change it around. Change the color scheme and the sizes of the elements, then add some ideas of your own.

If you are not sure where to start, begin with the main object or center of interest, analyze what comes next, and build one piece at a time slowly, line by line. You are simply using the sample to inspire yourself. If you end up with a completely different drawing, great! (If you end up with the exact same one, that's fine too.) This is an explorative exercise and there is no right way to do it.

2. Integrate two ideas into your own composition. Now use a new sheet of paper, around 11 × 14″. Divide your paper up into several spaces by drawing a variety of lines. Decide whether you want mostly angles or curves, straight lines, or circles. Use a variety of thick and thin lines and try to create a variety of different-sized spaces for your composition. Keep the spaces big enough to be able to draw in. Figures 1.22 to 1.24 show some examples. Use your own creativity.

FLAT-STYLED DRAWING PROJECT #2
Three examples of the kind of spaces you can create in which to develop your drawing.

FIGURE I.22
Curves and straights.

FIGURE I.23
Overlapping borders.

FIGURE I.24
Straights and angles.

FIGURE I.25
Marianne Tuttle — age 14
Incorporating texture for
interest.

FIGURE I.26
Schuyler Crawford — age 12
Trailing the object through the
spaces.

FIGURE I.27
Elsie Amidon — age 88
Using a theme for the subjects.

Choose at least 2 ideas—any portion or element—from the samples you have collected. You might, for example, select the wing from a bird, a particular flower from an arrangement, or a patterned animal design on a cereal box. Your ideas should represent recognizable objects. You can get as abstract as you want, but at least retain a semblance of the object so that you can create a stylized representation of it. Begin inserting these ideas into your spaces. Repetition holds a design together. If you use a piece of an idea in one space, you might want to change its size or color and represent it again in another space. You can trail ideas through spaces or confine them within the spaces. Use the markers any way that suits you; you might draw with the fine-tipped points and color in with the broad ones, or block in large areas of color with the broad tips and overlay fine detail with the fine tips. Figures I.25 to I.27 show some examples of what other students have done with this project.

REALISTIC DRAWING: FROM LOOSE GESTURES TO DETAILED REALISM

If you think you can't draw realistically, you are not alone. Perhaps 99 percent of people feel intimidated and frustrated because they can't draw realistically to their satisfaction. After watching thousands of people change their mind, I have some observations on the reasons why they can change.

I. THEY LEARN THAT REALISM IS FLEXIBLE AND LET GO OF THEIR IDEAS OF PERFECTION. The departure from total realism exists in many works by famous artists. Students are released from perfectionism when they begin to see this in artists' work. Figures 1.28 to 1.30 are examples of paintings by several famous artists who had no problem allowing or consciously creating distortion of proportions and imperfections.

2. THEY LEARN THEY DON'T HAVE TO LIKE EVERYTHING THEY DRAW AND BECOME WILLING TO EXPLORE. If you approach realistic drawing with an exploratory attitude and are not invested in the outcome, you will have more success than if you work under the pressure produced by fear of failure. If you make a pact with yourself to finish drawings that you don't like, you will gain the knowledge you need in order to grow.

Allow yourself to play with several degrees of realism. As you work, you will begin to experience how loosely or tightly you like to draw. Do all the stages of the projects, in the order they are presented, and you will experience a gradual sequence toward greater and greater realism.

Realistic Gesture Drawing

In gesture drawing, you attempt to see the subject as a whole and loosely record your overall impression of it. You can even draw live moving subjects with this technique. As you observe the subject, you let your drawing implement move almost at will, rapidly recording the feeling of action that you pick up from the subject. If you are drawing a stationary object, you relate to the energy and purpose of the object, rapidly recording your impressions with the same loose gesture of lines. If you *keep your drawing tool from lifting off the paper, and let it create a continuous flow of line*, it will help you record a gestured impulse of the object.

Obviously you can't be holding a preconceived notion of how the drawing should look. For instance, if you were drawing a boy running, you might end up with more than two legs, and the eyes, nose, and mouth might not appear on the face in the proper proportions. Figures 1.31 to 1.36 are some examples of gesture drawings that resulted from three- to five-minute poses of a live model.

One of the most helpful guides to gesture drawing is *The Natural Way to Draw*, by Kimon Nicolaides. In explaining this process he writes, "It doesn't matter where you begin to draw, with what part of the figure, because immediately you are drawing the whole thing, and during the minute

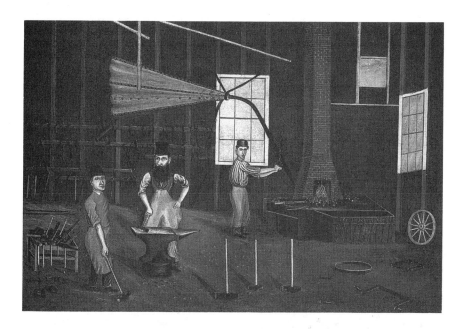

REALISTIC DRAWING
From loose gestures to detailed realism.

Many well-known artists prove that you can let go of trying for perfect proportions as you express yourself in realistic styles.

FIGURE I.28
Francis A. Beckett, 1833–1844, Blacksmith Shop, *1880, canvas. National Gallery of Art, gift of Edgar William and Bernie Chrysler Garbish.*

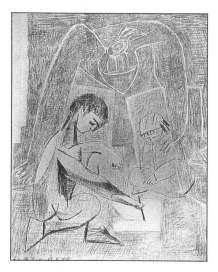

FIGURE I.29
Pablo Picasso, 1881–1973, The Young Draughtsman, *1954. National Gallery of Art, Rosenwald collection.*

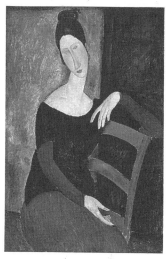

FIGURE I.30
Amedeo Modigliani, 1884–1920, Italian, Portrait of the Artist's Wife Jeanne Heguterne, *1918, oil on canvas. Norton Simon Museum.*

GESTURE DRAWING
This technique is a way of loosely drawing the subject as a whole. You are not concerned with accuracy, but you simply record the overall impression or mood you get from the subject.

that you draw, you will be constantly passing from one end of the body to the other and from one part to another." Nicolaides believed that your ability to grasp the gesture and movement in things is the most important key to drawing and that you will actually begin to understand proportion and perspective through the study of these principles of energy.

GESTURE PROJECTS

In order to complete these projects you will probably need several 30-minute to 1-hour sessions. Some of the sessions will involve an outdoor trip, so you will need to plan ahead.

SUPPLIES

A large tablet of newsprint paper (around 14 × 17″), or any large paper that can be clipped to a drawing board to keep it from flying around outdoors

A carrier for your supplies (such as a zip-lock plastic bag or small toolbox)

A blunt soft pencil (from 4B to 6B)

A black regular-tipped felt-tip marker

A black charcoal pencil

Optional: A few sticks of pastels or Conté crayon

 A beeper watch

FIGURE 1.31
Natalie Severin — age 8
A one-minute gesture drawing.

FIGURE 1.32
Amy Jones — age 10
A three-minute gesture drawing.

INSTRUCTIONS

1. People. Fortunately, it is not necessary to hire a model for the purposes of gesture drawing. Any open area where people are playing sports, rehearsing dance, walking leisurely, or sitting around is perfect. Using a watch with a beeper will help you encourage looseness by allowing only a few minutes to complete each exercise.

Five one-minute poses. Choose your location and get comfortable. Organize your supplies in such a way that you can quickly move from one spot to another. Select a subject and imagine yourself doing what the subject is doing. Imagine the movements you would be making with your body, and even imitate the movements with your own body if you want. Set

FIGURE I.33
Jennifer Burch — age 17
A one-minute gesture drawing.

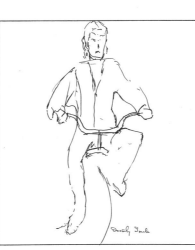

FIGURE I.34
Dorothy Soule — age 93
A five-minute gesture drawing.

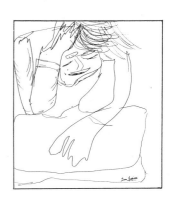

FIGURE I.35
Tom Lupica — age 22
A one-minute gesture drawing.

your timer for one minute and try to capture the movement of the subject using a black felt-tip marker. Lift your pen from the paper only when you feel you must. If the subject leaves before the 1 minute is up, force yourself to keep drawing. Nicolaides had models walk away in his classes and felt it was excellent training for the student to finish from memory. Let your arm and hand swing freely and draw large. You can do several drawings on the same sheet of paper.

Five two-minute poses. Use the blunt soft drawing pencil for some drawings and the black charcoal pencil for others. Draw with continuous lines, but slow down your hand a little and try to capture more realism and proportion this time. Don't worry if you can't control proportion, however, since it isn't the important thing for now.

Five three-minute poses. This time work with any media you want. If you have the option of pastel sticks or conté crayons, try turning them on their side and playing with the effect of tapered lines or shaded areas. Use a full sheet of the paper for each drawing and keep the feeling of drawing the body as a whole.

2. Animals. Follow the exact same process that you used with people. If you don't have any family pets, make arrangements to observe pets belonging to friends or neighbors, or take a trip to the zoo with your sketch pad. Observe the gait of animals when they walk, how they turn their heads, the

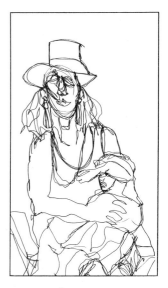

FIGURE I.36
Paula Greenstein — adult
A five-minute gesture drawing.

GESTURE DRAWINGS OF ANIMALS

Gesture drawing lends itself to capturing the overall impression of an animal in motion. Let your arm swing freely and your pen drag around on the paper to help you loosen up. Focus on drawing the general position and feeling you get from your subject.

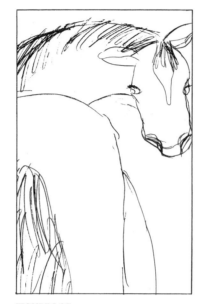

FIGURE I.37
Stephanie Kleinman — age 9

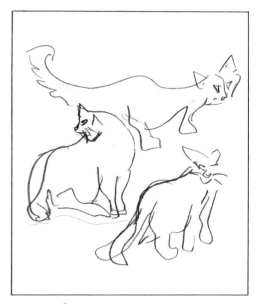

FIGURE I.38
Rebecque Raigoza — age 19

GESTURE DRAWINGS OF BIRDS

Each of these drawings were done in a few seconds. By drawing many positions on the same paper, you can reinforce your understanding of an animal's shape and form.

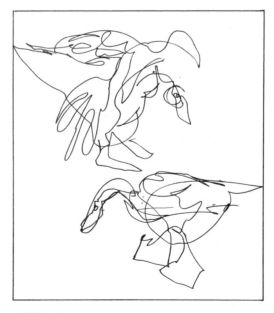

FIGURE I.39
Dorine Little — adult

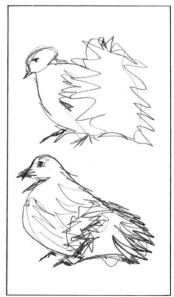

FIGURE I.40
Holly Schwartz — age 21

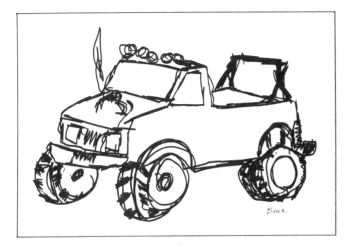

FIGURE I.41
Brock Essick — age 16

FIGURE I.42
Jennifer Youngs — age 17

amount of energy they use for different kinds of movements, and what kinds of sounds accompany their movements. Try to capture these qualities in your drawings. Figures 1.37 to 1.40 show some examples of student drawings from live animals in motion.

3. Inanimate objects. When you try to find the gesture in an inanimate object, you have to approach it differently. Since it is not moving, you need to find the natural impulse of its nature or purpose. For example, if you were drawing a chair you might establish what kind of chair it is and what kind of feeling it would provide for the sitter. There would be a great deal of difference in the movement of your hand in drawing a big fluffy stuffed chair as opposed to a straight-backed wooden one. If you were drawing a tree, notice if the limbs climb up in swirling motions or jut sideways in wide angular shapes; notice if the leaves billow out in cloudy formations or hang down in singular spiked forms. Even though it stretches your imagination a little, try to pretend you are the object and how it would feel. Figures 1.41 to 1.44 are student examples of this project.

GESTURE DRAWINGS OF INANIMATE OBJECTS
In order to capture the gesture of a still object, it helps to identify with its nature or purpose.

Realistic Contour Drawing

There are different interpretations of what the term *contour drawing* means. Some people refer to a very specific process in which you draw with-

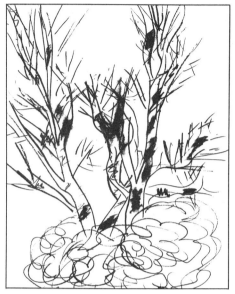

FIGURE I.43
Teresa Legg — age 10

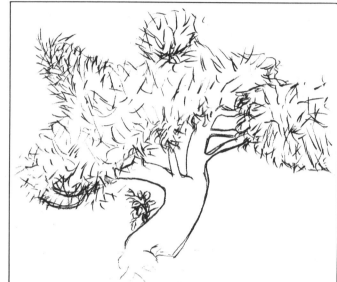

FIGURE I.44
Kellie Peterson — age 11

GESTURE DRAWINGS
OF TREES
In capturing an overall impression of objects in nature, it helps to notice the patterns and textures that form their construction.

out looking at the paper, while others are talking about a line drawing that only represents the outlines or edges of things. For now, you will be doing the latter, drawing the contour edges of an object, with the ability to look at the paper. (You will do blind contour, or drawing without looking at the paper, when you learn how to draw the human form in Chapter 6.)

Contour drawing is a technique that will help you through the transition from flat to three-dimensional drawing. Figures I.45 to I.48 show some contour drawings by students of various ages.

By following what is thought of as the outline or edges of each part of the object, the artist has created an impression of the object. In actuality there are no lines on the edges of objects; you train your eyes to see imaginary ones.

Part II of this book, "Drawing: An Endless Journey," will give you more guidance and information on drawing skills. For now, don't worry about proportion and perspective; just explore contour drawing for the experience. It isn't necessary to achieve perfection, so quiet your inner critic and enjoy these projects as a step in your own personal journey. You might surprise yourself with the beautiful drawings you can accomplish.

CONTOUR PROJECTS

Take your time with each exercise, and don't hesitate to repeat one if you are not satisfied. You might spend several days on this section, as it is one of the most crucial concepts to grasp in learning the skills inherent in realistic drawing. Be easy on yourself and keep a relaxed, nonjudgmental frame of mind. If you find yourself getting frustrated with proportion and dimension, remember that these are just practice exercises to help you understand the principles of contour drawing. You will need approximately 1 hour for each one of the projects below.

SUPPLIES

Several sheets of drawing paper (around 9 × 12″ to 11 × 14″ sizes)

Your drawing board and clip

A black regular felt-tip marker

A black razor-tipped pen

A sharply pointed pencil (around 2B to 4B) and a plastic or kneaded eraser

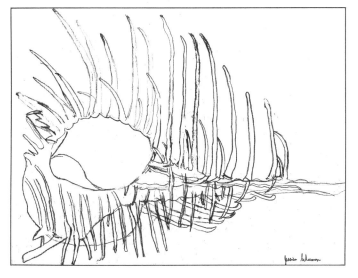

FIGURE I.45
Jessica Schuman — adult

CONTOUR DRAWING
By following what appears to be the outline edges of an object, you can create an impression of it. Contour drawing is a style of realistic drawing, but it doesn't capture the kind of three-dimensionality that you can achieve with shading.

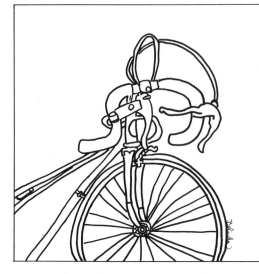

FIGURE I.46
Belinda Mossler — adult
Contour of a bicycle.

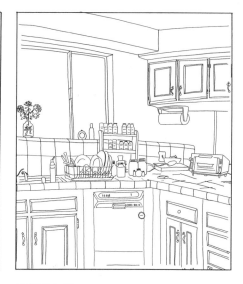

FIGURE I.47
Noel Chen — age 15
Contour of a kitchen.

INSTRUCTIONS

1. Draw from an upside-down contour drawing. In her book *Drawing on the Right Side of the Brain*, Betty Edwards has her students copy an upside-down contour drawing as accurately as they can on a blank piece of paper. This helps people get over their fear of realistic drawing, because when the model is upside down they aren't as concerned about the realistic content of the picture. If they just focus on the shape of the lines and the spaces between them, they can often be more successful. This dramatically shows how the amount of tension produced by trying to duplicate realism will directly hamper your ability to draw.

Make a blank rectangle that is the exact same size as the border in Figure I.49. Without this exactness of size, you may have problems with proportion. Using a pen with a line producing similar thickness to that of the sample, copy the lines and spaces that you see into the blank square. Be as accurate as possible. Keep the sample upside down and don't pay any attention to the objects you are drawing.

I have students first do this exercise with black ink instead of pencil, because the inability to erase encourages you to be more alert and trains

FIGURE I.48
Stephanie Kleinman — age 8
Contour of a live model with
texture of shirt and hair
added later.

your eyes toward accuracy. Consider the size of the blank spaces with the same attention you give to the direction and shapes of the lines. It can help if you select some of the main lines first, and then continue to work from different sides of the drawing toward the middle. Figures 1.50 and 1.51 will give you some idea of how other beginning students performed on their first try.

After you draw the picture in ink, repeat the same process in pencil. Use the eraser as much as you want, but take time to observe closely before making each line.

2. Inanimate objects. Use the razor-tip pen and the larger drawing paper for this exercise. Choose an ordinary household item that is simple but has several sections or parts. This exercise is not for the sake of making a finished drawing, so the object you select needn't be aesthetically beautiful. For example, you might pick a popcorn popper, the family car, or a lawn edger. You will draw the object from three different angles, so if it is too big to put on the drawing table, place it in a large open space and move around it. Draw all three views on the same paper. It isn't necessary to make them the same size, and you can be very loose in their placement. Draw with your finger on the paper, actually mapping out the three spaces that you intend to use and their size and relationship to one another. Decide which one of the three spaces you will use to start the first view. Figures 1.52 and 1.53 show some examples by students.

Study your object for a moment. Determine how many main sections it has. If the parts overlap, it will help if you draw what is in front first and then slowly add each part that is behind it. If there is a central part from which everything projects, it will help to start with that. If there are no overlapping parts, it may help you to start near the top of the object and work your way down. Pay attention to the size of the spaces between the lines; this will help you control the proportions. Continue this process until you have captured all the main parts of the object. Then follow this same procedure to add the second and third views of the object to your composition.

3. A piece of a room. Use the pencil and eraser for this project, with any size paper you prefer. Select a part of a room and sit as far away from it as possible. Draw the baseboard lines, the ceiling lines, or the corner line first, in very light pencil. You can draw the objects in the room right over these lines and erase parts of them later. You will be dealing with some perspective in this project, but you don't need to be accurate with it yet. Allow yourself to follow what you see as closely as you can, but do not be critical of yourself. It is likely you will have furniture and objects overlapping one an-

FIGURE 1.49
Sample of upside-down contour project.
COPYRIGHT 1986 BY MONA BROOKES/PUBLISHED BY JEREMY P. TARCHER, INC.

FIGURE I.50
Bryan Macrina — age 12
Result of upside-down project
with ink.

FIGURE I.51
Carrie Hipkiss — age 14
Result of upside-down project,
first try with ink.

other. It can help to draw what is in front first and then progressively add each object behind it. Keep the whole drawing in very light pencil line until you have all the objects in place, and use the eraser as much as you wish to make corrections or additions. You can eliminate objects if you wish, drawing only the ones you feel will complete your composition. When you are satisfied with the outcome, erase all the unwanted lines and darken the ones that are left. As an option, you can darken the finished drawing with ink and erase all of the light pencil lines. Figures 1.54 and 1.55 show some student examples of this project.

Realistic Volume Drawing

You can further develop your realistic drawing skills with the techniques of shading, perspective, and contrast. In Chapter 5 you will work on these skills in depth, but for now, just try an introductory exploration. You can use light contour lines to establish your composition and then add shading, or you can block in the shaded patterns without using any drawn edges. In

FIGURE I.53
Victor Hipkiss — age 17
Contour of coffee grinder.

FIGURE I.52
Lindsey Robinson — age 13
Contour of orange juicer.

CONTOUR PROJECT
Three views of the same inani-
mate object. In this exercise, you
do not aim to make a finished
drawing. Your goal is to train
your eyes to recognize the rela-
tionship of shapes to each other
and to become aware of details.

CONTOUR PROJECT
Two studies of a part of a room.
In this exercise, you can begin to
understand the relationship
between objects. Achieving cor-
rect proportions is not necessary
to study the scene.

FIGURE I.54
Alexandra Waterman — age 11
A study in noticing detail using
contour line.

FIGURE I.55
Heather Glick — age 8
A study in overlapping objects.

order to compare the two techniques, you will try both methods with the same project. Figures 1.56 and 1.57 show student drawings of the same still life, using these different approaches.

Figure 1.58 shows a student example of a quick contour sketch she did of a live model. She did the first sketch to warm up. Then, with confidence, she did another contour drawing and developed it into the shaded finished volume drawing in Figure 1.59.

Figures 1.60 to 1.62 show other student examples of realistic volume and shaded drawings. Notice the consistent light patterns, which show the source of light coming from one main direction, and how the contrast of dark against light creates definition of the objects.

VOLUME PROJECTS

You will need approximately 1 ½ hours to complete each one of the two drawings. You can break that time up any way you wish, knowing that you

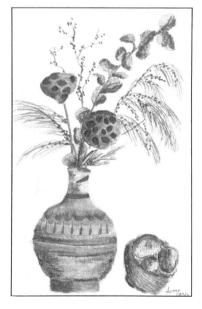

FIGURE 1.56
Sebastien Bailard — age 14
An example of drawing contour edges first, and then shading in.

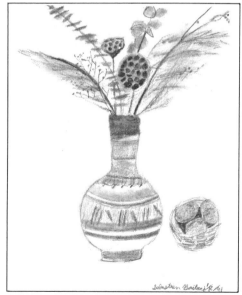

FIGURE 1.57
Anisha Patel — age 14
An example of blocking in patterns of shading without any contour edges.

DIFFERENT WAYS TO CREATE VOLUME AND DIMENSION
There is no "right way" to draw. This project will help you develop many options to express yourself in capturing realism.

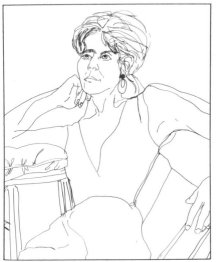

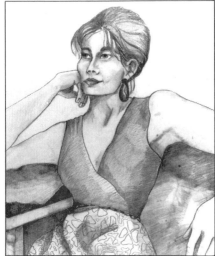

REALISTIC VOLUME
DRAWING
By noticing and duplicating pat-
terns of light, you can create
volume and dimension in your
drawings.

FIGURE I.58
Teri Prather — adult
A contour warm-up drawing of a
live model using black felt-tip pen.

FIGURE I.59
Teri Prather — adult
The finished drawing of the
model using pencil and shading.

can return to the project after a break or even on another day. It will help if
you have a place to leave your drawing project. Having the project available
to look at and the supplies laid out will inspire you to sit down and continue
where you left off.

SUPPLIES

A couple of pieces of 11 × 14″ drawing paper

An assortment of drawing pencils, such as H, 2-3 B, and 5-6 B

A kneaded eraser

Two simple objects

A spotlight type lamp (to illuminate the objects)

INSTRUCTIONS

Set up the objects as a still life, in a dark part of the room. Put the spotlight
to one side of the still life and create as much contrast in the shadowing as

FIGURE I.60
Julia Piloni — age 13
Still life objects lend themselves
to studying light patterns.

FIGURE I.61
Tyler Neumann — age 12
With the basic information about
form and structure, very young
children can master volume
drawing with a live model.

possible. If a still life sits in a room with many light sources, the patterns of light are unnatural and very confusing.

1. Sketch in the edges first. Using the H pencil, create a very simple contour drawing of the objects. Keep the drawing lines very light and use the kneaded eraser for any corrections. Study the patterns of light and dark before you start blocking them in. Notice the darkest shade in the arrangement and see whether you can locate all the places it appears. Then find the lightest shade and do the same. Now focus on the shades in between and locate all the places they are repeated.

Using heavy pressure with the 5-6 B pencil, block in the darkest areas you see in the whole composition. With less pressure, use the 2-3 B and lightly color in the lightest areas next. For the lightest smooth gray, you can make a thick swatch of 6 B pencil on a piece of scratch paper, rub your finger in it, and use your finger to apply the shading. You can make the lightest areas barely darker than white paper, by lightly smearing with your finger. Then slowly lay in the medium shades of gray with different amounts of pressure and the use of your fingers to smear the lead. You can use your kneaded eraser to pick up highlighted areas.

FIGURE I.62
Seth Roback — age 16
An example of using dots and
texture to create shading and
volume.

2. Working without edges. Using the same arrangement, repeat the prior instructions, but eliminate the step in which you drew the contour sketch of the objects first. Because you don't lightly sketch the objects first, your method of drawing is completely different. You observe patterns of dark and light and block in whole patches of shades onto the paper, without an outline of the object.

Start with the main object and decide which section of it you are going to draw first. Using your light to dark pencils and your finger for shading, block in all of the patterns of light and dark you see in that section. Then move on to the adjoining section and do the same. Keep blocking in each section of the composition, making corrections with your kneaded eraser and checking the proportions of the various pieces of the objects.

Until you have had a lot of experience, this method usually creates a much looser drawing. In the beginning your work will look similar to the way it did when you were doing abstract drawing. Only near the end of the drawing does the realism of the objects come through. The edges of one object as it appears separate from another is created by the contrast in shades and tones, rather than by creating a line for an edge. Once you have the composition completed and all the objects represented in relationship to one another, you can add finishing touches and darken areas for contrast and detail.

INTEGRATING DRAWING STYLES: CREATING YOUR OWN STYLE

Now that you have had a taste of many styles of drawing, you can use them in any combination that pleases you. After all, unless you plan to sell your artwork there is no reason to second-guess what others would like. Drawing for the approval of others is deadly to your creative spirit. It takes you on detours from self-fulfillment and interrupts the process of self-discovery. Integrating whatever you learn from all the different drawing methods will put you far ahead of being a slave to any one way of doing things. Developing a style that you like, whether or not anyone else likes it, will put you into the realm of personal satisfaction and self-expression, instead of the stress that comes from trying to conform and to please others.

There is nothing to lose from trying any wild idea you have. Some of the most creative new ideas grow out of synthesizing and mixing old ideas in new ways. Annette Polan, a fellow artist who teaches portraiture at the Corcoran art school in Washington, D.C., decided to break away from the tradi-

tional ways of painting and hit on some very exciting results. She uses graphite and acrylic on large expensive drawing paper, with all kinds of solutions and mixtures. Her large works, which are somewhere beyond drawing or painting, grab you into them with layers and layers of subtle colors coming through intricate details of realism.

As you go through the lessons in the book, remember that you can veer away from the instructions any time you get an inspiration and use any of the styles you have learned. I encourage you to mix ideas together and create new projects and methods of doing things. The goal of the process is simply to please yourself and to release whatever you have to communicate. Try mixing media and styles together in ways that might interest you. Take the liberty of inventing new ways of seeing things and interpreting them in your drawings.

Figure 1.63 is an example of a traditional style of drawing the human model; figure 1.64 shows how an eleven-year-old student felt free to develop her own unique style of drawing the same model. In Figure 1.65 the student used a combination of contour drawing, scribble-type textures, and cross-hatched shading techniques to create a drawing from a garden cart in the yard, then added little children peeping over the edge from her imagination.

FIGURE 1.63
Tahni Torres — age 15
Realistic style.

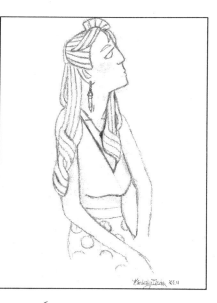

FIGURE 1.64
Kim Ikeda — age 11
Abstracted style.

DIFFERENT INTERPRETATIONS OF THE SAME MODEL
Create your own style. Use the model for inspiration and explore your options. It isn't necessary to create a likeness of the model.

INTEGRATED DRAWING STYLES

Try any wild idea you have. Some of the most creative styles grow out of synthesizing and mixing old ideas together in new ways. Drawing for the approval of others is deadly to your creative spirit. Use any combination of styles you like and draw for yourself.

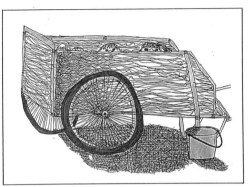

FIGURE I.65
Brittany App — age 11
Brittany used contour drawing, scribbly, textures, and cross hatched shading to draw this cart from the yard. Then she added the children from imagination.

FIGURE I.66
Jessica Jacobs — age 10
Jessica photocopied her own drawing, tore it up, and used some of the pieces to create a collage, which she then drew on top of.

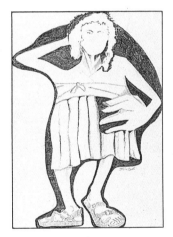

FIGURE I.67
Joel Axelrod — adult
Joel, a medical doctor, who came to classes for relaxation, developed this whimsical style to draw the live model.

Figure 1.66 shows how a young student used photocopies of her own drawing, tore it into pieces, and used some of the pieces to achieve an integration of a drawing and a collage. A medical doctor, who came to the class for relaxation, used a combination of contour line, shaded volume, and a whimsical abstracted style with the live model in Figure 1.67.

When you realize you don't have to like everything you do, you will be free to explore your own ideas and discover your personal form of artistic expression. Let yourself by inspired by other artists, and don't worry about playing around with any idea you see. The next chapter will relate a few stories from some of the students who have used this method and the results they accomplished. None of these students could draw the kind of work they eventually achieved when they began, but they are very satisfied with their progress. They feel that the freedom to explore and integrate ideas from many different methods is the major key to achieving the results they now love. As you enjoy their stories and artwork, remember that you can integrate their styles and ways of seeing things into your own explorations as well.

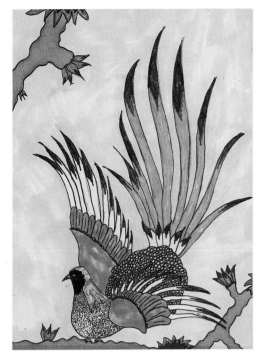

FIGURE 1. *Kindred — age 10*

KINDRED GOTTLIEB
Student from ages 9 to 17

"Coming many years to class gave me the background. Once I knew that I could draw, I had the confidence to explore beyond. Now that I'm in Art School I do art every day, and I don't have to like it all. I know how to express myself in free creativity now."

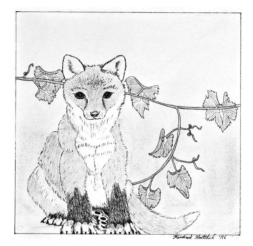

FIGURE 2. *Kindred — age 13*

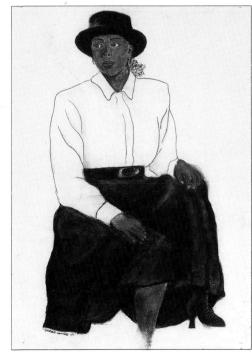

FIGURE 3. *Kindred — age 16*

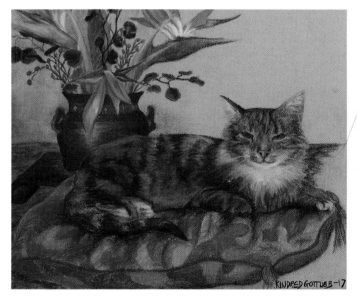

FIGURE 4. *Kindred — age 17*

NOEL CHEN
Student from ages 3 to 16

Noel was one of the original 100 children at the nursery school where the drawing method was developed. Drawing helped her to transcend the inability to understand English and adjust to finding herself in a foreign environment. She had come to the United States at 3 years old and spent most of her time hiding inside her locker cubby at school. The confidence she gained through drawing transferred to other subjects and gave her a vehicle for communication.

FIGURE 5. *Noel Chen — age 3. Sitting inside her locker cubby.*

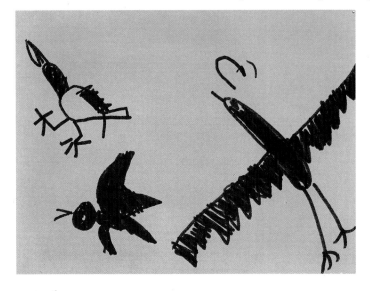

FIGURE 6
Noel — age 3
First time she finally came out of her locker cubby and joined the drawing lesson. The crows were inspired by a story we read and basic information on the shape of crows.

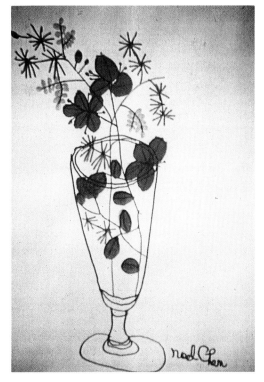

FIGURE 7
Noel — age 4
From a glass of flowers at the table. With very little guidance, Noel was now able to draw from independent observation.

FIGURE 8
Noel — age 5
By piecing together ideas from several sources, Noel composed this wonderful elephant scene. It became the cover for "Drawing with Children" in 1986.

FIGURE 9
Noel — age 6
Now able to read and speak English, Noel drew this illustration from a book she read.

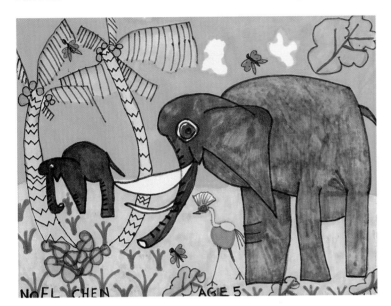

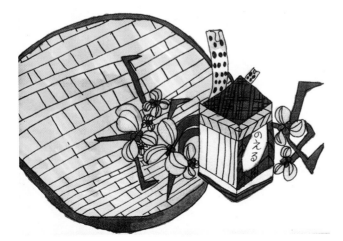

FIGURE 10
Noel — age 7
By seven Noel was confident to draw anything put in front of her. This still life was done with her own independent interpretation.

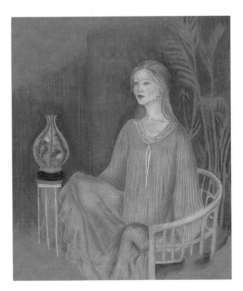

FIGURE 11
Noel — age 15
First drawing of a live model. At nine Noel moved back to Japan. We corresponded for years. She came to the U.S. at fifteen to visit and take lessons again. This was her first try at drawing from a live model. Noel aspires to be a professional artist.

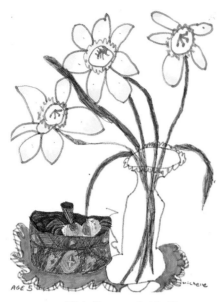

FIGURE 12. *Michelle — age 5. Marking pen.*

MICHELLE STITZ
Student from ages 4 to 14

"School was really hard in the first couple of years. I was always daydreaming and couldn't focus. I know I learned to concentrate from the drawing lessons, improved my handwriting, and became an honor student. The recognition I get from being an artist helps me have friends and feel more secure."

FIGURE 13. *Michelle — age 10. Watercolor.*

FIGURE 14. *Michelle — age 12. From a live model. Pastel.*

FIGURE 15. *Michelle — age 14. Oil pastel.*

FIGURE 16. *Noel Chen — age 16*

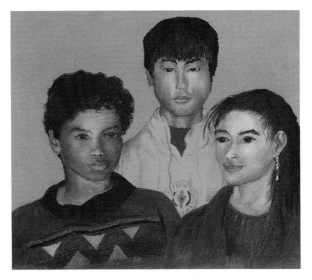

FIGURE 17. *Kindred Gottlieb — age 17*

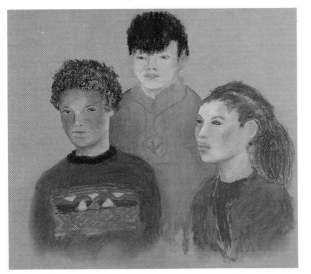

FIGURE 18. *Ray Gottlieb — adult*

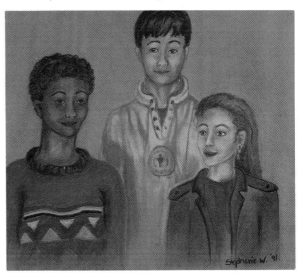

FIGURE 19. *Stephanie Wolfus — age 15*

Using the instructions on how to use the circle and tube method to draw the human body and develop the features of the face (explored in Chapter 6), these students each used their own style to draw the group of teenagers who posed for the drawing session.

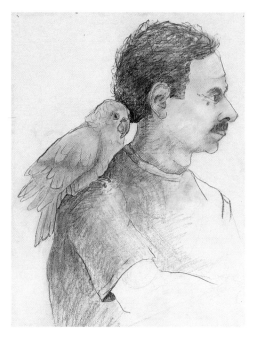

FIGURE 20. *Pam Wissinger — adult. Portrait of live model. Pastel and charcoal.*

FIGURE 21. *Tomas Dessle — age 10. Inspired by illustrative materials. Marker.*

FIGURE 22. *Bill Blake — age 13. Tiger inspired by a greeting card. Plant created from imagination. Marker.*

FIGURE 23. *Michelle Bourke — age 14. Inspired by live birds in an aviary with photographs for working in the studio. Pastel pencil.*

FIGURE 24. *Ikari Kimiyo — age 11.*
Pastel sticks.

FIGURE 25. *Anisha Patel — age 13.*
Conté Crayon and pastel.

FIGURE 26. *Kim Ikeda — age 11.*
Pastel pencil.

FIGURE 27. *Erik Olmstead — age 9.*
Marking pen.

Following the instructions in Chapter 6 on draw-
ing from still-life arrangements, these students
used a variety of compositions and media.

FIGURE 28

First try by adult beginners. These four different versions of the same pose were done by adult beginners after a two-hour warmup lesson in using the circle and tube method and developing features on the face. Each of the students expressed amazement and satisfaction at their results.

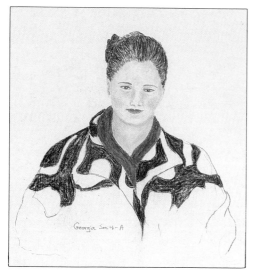

b. Georgia Smith

a. Phyllis Wood

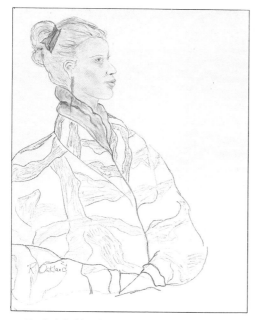

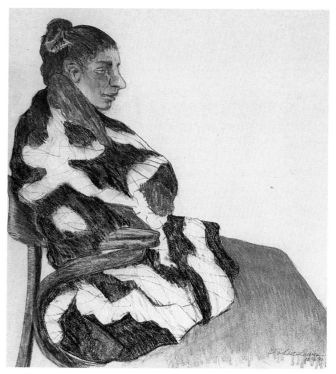

c. Rachel Oakland

d. Robert Lewis

Understanding What Is Possible

Unless you see what kinds of results are possible, you may limit your options and set your sights too low. This chapter will include samples of the work of some of my students, who will share their thoughts with you. They will tell you about some of the blocks they overcame as they learned to draw.

Note that I have not chosen examples of work by students who were recognized as gifted before I met them, although many of them have become designated as artistically gifted since they started. All of the adults in this section are those I call *terrified adults*, who either thought they couldn't draw at all or felt inadequate about their drawing ability. Keep in mind that all of these students were just as insecure as you may be when they started this drawing program.

If you think you can't achieve the kind of results you see in this chapter, I encourage you to hold off from such an opinion. I have watched hundreds of people dubious about their ability sign up for classes, loudly announcing they didn't think they were going to be able to do as well as those whose work they saw around the school. A few weeks later, I inevitably saw them engrossed in their work and producing equally wonderful drawings. The truth is that when you get the same information these students had to accomplish their results, you will find yourself coming up with comparable drawings.

The first drawings in this chapter are by students in their first and second attempts, followed by works by students as they made progress. Lastly, I'll share the stories of five different students who overcame obstacles that you may experience yourself. This will give you some ideas of what you can

expect for yourself and give you the opportunity to learn from other students. Learning from others can inspire you to know what is possible and give you a model of what is achievable. When your expectation level is high for yourself, you will encourage a high-level result.

FIRST ATTEMPTS: REALISTIC EXPECTATIONS

Imagine that you were expected to throw a clay pot on a potter's wheel, without ever having seen anybody do it. Imagine that the only examples of pottery you had ever seen were very large and perfectly formed ones, done by experts. No one would think of blaming you if you wanted to quit after the first or second try. That is why ceramics teachers go to great lengths to show you how the process is done and let you see first attempts of others. They give you information on how to prepare the clay, how to work the wheel, and how to use your hands. Then they let you know you are right on schedule as

From Adele: "Initially, I went to one of Mona Brookes' slide show presentations with the hope of helping my three young nieces learn to draw. I thought I was beyond hope, and was only present for them. To my surprise, as I listened to Mona explain her method, I realized that even I might be able to create. When I took the first class and found the pastels in my hand, it was just like other things that I have been able to master. Once it was explained and I was shown how, I was able to achieve more than satisfactory results. Seeing my first drawing of the teapot and vase of flowers take shape was magical."

FIGURE 2.1
*Adele Chebelski — adult
First lesson, pastel pencil,
still life.*

you make small, wobbly pots at first. You feel you are doing just fine as you create your first awkward attempts.

You need the same kind of modeling in order to have a realistic expectation of your drawing potential. If you feel that you can't accomplish the same kind of results as other students have, you are probably in for a surprise. With the kind of structured information you are going to receive in the following chapters, you will probably have more success than you anticipate. However, allow yourself the privilege of the beginner, and don't expect to like everything about your first attempts. If you have drawn awkwardly formed objects, with inaccurate proportions and shading, you are going through the same process as most beginners.

By examining several first and second attempts of beginners, you can get a sense of what is possible when you are given information and shown what to do. I have chosen examples by people who either were afraid they couldn't draw at all or were trying a brand-new kind of drawing. Although they didn't feel their drawings were perfect, they were more than satisfied with their results. Their comments are included along with their work in figures 2.1 to 2.6.

From Melissa: "I had never drawn anything like this before. I thought it was going to be a lot harder than it was. But when I was shown many ways to do things it seemed easier. When I was all done I really liked it. I had fun."

FIGURE 2.2
*Melissa Lago — age 8
First lesson, pencil, using eyeball perspective.*

FIGURE 2.3
Brian Livingston — age 12
First perspective lesson, ink,
freehand.

From Brian: "I had never tried
to draw dimensional objects. I
thought it was going to be really
hard. Learning the elements of
shape at Monart helped me see
details. I liked how I learned to
see the overlapping perspective
and I found it pretty easy. After
the class I was at the Santa
Monica Merry Go Round and
saw all these neat little windows
around the outside. I ended
up drawing them and really
enjoyed it."

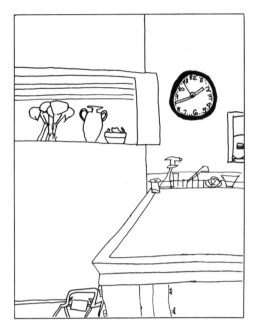

FIGURE 2.4
Erika Thost — adult
Second lesson, marker, graphic
inspiration.

From Erika: "I never thought I
could draw realistically. I didn't
even think about why, because
it was too painful. I took the
teacher training workshop and
realized I could do it. I went to
class and ordered markers to
draw at home. This statue was
my second drawing. It came out
nicely and I liked the way it
looked. It made me want to do
more."

FIGURE 2.5
Brett Schultz — age 16
First lesson, pencil, shading and volume.

From Brett: "I'd never drawn a realistic object with shading. I didn't think I could do it. After this first try, I felt I was willing to try again. Three years ago, I had a drawing class in seventh grade, but I didn't like it. We had spent three weeks studying Van Gogh. The teacher gave me a bad time because I didn't like him, so I never took drawing seriously."

FIGURE 2.6
Jeff Lee — age 10
Second try, ink, still life object.

From Jeff: "I thought I wasn't very good at drawing still life objects. This coffee grinder was only the second time I ever tried to draw a still life. I thought it was going to be hard, but I realized it was actually turning out pretty well. I certainly feel more confident now."

FURTHER PROGRESS: STUDENTS SHARING THEIR WORK

The next group of drawings were done by three students as they moved further along in their process.

STEPHANIE WOLFUS, STUDENT FROM AGE 10 THROUGH 16.

Stephanie's work is an excellent example of how the transition from a flat-style to three-dimensional and shaded work can be smooth and natural. Stephanie enrolled in class at ten years old. She began with two-dimensional drawings that were typical for a beginner. The drawing of the flying crane in Figure 2.7 is one of her first drawings. She continued to draw this type of project for a few weeks and then entered a summer class on life drawing. Figure 2.8 was her first attempt at drawing from a live model. It was two-dimensional, but it was also exotic and sophisticated; people who observe it at art exhibits gasp in appreciation of its beauty. She continued drawing in a similar style, had a break from classes when she entered junior high school, and then returned at fourteen years old. It only took one lesson in how to draw the model with the circle tube method (described in Chapter 6) for Stephanie to produce the drawing in Figure 2.9. This sensitive drawing of another student represents the first time she used the principles of proportion and shading. The transition was natural and easy; drawing in flat styles had not hampered Stephanie in any way. With more information about drawing the human form, she quickly grasped the full range of shading and became very confident in her handling of the live model. The drawings in figures 2.10 and 2.11 exhibit the understanding Stephanie mastered at such a young age.

From Stephanie: "When I came to class at ten I was very intimidated and afraid to do anything. But I liked the drawings I did and I began to feel confident. The Indian woman was the first time I did a live model. Having the quiet and being able to concentrate helped me study things and learn to see. Learning the circles and tubes to sketch a person really helped me figure out the forms and understand proportion. I started using the system for other things than humans, like lions and stuff. First, I learned the structure and then I learned how to keep loose."

ALICE FINE, ADULT STUDENT FOR 8 YEARS.

Alice's work is an example of how you can take the structure and interpret it any way you want. I met her in a school for learning-handicapped children, where I was teaching drawing and she was teaching English. She didn't ever remember drawing, even as a young child, and thought it was the last thing she could ever do. During her breaks, Alice would come to the art room and draw with the younger children. The two cats in Figure 2.12 is a project she did with a group of six-year-olds. She copied the cats from a greeting card and felt elated that she could draw at all. Within a few weeks, Alice was no longer dependent on the step-by-step lessons and began to make up creatures of her own. The animal in Figure 2.13 was one of the first signs of the primitive abstract style that Alice wanted to express herself through. She became prolific, graduated to the older children's classes, and lined the walls of her house with her creative creatures.

Next, Alice reluctantly signed up for an adult life-drawing class. She said she was uncomfortable to try but was willing, since she knew she would get to draw the models any way she wanted. We all looked forward to what the results might be, since she had her own way of doing everything. Figures 2.14 and 2.15 are examples of the abstract style that Alice developed in her life drawings. Alice taught at Monart, then went back to school and got a degree in teaching English as a Second Language through the drawing method. She also conducts teacher-training seminars with preschool and elementary school teachers, in which she helps them use the method in the classroom.

From Alice: "You don't stop cooking until you can make a gourmet meal, or you would starve to death. In the same way, you will starve to death creatively if you don't do art because you think you aren't a great artist. I have my childlike animals up on the walls of my house, and they make me happy. It doesn't matter that some art teachers would say they are immature and flat. Drawing them is like food for my soul."

KINDRED GOTTLIEB, STUDENT FROM AGE 9 THROUGH 17.

Kindred's progress demonstrates how quickly insecure students gain confidence. She first came to class when she was around nine years old. Even though she thought of herself as artistic, she felt insecure about her drawing ability. Her first drawings were similar to those of other students her age and I didn't consider her above-average in skill. When we looked for

STEPHANIE WOLFUS
Student from age 10 to 16

Stephanie entered the drawing program at age 10. Her first drawings were fairly typical for her age and began with the flat styles appropriate for young children and beginners. After mastering the basics she took a life drawing class and began by interpreting the model in a flat style, but with a great deal of confidence and sophistication. After a break in lessons, she returned to the program at age 14. After an introduction to drawing people using the circle and tube method described in Chapter 6, she immediately made the transition to using volume and shading and a three dimensional style.

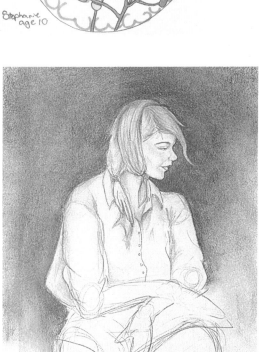

FIGURE 2.7
*Stephanie Wolfus — age 10
One of the first lessons, marker.*

FIGURE 2.8
*Stephanie Wolfus — age 10
The first live model, oil pastel.*

FIGURE 2.9
*Stephanie Wolfus — age 14
The transition to three-dimensional drawing, Conté crayon.*

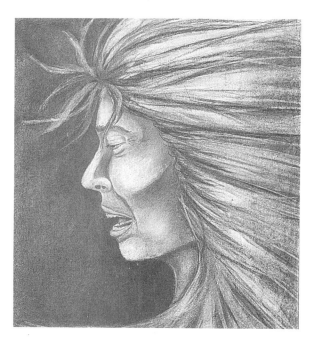

From Stephanie: "Having a quiet setting and being able to concentrate helped me study things and learn to see. Learning the circle and tube method to sketch a person really helped me figure out form and understand proportion."

FIGURE 2.10
Stephanie Wolfus — age 14
From imagination, charcoal.

FIGURE 2.11
Stephanie Wolfus — age 15
Study of live model, pencil and charcoal.

FIGURE 2.12
As a terrified adult beginner, Alice enrolled in the children's class. She fell in love with the magic of drawing and gained her confidence through the flat styled children's projects.

FIGURE 2.13
Alice began to create imaginary creatures and illustrate stories. She eventually developed a program of teaching English as a Second Language through visual aides and drawing.

FIGURE 2.14
When Alice took life drawing, she knew she could draw for herself. Her own style took on a sophisticated, abstract quality.

ALICE FINE
Adult, student for eight years.

Alice couldn't remember drawing as a child, so she decided to start in the five-year-old classes. After an introduction to the basics of drawing she began to develop a unique style. Alice especially loved to express herself through imaginary creatures and animated beings.

From Alice: "Drawing is like food for my soul."

FIGURE 2.15
When Alice studies human models, she watches her hand interpret the feeling and mood of the being. She has developed an expressive style that is natural for her.

some of her first drawings for the book, she didn't know where they were anymore. Within a few weeks Kindred did the bird in Color Figure 1 and had a great deal of confidence in two-dimensional drawing. Not long after that, she was considered artistically gifted in school and drew independently at home as well. The fox in Color Figure 2 was one of many drawings she did in a series that followed her interest in wolves, foxes, and dogs. When Kindred entered junior high school, she could no longer come across town to class and so had a couple of years' break. At fifteen she returned to Monart for weekend life-drawing workshops. She was unsure of herself at first, but with the remembered confidence she was pleasantly surprised. The charcoal-and-pastel drawing of a live model in Color Figure 3 is one of the first she drew.

At age sixteen, Kindred applied to and was accepted at the very competitive Los Angeles Arts High School, where she now shines as a student. Not only is she continuing her drawing development but is also showing real promise as a sculptress.

Along with several other students, Kindred came to some special classes for creating a cover for this book. The results of that project are the drawings seen in Color Figures 16 to 19; Kindred's is Figure 17. I hired the three teenagers seen in the drawings as live models, and all the drawings turned out lovely. But at the last minute the publishers and I decided to change the cover and in a panic asked Kindred whether she would try to put together a still life. Under the stress of a three-day deadline she agreed. When she drew the still life and cat in Color Figure 4, we all knew it was perfect for what we wanted. Kindred finished it the night before deadline at midnight. As she sat staring at it in the middle of the night, she looked as though she had acknowledged herself as an artist. I felt she would be one of the many students I would watch make a living as an artist someday, and I secretly wondered whether she would be one of the students who grew up in Monart who would teach others to draw.

From Kindred: "When I first came to drawing class I remember being very tense. I didn't feel that I had control yet. I was always kind of fighting myself. I guess going there a lot finally helped me feel confident. Now that I'm in art school and do it everyday I don't even worry about it. I do so much that I don't even have to like it all. Coming all those years to the classes gave me the background. Once I knew that I could draw, I had the confidence to explore beyond. Now I know how to express myself in free creativity."

OVERCOMING OBSTACLES: STUDENTS SHARING THEIR STORIES

Each of these five students had to overcome some kind of block or obstacle in order to feel successful with his or her drawing ability. I have chosen these people in order to share with you some concrete examples of how you can overcome your insecurities or doubts.

NOEL OHKI CHEN, STUDENT FROM AGE 3 TO 7, AND AGAIN AT 15.

The next student's story is important because it shows the necessity of feeling safe in order to express yourself creatively. I first met Noel when she was three years old. She was one of the original hundred children at Tocaloma Preschool, where this method was developed. Noel's teachers warned me that she might not join in the drawing session. They explained that she had just come from Japan and didn't understand any English; she seemed frightened and frequently spent the day sitting inside of her locker cubby.

As I entered the room, all of the other children were sitting expectantly at the drawing tables, awaiting the magic that they had heard about. I looked at the side and saw Noel sitting inside the cubby. Her big black eyes were alive with questions but she sat as still as a mouse. When I gestured to invite her to join us, she didn't move at all. Whenever I approached her with a hand or a smile, she retreated further into the cubby. I decided to give her the space she needed and not pressure her to join.

Each week thereafter, I would say hello to Noel and then teach the drawing lesson. She would watch me like a hawk but gave no indication that she was going to budge from her secure little cave. Color Figure 5 is a photograph of three-year-old Noel sitting in her cubby.

I can't remember how long the standoff lasted, but I will never forget the day Noel decided to come out. She came over to the table and sat down beside me and picked up a marking pen. She sat poised with the pen over the paper, waiting for instructions on what to draw. I took a picture book with a story about a crow and read a little bit. Then we studied the illustrations of the different views of crows and I showed her how the body parts of the crow were formed. She drew the large flying crow that you see in Color Figure 6 from my basic instructions. She looked up with a huge smile and then, to both our amazements, drew the other two crows by herself.

I could write an entire book on the twelve years of knowing Noel since, but suffice it to say drawing was the beginning of an enormous shift in her

whole life. Within a few days she joined in other activities at the school, and in no time at all she was speaking English and learning numbers and the alphabet. Her artistic growth was like an explosion, and she was prolific in her output. The drawing in Color Figure 7 was done from a glass of flowers on the table. By the time Noel turned five, she would confidently tackle anything she wanted to draw. She made the wonderful drawing of elephants in Color Figure 8 with very little instruction. She knew I loved it so much that she gave it to me when she was six. Years later, when I wrote *Drawing With Children*, it became the much-appreciated cover piece.

By the time Noel was seven, she was drawing anything put in front of her, from three-dimensional objects to pictures or photos of things. She had mastered the ability to draw anything in two-dimensional styles and loved to draw. She even had the confidence to go on national television and draw a complex still life by herself, while I chatted with the host. The storybook readers in Color Figure 9 were inspired by a children's book illustration, and the wooden box and dried pods in Color Figure 10 were done from a still-life arrangement.

What happened over the next few years was one of the most dramatic lessons I had in understanding the dynamics of teaching drawing. When Noel turned eight, she returned to Japan with her parents. At that critical age, when most students want to make the transition to realistic drawing, she had no structured guidance or exposure to the information and environment she needed. When she was around twelve years old, she began to write me letters, saying she really missed drawing and had forgotten how to do it. She explained how shy and insecure she had become. No matter how much I reassured her that she only needed some new information on how to draw in realistic three-dimensional styles, she doubted it was possible.

When she entered junior high school, in an English-speaking school in Japan, she finally had art classes available again. She happily wrote about enrolling in a drawing class. But soon more letters began to come, explaining how hard it was and how she was sure that she would never be able to really draw again. She explained that her Japanese art teacher was trained in America. She said that her teacher was very critical with the students, insisting things had to be done a certain way or they were wrong. Noel said she was doing poorly in the class. I was confused; it seemed impossible that this girl wouldn't be able to draw. But for the next few years the letters expressed more and more discouragement.

When Noel turned fifteen, her parents arranged for her to come to the United States and join my summer drawing classes. She had brought some of her drawings from school with her, which looked quite adequate to me.

But Noel was very critical of them and displayed a great lack of confidence. We were both grateful that we had an opportunity to work on the problem. During the first week she was here, she was constantly criticizing herself for every line she put on the paper. Within three weeks of the safe environment and permission to *draw for herself*, we all witnessed the rebirth of the capable and prolific artist that she is.

During that summer Noel and I got close enough to talk about what had happened and she poured out her frustrations. She was very worried about her art teacher in Japan finding out she had discussed these feelings, but she finally decided it was worthwhile for me to talk about her feelings in the book. She said she felt it might help others know how to stand up to these same frustrations.

From Noel: "My drawing teacher is Japanese, but she got her training in the United States. She's so sure her way is the right way. Sometimes, I don't know how to do something, but if I ask questions she comes over to my paper and draws all over it, telling me everything that is wrong. So I don't ask many questions anymore.

"I have a friend in the class. She was drawing a face and she liked it very much. The teacher came over and added all these shadows and she hated her picture afterwards. When we left the class she went down the hall and then got very angry because the teacher changed it."

I asked Noel whether she and her friend ever considered telling the teacher they didn't want her to draw on their papers. She cringed and said, "No, I couldn't do that. I don't want to be mean. My friend didn't say anything either, because she is shy and isn't the kind of person to be mean. Our teacher is a nice person, but the class is so hard and boring. When you draw with pencil it has to be a certain kind of shading on a certain kind of paper, and it takes hours and hours. We aren't allowed to use our fingers to smear or shade with, and can only use a certain kind of pencil stroke on bumpy watercolor-like paper. I wouldn't be allowed to draw on smooth paper, or use markers, or do contour line drawings. She says the only 'right' way to draw is a certain kind of shading."

I showed Noel a realistic contour line drawing of a man on a horse and asked her whether she liked it and whether she thought her teacher would like it. She said she really liked it and that she would like to draw horses that way but didn't think she would be allowed to in her class. She also felt that her teacher wouldn't think the horse drawing was "real" art, because it wasn't shaded properly. When I asked Noel whether she had heard of Picasso, she said "yes!" and expressed surprise that he had done the drawing.

I asked her whether she felt she could discuss some of these issues with her teacher, but she said she would never be able to do something like that, because she was too afraid of her and needed to get good grades for college.

After a lot of reassurance that she had the right to draw any way she wanted, Noel began to take off. We helped her understand that like most art students, she would have to do things the way the teacher wanted if she wanted to get good grades, but that she could ask questions in a kind and courteous way if she wanted to. She began to understand that there really is no right way to do art, and she reveled in her freedom to draw the way she wanted. By the time she went back to Japan, Noel was willing to try anything again. Once she learned there would be no judgment of her work, she began to explore more fully her own style. She had developed a sense of humor and would joke about her own inner critique. Color Figure 11 is one of the drawings that she did while she visited us. It was the first drawing Noel had every done from a live model. She liked it, but said her teacher would probably say it "wasn't shaded properly."

Noel has written since her return and says she still hates her art classes at school but has learned "not to care what the teacher says." She said she was liking drawing again, because she was working at home. I felt a summer well spent as I read, "I did a drawing that didn't turn out well, but what's important was I enjoyed it and it helped me get more practice."

MICHELLE STITZ, STUDENT FROM AGE 4 UNTIL AGE 15.

This next story is a dramatic example of how other areas of a person's life can be affected by involvement in the drawing method. Michelle began at the Monart School at the same age she entered kindergarten. The teachers had informed her mother that Michelle was having extreme difficulty focusing and seemed "spaced out" and "depressed." Since Michelle's mother had heard that the drawing method helped children with these kinds of problems, she decided to try it. When Michelle first entered the drawing program, it was hard to get her attention and her concentration was scattered. Her drawings were average for her age group, but it was hard for her to follow the instructions. Eventually, her mother noticed a steady improvement, connected to a growing love for drawing.

By third grade Michelle was designated as artistically gifted. Her interest in school and ability to focus on tasks increased immensely, and she was functioning as the top student in her class. Michelle remembers this transition, and attributes the improvement to her success in drawing. By the time she was fourteen, she said she was aware that her proficiency in drawing was

the glue that held her life together. As a budding teenager, she still has problems in her life and bouts with low self-esteem, but her confidence in art is the one thing she feels consistently encourages her belief that she is a successful and creative person. Michelle is now at a school that attracts artistically gifted students from all over Los Angeles and has been awarded recognition as the Senior Most Likely to Succeed as An Artist.

Color Figure 12 is a still life Michelle did with markers at age five. By age ten, her problems with concentration were over and she did the lovely watercolor in Color Figure 13. She didn't surprise anyone when she began to draw from live models at age twelve, with extraordinary independence and confidence. The portrait of a full-headdressed Indian in Color Figure 14 was done with very little guidance and captured the spirit of the model. Color Figure 15 is a recent oil pastel Michelle did of some sunflowers.

When I asked Michelle what she would like to share with you, she immediately talked about how drawing had helped her master other problems in her life.

From Michelle: "It was really hard at school. I was always daydreaming. I would stare out the window and I couldn't focus on what the teacher was saying. The teachers would get mad at me and yell stuff like SNAP TO! When I would start doing artwork it would really help. My handwriting was terrible and I was really bad at math. I know I learned how to focus from the drawing lessons and now I'm in Honor Status with math and my handwriting is fine.

"I was also very shy, but the recognition I get from being an artist helps me have friends and feel more secure. In fourth grade I got real competitive with a friend over who could draw better; then I talked with her and found out she was just as scared as I was, and we have become best friends. When I went on TV to show people how I could draw, I felt really good about it. I feel that if I never did anything else in life I could go on with my artwork and that it is the one thing that I can really do well. I am always picked as the best artist in school, and I feel I can go on and become a painter and do art."

Michelle was not recognized as a visually gifted child when I met her. The consistency of drawing every week, for years, and the guidance she received helped her feel the power that the creative process brings with it. If you are consistent with your involvement, you too will benefit in many ways from the process.

MICHAEL OVERMAN, STUDENT FROM AGE 9 TO 11.

Michael had been a student at the Monart Schools for a couple of years before I met him. His Monart teachers felt he had wonderful drawing skills,

but that he also had some obstacles that were holding him back. They said that they honored the students' freedom to draw for themselves, but that in his case he was being resistive in a way that might hinder his development. It seemed that Michael wanted to draw only the images that he already drew on his own and wasn't open to considering other media or projects. He was reported to balk at trying new things and seemed overly resistive to communicating about it. He wanted to draw people and joined my weekend life-drawing seminars. At the first session, he didn't want to use the circle-tube method of establishing proportion but was dissatisfied when he wasn't able to control things with his own methods. When I approached Michael he seemed defensive and angry. I backed off and let him know I would be glad to help if he wanted me to. I think as he watched older students use the method with success and in a relaxed manner ask for help, he decided he would try it. The minute he set his mind to it, he was successful. Each week he became more and more communicative, more willing to try new things, and less resistant to exploration.

The dragon drawing in Figure 2.16 and the airplane drawing in Figure 2.17 were the kinds of drawings Michael did so skillfully when he came to us. The contour drawing of the tree in Figure 2.18 was one of the first attempts at trying something new. The study of the live model in Figure 2.19 was done after the breakthrough. He used the circle-tube method to establish proportion, chose to use charcoal and color, and needed little guidance to achieve this sensitive study of the model. Of course, he continues to draw his other kinds of work as well.

From Michael: "I was stubborn. Truly, when someone would even mention color I would automatically say I hated it and didn't want to use it. I once had a perfect drawing and I ruined it when I tried to use color. But one day I sat next to this man in life drawing that decided to use abstract bright colors all over the model. I decided that I would like to do it too. I was encouraged to watch what he was doing and try it too, if I wanted to. I tried it and I loved it. The next week I was more willing to try new things. I love class. I love drawing people now and hands. Ever since that day most of my pictures have color in them. Now I like to try new things to see if I like them. If I don't like it I can always go back to things I do."

RAY GOTTLIEB, ADULT STUDENT FOR SIX YEARS, ON AND OFF.

Ray's story is an example of how extraordinary ability can be hiding underneath your inner critique, especially if you have talents in other areas. If you are good at visual activities or have a deep emotional connection to such things as dancing or music, it is likely that you will also excel at drawing.

FIGURE 2.16
Composite drawing, pencil and ink.

FIGURE 2.17
From imagination, pencil.

FIGURE 2.18
Contour of tree, ink.

MICHAEL OVERMAN
Student from age 9 to 11.

In the beginning of his lessons, Michael resisted exploring new projects or media. As he watched other students learn from each other and enjoy the safe environment, he decided to take risks and try new things. After the first breakthrough he quickly grew in skill and depth of expression.

From Michael: "I didn't want to try new things. I was stubborn because I was afraid I would ruin a drawing. One day I was encouraged by the man next to me. I tried a different technique and loved it. Now I'm willing to see if I like something new."

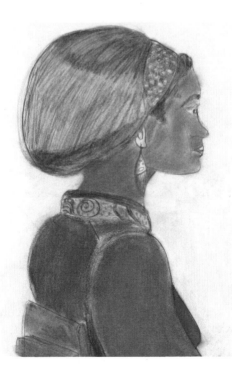

FIGURE 2.19
Live model, pastels. A breakthrough in trying new ideas.

When I was working in a school for learning-handicapped kids, a sensory integration teacher introduced me to Ray, a vision therapist. We immediately made a trade-off: I began learning about vision therapy and Ray came to the drawing classes. He thought the drawing method was applicable to his work and that he could integrate it with his vision training. He had no idea whether he could draw or not, but he was intrigued with any method that taps into one's hidden potential.

I'll never forget Ray's first day. He came to an all-day workshop and I watched a very special connection to drawing unfold. At first he seemed uncomfortable and self-critical, but soon his eyes and facial expressions were like a million light bulbs being turned on. By the end of the day his drawings were taking on a unique style and his choice of composition and quality of line showed a high degree of confidence. Figure 2.20 is a drawing from Ray's first day.

Although he was afraid he couldn't draw, Ray had incredible concentration and visual perception. It was obvious on the first day that he was about to uncover a wealth of hidden talent. Neither of us would have guessed how fast it would appear. The next week, he brought out a drawing tablet and excitedly showed me some sketches he had done on his own. There before my eyes were sketches of human faces, including one of Edward G. Robinson, that were more accurate in proportion and likeness than those of any one-week beginner I had ever witnessed. Within a few weeks he was drawing everyone who came around his house, and the portraits were immediately recognizable to the people who knew them. Here are some of those portraits of friends in figures 2.21 to 2.23 and a lovely sketch of two girl figurines in Figure 2.24.

Ray's portraits of people had an aliveness in their energy. He seemed to achieve likeness with ease and was quickly capable of handling volume and shading of still-life and other three-dimensional objects as well. The drawing in Figure 2.25 was done from a live model in class. It was a delight to see how quickly Ray came from a position of insecurity to proudly sharing his drawings with everyone in his life.

From Ray: "When I came to the class my preoccupation was working on my fears of making a mistake and keeping my anxiety level down. The safe, nonjudgmental environment helped to do that. I had very little idea that the drawings were coming out well. It was only after I got home, the next day, that I realized how much I liked them. I had a lot of fears about whether I could do it again. After a few days I got my nerve up and when everybody was asleep at night I attempted to draw on my own. I followed the

FIGURE 2.20
Ray Gottlieb — adult
Ray's first drawing experience was at an all-day in-service workshop for teachers. At first Ray was uncomfortable and self-critical, but by the end of the day he was drawing with confidence and skill. He was soon surprised to discover the depth of the artist hiding inside himself.

RAY GOTTLIEB
Adult

Within the first week of classes, Ray began doing sketches of people with unusual skill for a beginner. His portraits showed an aliveness and accuracy of proportion. He had a high degree of natural ability to capture likeness. Within a few weeks he was drawing everyone who came to his house, and they were immediately recognizable to the people who knew them.

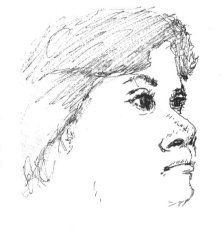

FIGURE 2.21

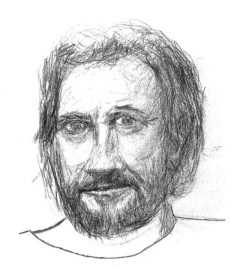

FIGURE 2.22

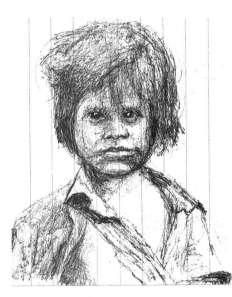

FIGURE 2.23

FIGURE 2.24

alphabet of shape that I had learned, at each step, and was amazed at how well my drawings came out. I began by copying paintings by Botticelli, and the *Mona Lisa*, and a photograph of Edward G. Robinson. Then I drew people who visited the house. I began to draw several times a day.

"It was painstakingly slow and laborious at first, but I became aware that if I used the method I was shown, to see each detail through the alphabet of shape, I would get the form and then I would go further and further into each detail. I was amazed at how much more I could see by looking that way. My perception of the world changed, and I went around teaching everybody who was interested. As I got better I got faster and I began to sketch people around me. Even though I was paying attention to the details of the line categories, and their relationship to one another, it was surprising to see that what came out in the picture was an aliveness and an accurate portrayal of the person's personality. Something is freed up in the student during this drawing process. I noticed that even the younger students using the method had an extraordinary quality of aliveness in their drawings."

Ray is only one of many visually adept people in fields other than art who quickly uncovered a high degree of artistic ability. I have seen the same thing happen with such visually alert people as surgeons, dentists, optometrists, computer circuit-board assemblers, athletes, and seamstresses. There also seems to be a high correlation between the ability to draw people and the ability to relate to them through their emotions or their bodies. Psychologists, dancers, massage therapists, social workers, physical therapists, and theatrical people seem to have a high degree of hidden ability in drawing from human models.

If you are too young to have one of these occupations, notice whether you have a high interest in observing things or watching people. You may be more visually aware than you know. You may be a closet artist, like Ray, and surprised at how easy it is to let your artist come out.

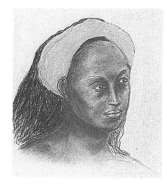

FIGURE 2.25
Ray Gottlieb — adult
This lovely pastel portrait of a live model was done by Ray after about a year of classes.

From Ray: "The safe non-judgmental environment helped keep my anxiety level down. I became aware that if I used the method I was shown, to see each detail through the alphabet of shape, I would get the form and then I would go further and further into each detail."

AMY SCHNAPPER, ADULT STUDENT FOR THREE YEARS.

Amy's story is almost the opposite of Ray's. It is the story of many people I meet who thought they had artistic ability and somehow lost it. The "somehow" is always vague to them, but I hear hundreds of people telling the same story. The story almost always involves an incident in which a judgmental statement was made or in which there was an implication that they didn't "do something right." If you can reclaim your confidence, you will be amazed at how far you can take your desire to draw. Amy is only one

of several students who has taken it to the level of finally becoming the professional artist she secretly wished she could be.

Here is how Amy began drawing again. My chiropractor put *Drawing With Children* in her waiting room, for patients to read along with the usual magazines. One day, she informed me that one of her adult patients had been sparked by the book and would probably call me for classes. A few weeks later, the owner of the Monart School in Santa Monica, Karen Jackson, called me and began a wondrous story about a new adult student. I suddenly realized it was the woman from the chiropractic office.

Amy had chosen to start in the younger children's class, as many of the adult beginners do. Karen said that she was showing signs of a unique style and that I might want to take a look at her work. She said that Amy did the projects along with the children, but that she needed to give her more liberty than most adults wanted in changing the style and content. She also told me Amy was doing a lot of work on her own and developing a definitive style of drawings, which included clever messages and captions.

Deciding to meet Amy, one day I walked into the eight-year-old class. I found a magical woman with an animated and childlike quality who seemed to be more like one of the kids than like an adult taking classes with them. After the class Amy sheepishly took out her portfolio and asked what I thought. She had the kind of look children have when they are afraid someone will be judgmental of their work. But on my first glimpse I knew we had something phenomenal going on. *Desert Dessert* in Figure 2.26 was the first drawing I saw.

Amy looked a little confused when I told her she might seriously think about marketing her work. She told me she was a business consultant and had simply taken the class for relaxation and self-expression. She said she needed some time to think about it all, and we made a date to talk further.

What has transpired since is an exciting story. Amy decided to devote some serious research and time to her art. Then one day I received an invitation to come to her first gallery showing. I found myself wanting to buy several of her pieces—not because she was one of our students, but because I really wanted to have them. Figure 2.27, *Revolution of the Species*, was all I could afford for the day, but there were many others I coveted. *Three Wise Cats*, in Figure 2.28, has become one of the pieces in Amy's greeting-card line, called Dr. Schnapper's Coloring Cards.

Just to prove to herself that she could draw realistically, Amy also took some of the life-drawing seminars at Monart and conquered her fear that she couldn't. She had to go through the childhood trauma that she had en-

dured over drawing live subjects, but in the safer environment she was able to come through to the other side. When she saw that she could succeed after all, she simply realized that she didn't like the realistic style well enough to pursue it further and returned to her own style of self-expression.

Today Amy has taken her expertise in business and combined it with her love for art. As I write this page, she is selling her work for handsome prices and has incorporated Artfully Yours as a business expanding into many areas. She has a humorous line of art that addresses itself to adults in the field of emotional recovery, called The Art of Recovery, and another line for children called Color Creatures. Although she is more than capable of attending the adult classes at Monart, Amy continues to be enrolled in the children's classes, where she feels she gets her inspiration.

From Amy: "When I was a kid, my friend Kay and I were the best artists in school. I was given private lessons at the Corcoran, but I don't remember them at all. All I do remember is that I didn't like to draw that way and that I really wanted something else, but I didn't know what. In seventh grade there was this guy Lee, who drew great tattoos. I took from the stuff he did and got an award, but I felt bad 'cause I knew Lee should have gotten it. They wouldn't give Lee an award 'cause he was like a gang kid. Then I was asked to draw a live object and I was told it wasn't good and was showed all the ways it was wrong. I hated it. I decided I would never draw real things anymore and then no one could tell me how it was wrong. I drew a little, as a teenager, and then I just stopped. I don't remember why I stopped. For twenty years art wasn't a part of my life.

"I was feeling really stressed out by all the pressures of the business world and suddenly got this urge to draw to relax. At first I started drawing some of these little characters. But I thought, why am I doing this, what is the point? I showed some of them to a friend, and when I tried to describe what the point was I got real upset. He said, 'What are you going to do about it?' and really challenged me. I went off to the art store to buy paper, and all these memories started flooding back, like I already knew I hated drawing tablets with spiral-bound sides. That whole world and all the negative memories slowly started coming back. I researched art schools and private teachers and enrolled in a class. But it was real hard to be in his class, because he wanted you to do it his way. I didn't want to deal with that. I had spent a lot of years in college and I knew how stupid that kind of teaching was. I had been doing things other people's way my whole life, so I quit.

"I went to my chiropractor's office and found this book called *Drawing With Children*. I looked at the pictures and they looked so full of life. I didn't

FIGURE 2.26
Desert Dessert, *one of Amy's first imaginary pieces.*

FIGURE 2.27
Revolution of the Species, *one of the many pieces Amy sold at her first gallery showing.*

AMY SCHNAPPER
Adult, student for 3 years.

Amy was one of the many adults who came to the children's drawing classes to relax and have fun. Three years later she made a major shift in her career and is supplementing her income as a working artist.

From Amy: "The bottom line is, I have finally realized I am an artist. I finally got permission to draw the way I wanted to. I'm so inspired I feel I will never catch up with all the ideas I want to express."

FIGURE 2.28
Three Wise Cats, *one of the series of greeting cards Amy produces through her company, Artfully Yours.*

read the book, but I saw in the captions how there was no judgment and comparison. I got the message that there was no 'wrong.' After I signed on with the eight-year-olds I suddenly realized that everybody but me was only three feet tall. I didn't expect them to be so little. I felt large and foolish at first. Then we all covered our eyes to do the eye exercises and I suddenly felt we were all the same. When we opened our eyes I was the same as everybody else. The teacher left me alone and treated me just like everybody else, and the kids didn't seem to care about my being there. I got increasingly accepted as one of them. I hated it when other adults came in who tried to set themselves apart as better. One day I was doing some real complex precision stuff and nine-year-old Michelle said, 'Wow, you should be an artist when you grow up.' One of the other kids laughed and said, 'Michelle, she is a grown-up.' Can life get any better? I had passed for a nine-year-old. After all this acceptance, I finally took the life-drawing class. It was slow for me, but I got over the fear. I realized I could do it well if I wanted to, but I still didn't like it and felt totally accepted to choose my way instead.

"The bottom line is, I have finally realized that *I am an artist*. When I put forty-four pieces in my first gallery show, it was in honor of my forty-fourth birthday. I sold a bunch. A man came in that I didn't know, who was a marriage and family counselor. He bought the piece titled 'Anger' and told me how he had never seen anger look so good. Because he wasn't a friend and I really saw that he was paying money for the piece for his office, I realized he was a customer and I was an artist.

"The Monart environment is actually designed and sculptured to support me as an artist. It gives me permission to draw the way I want to. It gives me permission to go around the room and learn how other people are doing things. I finally have permission to look at things and copy ideas, because I know it will come out in my own way anyway. The only 'supposed to' that I get is that I am supposed to create it the way I want. But I'm not just left alone to flounder. Karen constantly comes around with comments and ideas and shows us how to do things, but she makes it clear that we don't have to do anything she says. The variety of projects gets me so stimulated that I have endless projects spinning off in my mind to do as well. I get so inspired that I feel I will never catch up with all the ideas that I want to express."

Another adult student, Sarah Oblinger, enrolled in the children's classes with a similar outcome. She, too, reclaimed the artist she had lost at a younger age. When I see her greeting cards in national chain stores, my heart sings for the artist in all of us. Figure 2.28 is a card from her line.

While I am not suggesting that you become a commercial artist, Amy and Sarah are examples of how much more you can expect of yourself than

FIGURE 2.29
Sarah Oblinger — adult
Beyond Beauty
Sarah was a closet artist who enrolled in the children's classes at Monart. She now has a line of greeting cards that can be seen in many card shops.

you may imagine. We are all suffering from some kind of artistic block from the competitive and judgmental environments that we live in. If you can break through that block, your potential to be creative is limitless.

YOU TOO CAN LEARN: IT IS MORE THAN POSSIBLE

There are hundreds more stories about blocked or insecure artists, but they all add up to the same conclusion. No matter what happened previously to cause you doubt or resistance, you can overcome your blocks with information and a safe environment. No matter what you have heard to make you doubt, forget it and go after what you want. I haven't met a single person with normal mental and physical capacities who wasn't able to learn to draw. If you are a teacher and think you can't possibly draw well enough to teach others, put that thought aside also and decide to learn along with your students.

PART

2

DRAWING:
AN ENDLESS JOURNEY

STARTING WITH
THE PRELIMINARIES

This chapter will begin to give you the basic information that you need to develop confidence and to understand the rudiments of drawing. The two factors that affect your success the most are *creating the proper environment* and *learning how to see*. As you explore each of these factors, you will see how they will help you achieve success.

CREATING THE PROPER ENVIRONMENT: INTERNAL AND EXTERNAL

Your environment is as important to your success as any particular drawing method. The following elements are critical in establishing such an environment, both internal and external.

Rethinking Some Myths

Here are some crucial facts to consider in rethinking some widely accepted attitudes. They are related to the artist block you might be experiencing.

Myth 1. *The ability to draw is inherited.* This is one of the main reasons people believe they cannot draw or give up after only a few attempts. After ten years of drawing with thousands of people who thought they couldn't do it, I am convinced that this is false.

Myth 2. *There is a right and wrong way to draw.* In art museums you will see all manner of drawing, from precise to sloppy, from beautiful to ugly. Even art critics are in constant disagreement about what comprises good and bad art. Art students sometimes hand the same work to different teachers and get wildly divergent opinions. Unless you have been commissioned to do a certain drawing, it is not necessary to please anyone but yourself.

Myth 3. *Drawing is simply for pleasure and has no practical use.* Operating on this premise, many schools deeply cut art budgets. However, educators are beginning to recognize what a drastic mistake this is. Administrators and teachers report that the art process, and realistic drawing specifically, helps teach problem-solving skills, develops concentration and visual perception skills that are applicable in many other areas, and promotes relaxation and creative energy that is healing to the mental and emotional body.

Myth 4. *You can't really draw if you have to look at a picture or a photograph of the subject.* You cannot realistically draw the endless array of animals, birds, vehicles, and foliage that exist from your imagination alone. If you cannot locate such subjects, you need to look at pictures to study how the body parts or structure of the subject is formed.

Research, which I will cite in "Notes to Teachers," shows that the skill level of students who learn from photographs is comparable to and sometimes exceeds that of students who learn from live models. Many famous artists worked from photographs to create some of the priceless paintings you see in museums.

Myth 5. *Real artists successfully draw what they want without making mistakes.* Nothing could be further from the truth. Most artists are dissatisfied with many of their preliminary works. Sometimes they do a project over and over, adjusting and changing parts they don't like. When students are asked the question, "If a professional artist does five drawings, how many do you think he or she will like well enough to frame?", the typical answer is one or two at the most. "How many of the five do you think the artist will dislike so much he or she will want to throw them away?" brings the response of one or two. All agree that the one or two left over may be given to friends or relatives. But students have trouble allowing themselves the same ratio and don't think of this phenomena when they approach their own work.

Give yourself freedom to explore the way professional artists do. Only

with freedom will you maximize your progress. Finish some of the drawings you don't like, without trying to hide them or apologize for them. This will empower you to learn from your efforts and take advantage of the magic that originates in so-called mistakes.

Communication with Yourself

Your body language and inner dialogue will affect your results more than you can imagine. Confidence and drawing ability are greatly influenced by the emotional environment you create for yourself. Negative thoughts about your ability interfere with your concentration and creativity. Drawing and concentration are as inseparable as creativity and risk taking. If you aren't satisfied with your performance, you may not realize that it is due to lack of concentration instead of ability.

Learn to notice the inner dialogue going on in your head or the negative body language you are expressing in your movements. For example, if you are slumped in the chair sighing as you think critically about yourself, and you are using your free hand to prop up your fallen head, you might not notice that your paper is slipping around and hard to control, resulting in a drawing that is out of proportion and sloppy. On the other hand, if you sit up straight, think positively, and use your free hand to take charge of the paper, you may see a dramatic difference in your results.

As you begin to draw, notice your internal dialogue and how you treat yourself. If you become frustrated and don't like what you are doing, remember what you had just been thinking about and what you were telling yourself. Poor performance or dissatisfaction may be directly related to comparisons or negative feedback you are giving yourself.

Take note of the following words. Notice how your self-confidence can be affected by their use.

Words That Inspire Self-Criticism or Competition

Bad, Ugly, Dumb, Poor, Inadequate, Unacceptable, Worthless

Good, Desirable, Proper, Worthy, Acceptable, Skilled

Cheat, Copy, Steal

Worse than, Less than, Worst, Defeated

Better than, Winner, Superior, Best, Surpass

Words That Instill Frustration or Fear of Failure

Right, Correct, Acceptable, Accurate, Fit, Appropriate

Wrong, Incorrect, Faulty, Unacceptable, Improper, Unfit

Mistake, Mess, Error, Incorrect, Inaccurate, Crooked, Amiss

Hard, Unable, Can't, Impossible, Effort, Slow, Complicated

You will continue to be competitive and insecure about your artwork as long as you use such words. I suggest that you replace these words with neutral ones. For example, when you use the word *mistake*, you immediately imply mistakes exist and that you can make one. There really is no such thing as a mistake in drawing: it is more a question of noticing something you don't like and deciding whether and how you want to change it.

It takes attention to break these habits. Here are some suggestions on using the kind of language that will help you in the transition.

Think about how drawings are *different* from one another, rather than merely describing them in terms of *good, bad,* or *better than*.

Realize that you can *like* one drawing better than another, without thinking it is actually a *better* drawing.

Rather than thinking that you did something *wrong*, consider that you did something you *don't like* and want to change.

Copying is a word with a bad connotation while *inspiration by an existing idea* evokes a more positive response.

Instead of thinking you *failed*, enjoy the *challenge of problem solving*, exploring how you can make adjustments and changes.

Perhaps what you want to do is not *harder* than you can handle; it might have more detail and just *take longer*.

The following two checklists are designed to set a positive tone and help you remember the most essential principles for creating your internal and external environments. Photocopy the lists and post them in your drawing area. Review them each time you draw, especially if it has been a long time since your last drawing session.

The Internal Environment

You need to pay as much attention to your feelings and thoughts as you do to your work space. No matter how organized your drawing area, if your mind is cluttered with negative thoughts or if you are having trouble concentrating, you may be setting yourself up for disappointment.

- **Establish positive and realistic expectations.** Keep an open mind and develop a positive attitude. Don't expect to like everything you draw. Remember there is no wrong way. Know that you are your own teacher.

- **Concentration.** Talking can interrupt the mind, eyes, and heart from drawing the way you would like. Put socializing aside for awhile.

- **Warming up.** Do some eye-relaxation exercises and shape warm-ups to get your visual juices working.

- **Patience.** Build an appreciation for the time it may take to learn to see. Understand that once your eyes are trained, your hand will easily follow. Silence your inner critic.

- **Planning.** Establish the habit of planning your project and organizing your supplies before you leap into the drawing. Most of your frustration and disappointment will be eliminated by respecting the planning stage.

- **Speed.** Realistic drawing doesn't work well if you draw before looking. Take time to study the details.

- **Exploring and feeling.** Allow yourself the freedom to explore without needing to like everything you do. Take risks. Let your feelings guide you without worrying about technical results.

- **Fun.** Follow your feelings and *draw for yourself.* Avoid comparisons or implications of right and wrong.

- **Use every opportunity.** Finish drawings that aren't perfect. Makes opportunities out of your so-called mistakes.

The External Environment

This checklist will help you remember the factors to consider in setting up your drawing space:

■ **Accessibility.** Keep your equipment set up as much as possible. You are more likely to draw when you don't have to set up and clean up each time.

■ **Quiet and isolation.** Try to set up a space that is away from distractions. Eliminate noise from such sources as television and radio.

■ **Size.** Make sure you have freedom to move around and to spread your equipment out in an orderly fashion.

■ **Drawing surface and seating.** You will need a smooth desk or tabletop, as well as a portable drawing board. Be sure the chair is at a height that allows your elbows to rest comfortably on the surface of the table.

■ **Neatness.** Clear all unnecessary items away from the drawing area. When training your eyes, you don't want clutter to distract you.

■ **Lighting.** Avoid fluorescent light, which is hard on the eyes. Watch that neither your hand nor your body is casting a shadow onto the paper. A swivel light that attaches to a table with a screw-on clamp is best, since it allows for adjustments in different situations.

■ **Idea Files.** You don't need to feel guilty about looking at other works of art for inspiration. Professional artists don't draw entirely from their imaginations either. Don't prevent yourself from copying ideas from photographs, graphics, and commercial artwork. You will interpret them differently anyway.

■ **Demonstration area.** If you are going to be teaching others, choose an area that has a wall or flat surface for demonstration. Be sure that your demonstrations are large enough to be seen by the students in the back of the room. Set up a small table for still-life or other three-dimensional objects. Make sure everyone in your group can see the setup from their drawing level.

LEARNING HOW TO SEE:
THE 5 BASIC ELEMENTS OF SHAPE

Learning how to draw is really about learning to see. When I meet a person who draws well but has not taken lessons, he or she usually had some kind of training in observation and paying attention to the visual world.

There is a widespread opinion that some cultures have more talent for drawing than others. I suspect it is more a matter of certain cultures putting more emphasis on visual ways of thinking and visual appreciation. Children who are brought up in a home where they are constantly exposed to things and asked to visually notice them are involved in drawing readiness. I am almost sure that is what happened to me with my aunt Beverly; she was always involved in visual activities and constantly asked me to notice the myriad of things she was pointing out.

When I use the phrase *learning to see*, I am not only referring to the eyes. If all five senses are activated, you will make a different kind of observation of an object. For instance, if you are drawing a goose, you want to pay attention to the way it moves its head and neck, the comical honking noises it makes, and the way its feathers overlap one another. You would also catch the energy and feeling of the animal more accurately if you remembered the fear you might have experienced as it aggressively hissed and pounced toward you.

Along with using all five senses, you want to draw with your mind, your body, your emotions, and your spirit. A person can pay close attention to visual information but completely miss the mood or the feeling. Try to stay relaxed and yet alert, tuning in to how you are feeling and seeing.

It is important to release the tensions of the day and to do mind, body, and eye relaxation exercises. This will aid you or others you are working with in reaching a state conducive to concentration and visual focus. The five minutes you spend doing these relaxation and warm-up exercises are well worth it. If, after the drawing begins, you start to experience frustration or a group you are working with begins to get restless or disorderly, don't forget that you can stop the drawing and do these exercises at any time.

The first exercise is for mind and body relaxation. The second exercise, which is called palming, was devised by William Bates, author of *Better Eyesight without Glasses*, and can be used before any physical or mental activity in which you want to perform at a peak level. It relaxes all the sensory nerves, including sight, and rids you of mental and physical strain. Palming enables the eyes to see better for longer periods of time and to maintain a more relaxed state.

Mind and Body Relaxation

1. Sit squarely in the seat, with uncrossed legs, resting your elbows comfortably on the tabletop. Pull up from the crown of your head to straighten the spine, and relax your *shoulders*.

2. Relax the tension in your *face*, especially the jaw. Let your *mouth* drop open and hang slackly. Then check out your *neck* and wiggle the tension out of it by rotating your head from side to side and up and down.

3. Take a deep breath and let your *shoulders* drop as you exhale. Keep pulling up from the head with a straight spine as you drop your shoulders. Don't let yourself slouch. Do this at least two or three times.

4. Relax the *throat* and *chest* area. Breathe deeply through the nose and out the mouth.

5. Check your whole body and see whether you are holding tension anywhere else. Release it.

The Bates Palming Exercise

1. Take off your glasses if you wear them.

2. Rub your hands together until they get hot.

3. Rest your elbows on the desk or tabletop surface in front of you. If this is not possible, rest your elbows near the waist area.

4. Cup the palms of your hands and place one over each eye, heel of palm on cheekbone, fingers crossed over the forehead. Make sure that you are not applying pressure to the eyeballs.

5. Close your eyes. Think of the area behind your eyeballs and feel it relax. Breathe deeply, let your jaw drop a bit; let your shoulders drop and relax again. Then go back to the spot behind the eyeball and relax it again . . . and more . . . and even more.

6. Open your eyes slowly and try to maintain this relaxed state while you draw. You can repeat this exercise for a minute or two at any time during the drawing session.

The 5 Elements of Shape

Hundreds of people tell me stories about why they dropped out of prior drawing classes and gave up in total frustration. One of the most common reasons they give is that they felt overwhelmed by visual complexity. They say they don't have any idea of what to look for and didn't know how to follow the teacher's insistence that they look more closely.

When I first developed this drawing method, none of my students was more than five years old. It would have been impossible to teach them a philosophy of drawing or to explain concepts about volume, perspective, or shading. As I tried to figure out how to teach these children, my friend Elliott Day began to take an interest in my problem and volunteered to be a sounding board for my ideas. As a musician and composer, Elliott explained how all musical compositions grew out of the 12 basic elements (or notes) that had been decided upon to represent a tonal scale. He reminded me that all written words also grow out of the number of basic elements (or letters) that made up any particular culture's alphabet. Given this line of thinking, he kept asking questions about what basic elements I had learned in order to draw any shape.

Though I tried to recall any system in my art education that was used to get me to understand all shapes through a basic alphabet of specific elements, I couldn't remember any reference to such an idea. Different teachers and books used different sets of shapes to explain visuality, but none of the combinations of lines or shapes was basic enough to explain all the shapes possible. Elliott made me realize that there was no set of elements to use in the visual arena and that this lack was probably directly related to the confusion most people had when trying to draw. Our quest for discovering the universal elements of all shape began.

The chart in Figure 3.1 represents the result of that search. It has been eleven years since we created the chart, and no one has come up with a shape or object that isn't a combination of the 5 basic elements. In an article in the *Brain Mind Bulletin*, its publisher, Marilyn Ferguson, referred to the 5 elements as "the Alphabet of Shape," and the title has stuck. This alphabet teaches you *what to look for*.

Make a copy of the chart so you can refer to it at any time, without having to flip through the book to find it. In a few pages you will be instructed to photocopy all the warm-up exercises in the remainder of the chapter, so do so at the same time, if possible.

First, I want to warn you about a tendency to misunderstand the concept *elements*. I often hear people talking about five basic shapes, instead of five basic *elements of shape*. These are not the same, and it is very important to understand the difference. Five particular shapes do not make up all the shapes in the world. There are millions of shapes, which is why you get overwhelmed when you try to analyze the shape of something. There are five *elements* that make all the shapes in the world. Once you understand that everything you look at is made up of a combination of the five basic elements, you can analyze any shape and reproduce it on a piece of paper.

You will now learn to isolate and observe these five elements in everything you see. The contour edges of the objects you wish to draw, and the edges of the spaces between them, are represented by continual patterns of these same five elements of shape. The elements give you the information you need to re-create any shape, whether simple or complex, on a piece of paper. Students report that seeing the edges of everything in terms of these five elements is the tool that helps them know what to look for.

As you familiarize yourself with these elements, use all your senses to explore and recognize them in your environment. Look at them on the chart, say the names out loud and hear them as you recognize them, and walk around the room to find examples of the elements as you touch and feel them. Later on, if you are drawing an object that is giving you difficulty, pick it up and feel it in order to better understand its shape.

If you haven't had time to photograph the chart, make a quick hand copy of it, so you can refer to it as you analyze each of the elements.

I. THE DOT FAMILY. The dot family includes any shape that is roundish and filled in with texture or color. It has no straight or pointed edges. It can be perfectly round or very wobbly, as long as it is solid and filled in.

Most of us think of a dot as small, and this limits our imagination. Open up your mind to dots of any size, and notice at least three in your environment. Move around the room and touch and closely observe dots as you recognize them.

Close your eyes and build your inner vision by seeing images of dots ranging from very small ones all the way up to huge ones, such as a grain of sand, a nailhead, a button on a coat, a kidney bean, a beach ball, a weather balloon, the moon.

2. THE CIRCLE FAMILY. The circle has the same variety of shapes and sizes as the dot but is empty of texture or color. The rim does not have to be thin, and the shape can wobble as long as there are no pointed edges.

THE 5 BASIC ELEMENTS OF SHAPE

THE DOT AND CIRCLE FAMILY

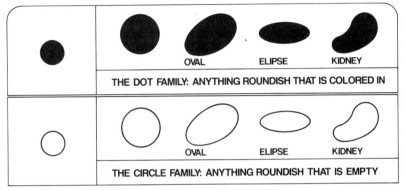

OVAL ELIPSE KIDNEY

THE DOT FAMILY: ANYTHING ROUNDISH THAT IS COLORED IN

OVAL ELIPSE KIDNEY

THE CIRCLE FAMILY: ANYTHING ROUNDISH THAT IS EMPTY

THE LINE FAMILY

THE STRAIGHT LINE FAMILY

SPIRAL

THE CURVED LINE FAMILY

THE ANGLE LINE FAMILY

MONART SCHOOLS
1979 MONA BROOKES

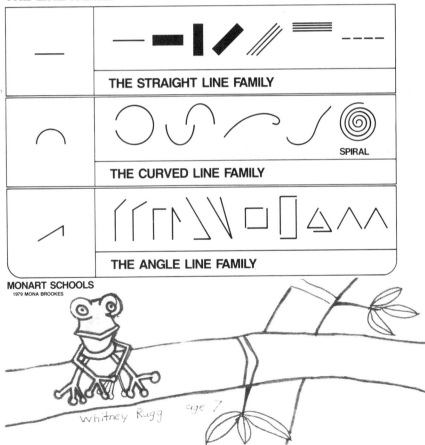

Whitney Rugg age 7

FIGURE 3.1
THE ALPHABET OF SHAPE
The contour edges of the objects you wish to draw and the spaces between them are represented by continual patterns of the same five visual elements.

Find at least three circles and explore them. Be careful that you see the entire circle. For example, when there are flowers coming out of a vase, you can't really see the whole circle that forms the opening at the top of the vase. If you slip a circular ringed bracelet over your wrist, you are left with seeing only a curved portion of it. Your drawing ability is blocked when you try to draw from what you think instead of what you see.

Try to imagine as many different circle shapes as you can in a variety of sizes, such as a metal washer, the rim of a bowl, a hula hoop, a race track, or the white-light ring around the moon.

3. THE STRAIGHT-LINE FAMILY. Most people think a straight line can only be thin. As you look at the chart, notice the straight lines that are wide and see them as lines rather than as small rectangles. You can observe a door or the ceiling of a long room as a wide straight line when considered in this way.

When you observe and explore straight lines in the environment, they are usually attached to things and have to be isolated in order to be recognized, such as a line going from the ceiling to the floor in the corner of the room, one side of a picture frame, or one particular branch in a tree. If you are inside a man-made structure, you are probably surrounded by an endless variety of straight lines.

Create straight-lined images in your inner vision, remembering to vary the width and the length. You might envision a stretched-out piece of fishing line, a ruler, the short yellow broken lines in the middle of the street, the edge of a hundred-story office building, or a highway in the middle of the desert.

4. THE CURVED-LINE FAMILY. The minute a straight line begins to bend, it becomes a member of the curved line family. Of course, the ways in which a line can bend are infinite as long as it does not close in on itself and make a circle. Since curves have a tendency to be strung together in many different directions, it becomes important to isolate them in order to see them individually. For example, the letter S is really two curves joined together.

One of the biggest challenges in drawing is identifying a series of curves strung together that change direction. Human beings, as well as animals with a lot of muscle definition and rounded body parts, fit this category. An example is the curve of a horse's neck, followed by the one across

the back, then the one over the rump, and the many curves in the hips and legs. Isolating these curves one by one, and their directions in relationship to one another, allows you to move beyond the apparent complexity.

Close your eyes again and conjure up as many images as you can of the different sizes and widths of curves. Keep in mind that you need to isolate one curve at a time, such as an eyebrow, the handle of a teapot, the stem of a flower, the arch of a building entrance, or a rainbow.

5. THE ANGLE-LINE FAMILY. Once a straight line becomes so bent that it comes to a point, it becomes an angle line. It can be thought of as two straight lines joined together at a point, but even then it would need to be included in the basic five elements because of its common occurrence. Observe on the chart how an angle can be very narrow or very open. Notice how you can create triangles, rectangles, and squares when you join angle lines together. As with straight lines, you will need to isolate angles from what they are attached to in the environment.

As you imagine angles in your inner vision, you might refer to the chart to stimulate the variety of degrees and sizes possible, such as the bend in a spider's leg, the tip of a shirt collar, the corner of a room, the fork in the branches of a tree, or a laser beam reflecting off something.

WARM-UPS: DUPLICATION, DIFFERENTIATION, AND MIRROR IMAGING

Before drawing representational objects, you will draw the five elements in both random and structured warm-ups. It is important to do warm-ups before drawing sessions to help you remember the five elements and how they relate to the objects you want to draw. This also gets you into a focused and concentrated state that awakens your senses and makes you alert to visual detail. Everybody knows that dancers should warm up before they leap into the air, or they may be off balance and out of control. The same is true of you, as a drawer. If you leap into the drawing before you warm up your eyes and your senses, you may be off balance and unable to control your drawing the way you would like.

These warm-ups are designed to train your eyes in seeing the five elements of shape. It is important that you don't mindlessly copy the models shown, without paying attention to what you are doing. As you duplicate

each line in the exercise, think of which one of the five elements you are using to construct the pattern. It helps if you actually mumble aloud for awhile, saying the name of each element as you draw it. Such training is the key to recognizing line and shape in the objects you want to draw. The more you ingrain these elements into your awareness, the better. When you later draw realistically, your eyes will be used to the training and automatically see these same elements in the construction of an object, allowing you to capture its proportion and shape.

In addition to trying the warm-ups that follow, don't hesitate to make some up for yourself. Any kind of exercise in thinking, exploring, or drawing the five elements will serve the same purpose.

If you haven't done so already, photocopy the warm-up exercises in the remainder of the chapter. If you don't want to mark in your book and are unable to get to a copy machine, take a piece of scratch paper and draw squares the same size as the blank ones in the sample. Then copy the warm-ups using your scratch paper.

First you will do some basic warm-ups in *duplication,* then some that train your eyes in seeing *differences.* After these, you will try some *mirror-imaging* warm-ups and then do some with *realistic objects.* ·

Duplication Warm-Ups

Duplication simply means copying an existing combination of the basic elements. You can't really learn how to draw without learning how to duplicate shape and pattern of line. If all you ever did was copy, you could get stuck there, but copying is one of the important parts of learning to see and has its place in your eye training.

DUPLICATION PROJECTS

Study figures 3.2 to 3.5, a set of warm-ups that get progressively more complex. In each square is a model (or pattern or design) that is composed of the five elements of shape in different combinations. None of the models is too

complex to accomplish for anyone over eight; you will simply use more time and more concentrated focus as you progress toward the last models.

There is no reason to try for perfection. You don't need to be exact. If you want exact duplication, study photography, not drawing. The main goal is to duplicate the combination of elements in order to create the same pattern. For example, if you see a shape full of straight lines, it isn't necessary to count the number of lines; you can simply create the type of shape and fill it with a similar straight-line pattern. This relates to the way you will eventually draw. You wouldn't want to draw every leaf on a tree exactly as you saw it; instead, you would create the type of pattern the leaves make.

It will take approximately 45 minutes to do the set, but you can take as long as you want.

SUPPLIES

A photocopy of the warm-ups (or scratch paper to use next to the book)

A black regular-point felt-tip pen (or any pen or pencil with a similar thickness of line to the model)

INSTRUCTIONS

Simply copy the design in each square, using the five elements of shape to construct the parts. Don't forget to say the name of the element you are using in your head (or out loud if you can). As the models get more complex, remember that they aren't harder—there is just more to them and they will take more time and concentration. They are made up of the same five elements over and over. There is no right or wrong way to draw the designs; you can start in any portion of the square that works for you. However, it helps to keep turning your paper in any direction that makes drawing more comfortable. Relax and have fun as you train your eyes and your mind to recognize the five elements. If you get frustrated by any particular one, skip it and come back to it later.

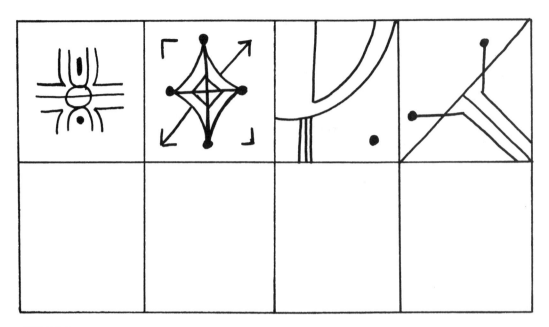

FIGURE 3.2
Duplication exercise.

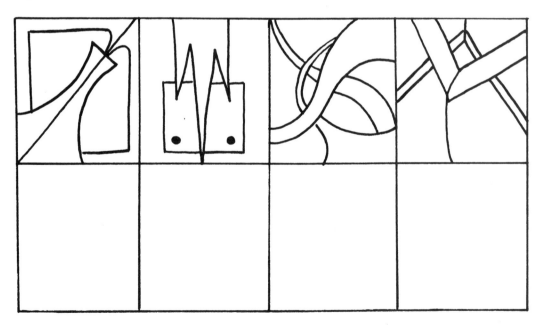

FIGURE 3.3
Duplication exercise.

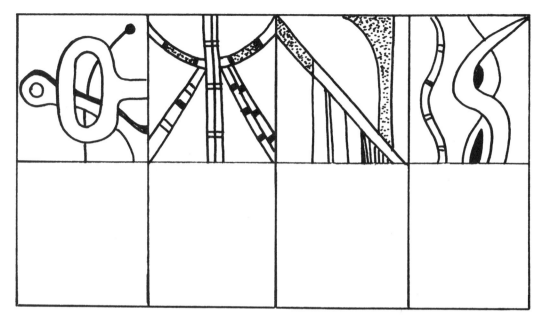

FIGURE 3.4
Duplication exercise.

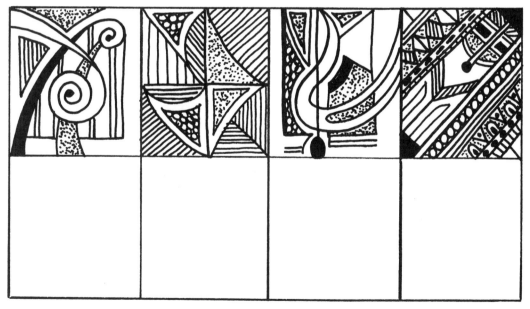

FIGURE 3.5
Duplication exercise.

Differentiation Warm-Ups

Differentiation means the ability to discern differences and sameness. As you compare the patterns in the boxes, you are doing a kind of visual mathematics as you count or analyze the way the elements are arranged. As you do these warm-ups you may notice a completely different kind of feeling from the one you experienced in the previous exercise. If so, it is because you will use a completely different mental process to work with them.

DIFFERENTIATION PROJECTS

You will use figures 3.6 and 3.7 for this exercise. You will simply be studying the exercise and choosing which boxes are the same. Since you won't be doing any drawing, the exercise will go fairly fast—you will only need 5 to 10 minutes at the most.

SUPPLIES

A photocopy of the warm-ups (or scratch paper to write your answer)

A colored marker to circle your choice

INSTRUCTIONS

Notice that the models are on the left-hand side of the warm-up sheet, with a stripe of thick black lines separating them from your choices. Study the first model, then look across the separation lines and study the four similar designs you have to choose from. With your colored marker, circle the design that is the same as, or most similar to, the model. As you study the designs, recognize each mark as one of the five elements of shape. See how the elements are combined in the model and begin to compare them one by one with those in the choices. As you study each choice you will count the elements and notice their direction, eliminating a choice at a time until you find the same combination.

FIGURE 3.6
Differentiation exercise.

FIGURE 3.7
Differentiation exercise.

FIGURE 3.8
A duplicated image.

Mirror-Imaging Warm-Ups

One of the things that frustrates beginners is drawing two sides of an object symmetrically. This happens in still life with vases or bottles and in figure drawing when you attempt to draw both sides of the body. Being able to duplicate the symmetry in objects accurately is one of the skills that those who draw are particular about. Drawing two sides of an object that look the same but are in the reverse order is a challenge that takes some practice. Betty Edwards, in *Drawing on the Right Side of the Brain,* uses an exercise that helps you work on this skill. The following warm-up is based on this idea but adds an important factor: your ability to analyze the process through your understanding of the five elements of shape.

MIRROR-IMAGING PROJECT

Study the example in Figure 3.8. Notice how the left side is a solid black line, there is a dotted line down the middle, and the right side is a solid line. Notice that the configuration of the solid line on the left is the *same* as that of the solid one on the right. Now study the example in Figure 3.9 and notice that the line on the right is *in reverse of* the one on the left, and therefore a mirror image. You will be drawing this kind of reverse image in the warm-ups provided in Figure 3.10. This exercise will probably require more concentration than any of the others, but don't give up quickly. I have never seen a person who was not able to grasp this concept, even though I have seen quite a few people struggle with it for up to 10 or 15 minutes before succeeding. It could take you anywhere from 10 minutes to 45 minutes, depending on the amount of adjustment your eyes need to create the reversal. Above all, treat this like a game instead of a test, and you will enjoy the challenge.

FIGURE 3.9
A mirrored image.

SUPPLIES

A photocopy of the warm-up (or scratch paper to use next to the book)

A black regular-point felt-tip pen (or any pen or pencil with a similar thickness of line to the model)

INSTRUCTIONS

Study the first model in the series of warm-ups in Figure 3.10. Notice that there is a horizontal line across the top (the top border) and another across the bottom (the bottom border). Add the dotted line down the middle first, and use it to relate the direction the elements of shape take. Recognize the first element you see descending from the top border. You will need to isolate it from the string of elements that make up the whole configuration. Acknowledge it as a straight line, but notice that it doesn't come straight down from the top border; it slants in toward the dotted middle line. This is the key to doing the warm-up. Notice each element of shape; recognize which one it is; notice how long or large it is; notice the sizes of the space between it, the next line, and the mid-line; and, most of all, notice whether its direction is toward or away from the mid-line. Then draw it. Repeat the process for the next portion of the configuration.

If you find that you duplicate the image instead of reverse it, you can just cross it out and do it again with a different-colored pen. Remember, this isn't a test; it is just a warm-up, and you can mark all over it any way you want. By the time you do the third exercise, see whether you can eliminate the dotted line.

When you get to the monster faces, note that the completed warm-up will show two monsters facing each other; this will help you get oriented. When you get to the blank top and bottom borders, make up some monster faces of your own and mirror-image them.

ACHIEVING REALISTIC DRAWING OF OBJECTS BY RECOGNITION OF THE 5 ELEMENTS

Once you have learned the alphabet of shape, it is only one short step to drawing recognizable objects. You will find yourself drawing objects instead of abstract designs if you arrange the elements into certain patterns. It is no harder to draw a realistic object than a design; it just takes a different kind of focus. You need to pay more attention to proportion in order to be satisfied. For example, if you are making two curved lines in a design, it really doesn't matter how long they are for the design to be attractive. However, if the lines are forming a swan's neck, you may need to notice how long they are in relationship to the body in order to be satisfied with the result.

FIGURE 3.10
Mirror-imaging exercise.

OBJECT-RECOGNITION WARM-UPS

Study Figure 3.11. The model of each object has an empty box beside it for you to draw in. You will simply duplicate the object in the empty box. This warm-up will take around 20 to 45 minutes, depending on how relaxed and focused you are. Try to achieve as much similarity as possible this time, although exactness isn't necessary.

SUPPLIES

A photocopy of Figure 3.11 (or scratch paper to use beside the book)

A black regular-tip felt-tip pen (or a pen or pencil with the same thickness of line as the model)

INSTRUCTIONS

Select any one of the models. You can draw the models in any order that you want. Study the one you chose and draw it in the empty box in the same way that you copied the patterns in the duplication warm-up. Isolate each element of shape, thinking of it as you draw it. Notice its size and length, and most of all notice its relationship to the other elements and the empty spaces. Those empty (negative) spaces will be discussed at greater length in Chapter 5. For now, just be aware that considering the size and shape of the empty spaces is as equally important as considering the drawn elements (the positive spaces). Paying attention to the relationships of the positive and negative spaces will assist you in achieving proportion more than any other concept.

There is no right place to start drawing an object, but there are certain guidelines that can help the beginner:

1. Choose a central part of the object to start with, and slowly analyze how each section is a combination of the five elements pieced together. Notice the edges of the parts and use contour lines to establish the general shape of the object. If the object is a living being, the central part is usually the eyes and features of the face. If it is a flower, the central part is usually the middle. If it is a machine, it is usually the base of the machine or the central piece that makes it function.

FIGURE 3.11
OBJECT RECOGNITION
WARM-UP
By taking the five elements of
shape and arranging them in a
particular order, you can draw
recognizable objects instead of
abstract designs.

2. Instead of starting with a central part, you might want to start with the simplest line that you see and slowly build off it.

3. Break each line apart from others, and recognize which of the five elements you are dealing with and how it connects to and projects from the central part.

4. Slowly build each part by adding it to the last part you drew.

5. After you have drawn the main sections of the object, add any small details or decorative lines that are within the contour edges.

Now that you have experienced how to use the five elements of shape to understand the construction of an object and can interpret that information on a piece of paper, you can draw any object you want. This is always a matter of slowly recognizing the elements of shape and how they fit together to form the particular object you are drawing. These warm-ups are very simple line drawings, but that is all you ever need to do a preliminary sketch or warm-up study of an object. After you understand the construction, you can choose to draw the object in any degree of looseness or complexity. Do these warm-up sketches as much as possible.

DEVELOPING CONFIDENCE: MAKING WARM-UPS AND DOING SKETCHES

Drawing is like any other subject. The more you do it, the more you feel satisfied with the results. The information in this chapter is all you need to begin to analyze and draw any object. The ability to capture the basic shape and proportion of any object is simply a matter of recognizing how the basic elements of shape are combined. The more you practice seeing the basic elements and how they fit together to make an object, and the more you do contour-line sketches of them, the more confidence you will achieve.

Recognizing the contour edges of things and the shapes of the spaces in between is the basic foundation for all other types of seeing. This concept eliminates the inability of knowing what to look for, which is the major frustration most beginners experience. When you know what to look for and can analyze the shape of anything you want to draw, you demystify the drawing process and gain confidence. Then you are free to interpret the subject any way you want and develop your own unique creative way of expressing it.

Make Up Your Own Warm-Ups

Once you have done the warm-ups in the book, you may wonder how you are going to continue the practice. There is actually no better way of warming up than to make your own warm-up exercises. You have to focus and concentrate on the task even more when you make them up yourself. Make a master page of blank squares and photocopy a lot of them. Then make warm-up sheets like the ones in the book. When you do the mirror-image warm-ups, use a blank piece of scratch paper and make top and bottom borders to work from. When you do object-recognition warm-ups, you don't always have to use the format of the squares. Take a small object and simply draw it step by step on a piece of paper.

Make Practice Sketches

One of the best ways to practice drawing and keep warmed up is to carry a sketch pad around to draw things at any free moment. You don't need a fancy project or beautiful composition to keep your drawing skills up. For example, when you are on a trip in a car, waiting in the doctor's office, or relaxing at the park you could be drawing the dashboard, the office chair, or a person's shoe near you. When you are listening to a lecture, waiting to be served in a restaurant, or in a business meeting you could be drawing the pattern of the sweater on the student next to you, drawing the sugar and creamer at the table, or drawing your own hand at the conference table. The point is not to create a finished drawing, but to establish a way to practice and to warm up your eyes and drawing skills. So carry a sketch pad, or grab a napkin or any piece of paper, and do warm-up drawings whenever you have idle time.

The next chapter will help you choose a project that you love, think creatively about planning the composition, and decide on the many drawing styles and media choices that are available.

CHOOSING YOUR SUBJECT, STYLE, AND MATERIALS

Not knowing what to draw is one of the most frequent problems people experience. Confident students often want to draw on their own but don't know what they want to draw. Teachers who say they can't make up projects ask for supplemental lesson plans. Most of these people don't need any direction or demonstration in *how* to draw; they simply want to be stimulated with some choices of *what* to draw. So if you feel unable to plan a drawing project, you are not alone. Once you can get past the block about choosing a project, you will find yourself drawing often.

INITIAL STEPS TOWARD BREAKING THE PROJECT PLANNING BLOCK

Here are three basic steps that will get you over the discomfort and help you take action:

I. NOTICE WHETHER YOU HAVE TROUBLE DECIDING WHAT TO DRAW. If you want to draw, you need to become aware of any resistance or lethargy when you try to choose a subject. In this chapter I will give you suggestions on how to plan your projects, but you will need to notice your resistance and counteract it.

2. DECIDE YOU ARE GOING TO ATTACK THE PROBLEM WITH A CON-CERTED EFFORT. You may notice you are uncomfortable when you begin to think about what to draw. You simply need to acknowledge your discomfort, without judgment, and decide you will choose a project anyway. The following steps will give you some guidelines in how to move through the resistance. They will teach you a method for arriving at a decision. The following kind of self-talk will help you establish new habits to break the block:

"I am prolonging the eventual need to plan projects for myself if I stay dependent on others to inspire me."

"I will notice how the projects in the book are formed and learn to make up similar ones of my own."

"I will collect things as I go along, making folders to contain different kinds of projects and notes to remind myself of my ideas."

"When I finish with this book, I will have collected project materials that I will look forward to working on."

3. MAKE A COMMITMENT TO CHOOSE PROJECTS AND TRY THEM. Now you can take action. It is only by taking action that you can break the block and be on your way to planning projects for yourself.

TWO MAIN REASONS FOR INABILITY TO PLAN PROJECTS

1. CONFUSION ABOUT KNOWING WHAT YOU LIKE. Many people don't really know what kind of art they like. They find themselves trying to like what is popular, in response to what they hear. Many have simply never been exposed to enough variety to have arrived at opinions. If you are not sure what you like, I suggest that you begin taking some trips to museums, looking through art books, or studying illustrative materials. As you see things you like, take note and imagine how the artist achieved the results. Discover what materials and process the artist used. Notice the kinds of subjects that stimulate your interest.

2. GENERAL INEXPERIENCE IN KNOWING HOW TO PLAN THINGS. It is the rare person who has learned how to plan things. When they draw, most beginners grab the supplies and quickly try to fill up the blank paper. Then many apologetically point out things they feel are going wrong with the

drawing, yet frantically race to finish. They seem to feel compelled to start but experience failure when they don't like the results. Sometimes they take a wild stab at a solution and then bail out if the first unplanned attempt doesn't work.

I encourage you to adopt some sort of planning process, such as the following one. It will increase the satisfaction you get from drawing and decrease the amount of worry you may have over possible failure. Failure is directly related to jumping in too quickly, before you know what you want or how to accomplish it. Here is an agreement you might make with yourself that will make planning a matter of habit:

Agreement

1. I will use the steps in this chapter as a planning process and take note of the sequence.
2. I will use this (or a similar sequence I devise) before each drawing session, until it becomes a matter of habit.
3. After I have established the habit, I can choose when I need planning steps and when I don't.

There are several steps involved in project planning. Note that you need to select a project and do it as I explain the process. While I won't be able to illustrate how to draw your particular project, the following general instructions will be all you need.

CHOOSING AND PLANNING A PROJECT

I suggest that you photocopy the outline on the following page and put it up in your drawing area.

You may need 1 to 2 hours to follow this process the first couple of times. You may even need to go out to some stores or to friends' homes to collect things. Start the process even if you are worried you won't have time to finish; you can come back to it later if you have to. Once you have gotten used to this outline, you can learn to plan projects in only 10 to 15 minutes.

Outline for Planning a Project

STEP I. DESIGN THE PROJECT

a. Choose the type of project.
b. Choose the main subject.
c. Organize the setup.

STEP 2. PLAN THE COMPOSITION AND STYLE

a. Decide on the overall use of the paper.
 (1) Bordered format
 (2) Open format

b. Choose the drawing style.
 (1) Abstract style
 (2) Symbolic style
 (3) Two-dimensional design style
 (4) Three-dimensional realistic style
 (5) Mix of different styles

c. Visualize the placement of subjects and background.
 (1) Main center of interest
 (2) Secondary centers of interest
 (3) Foreground, midground, and background

d. Create different effects.
 (1) Variety versus sameness
 (2) Repetition versus singularity
 (3) Harmony and balance versus incongruity and disorder
 (4) Black and white versus color
 (5) Hot versus cold color schemes

e. Visualize the mood and movement.
 (1) Creating life and movement
 (2) Keeping the eye interested

STEP 3. PREPARE FOR EXPLORATION

a. Choose the materials to use.
b. Gather and set up the supplies.

STEP 4. UTILIZE ROUGH DRAFTS

a. Sketch a general plan.
b. Allow for changes, as you make the final drawing.

STEP 1: DESIGN THE PROJECT

First, think of the word *design.* You are going to become a *designer.* This is an important point, because it is how you will activate yourself into taking charge. Most of us are products of an educational system that designs for us. We are provided with materials to learn from and are asked to answer questions that have been designed into a curriculum. We are not used to designing our own learning experiences, and we are not familiar with solving problems from the challenges we design for ourselves.

The first step toward breaking the block is to categorize the overwhelming number of subjects you could draw in a list of the basic types of project choices.

Choosing the Type of Project

The trick is to devise the shortest general list you can make. This reduces indecision and helps you single out a particular project that interests you. Here is a list that you can start with. Add any other categories that you feel are important to include. *Memorize the list and you will always have an easy way to get started.*

General Categories for All Types of Projects

1. Beings
2. Inanimate objects
3. Plants and flowers
4. Vehicles
5. Landscape or nature scene
6. City or building scene

Choose one of these general categories for the project you will be doing. For the sake of ease, it is suggested that you choose from the first four categories above and write it down on a piece of paper.

Choosing the Main Subject

Now you can select a more specific subject. Obviously, the number of possibilities within each category is limitless, but here are some short lists of what your choices might be.

BEINGS: men, women, children, babies, deer, elephants, birds, snakes, horses, mice, cats, dogs, space beings, angels, dragons, imaginary creatures, fish, starfish, whales, spiders, dinosaurs, bumblebees, etc.

INANIMATE OBJECTS: vases, kitchen items, household appliances, furniture, office equipment, machinery, statues, art objects, clothing, shoes, toys, musical instruments, etc.

PLANTS AND FLOWERS: Lilies, roses, birds of paradise, orchids, bottle bush, ivy, ferns, vines, cattails, banana trees, palm trees, oak trees, cacti, seaweed, etc.

VEHICLES: cars, trucks, airplanes, spacecraft, buses, trains, steamships, sailboats, hang gliders, surfboards, bicycles, roller skates, etc.

LANDSCAPE OR NATURE SCENE: meadow, farmland, Amazon jungle, riverbank, desert, mountain ranges, underwater environment, seascape, rose garden, redwood forest, African plain, etc.

CITY OR BUILDING SCENE: Storefront, city skyline, Victorian houses, farms, barns, palm-frond huts, railroad station, church, Buddhist monastery, adobe mission, European castle, log cabin, circus tent, etc.

List up to five things in the category you chose that you think you might like to draw as your main subject. Before you make a final decision, consider where you will need to go to get information or samples about the subject. For example, would your choice be a subject that was immediately available for study, or would it be one that required you to go find it? You also need to consider whether you want to draw from the real object or a drawing or photo of one. You can always add things from your imagination, but most artists need to look at information about the main subject to accomplish a realistic drawing. For the purposes of this exercise it does not matter whether you use photographs, illustrations, or real objects. Try to choose a subject that personally interests you and relates to something you love. If you select a subject that you like, you may have more enjoyment and success in the project.

Don't concern yourself with your drawing skills yet. This chapter is about learning how projects are planned, and it isn't necessary to end up

with a finished drawing that you are totally pleased with. *Choose something that you feel will be easy for you to handle.* It could be something as simple as a drawing of an animal that you can copy. The point is to get used to the planning process. Write your choice down on your paper now.

If you have chosen a subject that you need to find, do so before you continue. If you aren't sure of where to look, here are some clues:

- Libraries have checkout service for illustration files, which contain pictures of many subjects. Of course you can also check out a book on your subject.

- Greeting-card stores have posters, calendars, paper plates, wrapping paper, and cards that display a wide variety of subjects. They often have small three-dimensional knicknacks of animals, birds, and people, as well as objects for still life.

- Major bookstores and stationery stores have calendars on a wide variety of subjects. A few months into the year, you can get them at low prices.

- Toy stores have stuffed animals and miniature statues of all kinds of animals and vehicles.

- Florist shops will give you old flowers that are still fresh enough for drawing samples.

- Garage sales and thrift shops are a haven for interesting subject matter at bargain prices.

- Museum shops can be a bit expensive, but they often have many items that lend themselves to drawing projects.

Organizing the Setup

Bring the subject materials you have chosen to your drawing space. Remember to clean up the drawing area from prior sessions and get rid of all other distracting visual clutter. If you are drawing an inanimate object, find a pretty cloth or mat to set it on. If your subject is a still-life setup, shine a light to one side, if possible. *Sit quietly and get ready to visualize the plan for your drawing.*

STEP 2: PLAN THE COMPOSITION AND STYLE

When you plan a composition, you are simply deciding where you want to place things on the paper, what drawing style you will use, what details and background you will add, what mood you want to create, and how you want the eye to move through the drawing. Some people have an intuitive sense of what they want and don't like to be structured by design principles or rules about placement. However, most people are lost when it comes to designing compositions. If you take the following information as ideas for consideration, instead of hard-and-fast rules, it will help you organize your ideas into a plan. Don't worry about losing your spontaneous creativity. When your understanding of structure becomes a natural habit, your creativity will actually increase.

Review Step 2 of the Outline for Planning a Project, which deals with the steps toward planning your composition. Get a sense of the different areas that you will be considering before you take each step. You will go through these steps, one by one, as you apply them to your project choice. At each step I will give you general information and examples. For ease in understanding the examples, I will do drawings in a simple, flat style, using contour lines. As you study the examples, remember that I have used only one simple style of drawing. You can use any of the ideas, but translate them into your own unique style. Use your imagination along with these ideas to develop your own creation.

Deciding on the Overall Use of the Paper

The kind of paper and the size you choose is automatically the first decision you will make about your composition. No matter what your subject, there are only a few general shapes of paper. Of course, you can be inventive and cut any shape of paper you want, but the examples shown below are the basic shapes you will be deciding between. The basic shapes of paper are:

1. A square format
2. A tall rectangle (vertical format)
3. A sideways rectangle (horizontal format)

Consider some overall effects that you want to use in relationship to the paper itself. For example, do you want to use a border, float your drawing

Step 2: Plan the Composition and Style

a. Decide on the overall use of the paper.

 (1) Bordered format

 (2) Open format

b. Choose the drawing style.

c. Visualize the placement of subjects and background.

 (1) Main center of interest

 (2) Other centers of interests

 (3) Foreground, midground, and background

d. Create different effects.

 (1) Variety versus sameness

 (2) Repetition versus singularity

 (3) Harmony and balance versus incongruity and disorder

 (4) Black and white versus color

 (5) Hot versus cold color schemes

e. Visualizing the mood and movement.

 (1) Creating life and movement

 (2) Keeping the eye interested

within the shape of the paper, or take your drawing out to the edges? You also have the choice of combining these effects. The examples in figures 4.1 to 4.4 show some of the ways you can express these various choices. You may invent some others.

If you want to use a border, there is an easier way than using a ruler on each side to accomplish it. Take a piece of cardboard an inch or two smaller than the piece of paper you are going to draw on, and use it as a template. Place it on the paper and draw around it. If you want the rounded corners that you see in Figure 4.1, simply take a pair of scissors and round off the corners of your cardboard. If you want effects like those in Figure 4.4, you can use portions of the cardboard template for the straight edges and add the other lines freehand.

Then study your main subject and decide what size and direction of paper you want to draw it on. Your choice is simply a matter of personal

CHOOSING AND USING THE PAPER

Your first decision about composition is choosing your paper and how to use it. Here are a few of the many options you have.

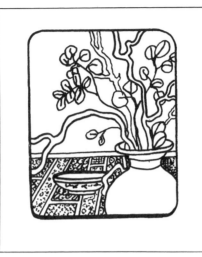

FIGURE 4.1
Containing the drawing within a border.

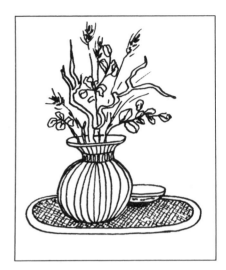

FIGURE 4.2
Planning the drawing within the openness of the paper.

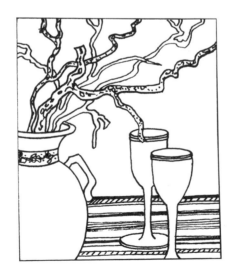

FIGURE 4.3
Expanding the drawing to the edges of the paper.

FIGURE 4.4
Combining borders with open spaces.

preference. When you start, you may decide that you want another weight or color of paper. A decision about the size is all you need at this stage of planning.

Place the paper in front of you, so that you can use it to visualize different compositions in your mind. Seeing different plans on the blank paper is a common practice among artists, as it allows them to control proportion and placement of their ideas. You can learn to imagine things on your blank paper and visualize different choices to fit the space allowed. Pretending to draw the different possibilities with your finger is a great way to begin training your eyes to see images on the paper. There is one exception to this: if you are going to use borders, it is best to draw them in before trying to imagine your composition on the blank paper.

Decide whether you want to use a border, an open format, or a combination of the two. If you are going to use a border, draw that now.

Choosing the Drawing Style

The variety of drawing styles were covered in Chapter 1. You can refer to that chapter to refresh your memory about the various possibilities: abstract styles, symbolic styles, two-dimensional flat or design styles, realistic gesture styles, realistic contour line styles, realistic volume and shaded styles, or an integration or combination of styles.

Think about all the drawing styles and imagine your subject drawn in those different ways. Try to picture your subject in loose styles, flat design-type styles, or realistic ones. Remember that there is no right or wrong and that you can mix the styles together. If you are not sure what style you might want, do some practice sketches on scratch paper to explore different ideas. Decide what style or combination of styles you are going to use for your drawing.

Visualizing the Placement of Subjects and Background

This section will be divided into three stages. First you will deal with the main subject; then you will decide whether you want to add any secondary subjects; and finally you will decide the overall placement in terms of the foreground, the midground, and the background.

I. PLACEMENT OF THE MAIN SUBJECT (OR CENTER OF INTEREST). When you decide where you are going to put your main subject, you are establishing the center of interest. Beginners and young children usually put it in the middle of the paper, without much thought. Sometimes the main subject seems to be floating in the middle of the paper, with the empty paper surrounding it. I encourage you to consider some other options. Here are three formulas that will give you some additional ideas.

Offset from the center. In Figure 4.5 you will see a drawing of a shell. Notice how the size of the paper was divided in four sections (with dotted lines) to establish the center. The center of interest (the shell) was placed about halfway between the corner of the paper and the center. A spot the same distance from any of the other three corners would create the same kind of center of interest. This method is similar to the technique of finding the golden section (or golden mean), which is a well-known method painters use in dividing up the canvas. Locating the golden section encourages harmonious proportions, but it necessitates the use of rulers and mathematical calculations. When I try to teach this method, people get confused and resist the complexity. You can use this system of offsetting the center of interest from the corner of the paper by simple observation.

¼-to-¾ ratio. Another way to find a spot of interest is seen in Figure 4.6: you simply divide the longer direction of the paper in half and then by half again, and choose one of the quarter division lines to place the center of interest. You don't need a ruler: eyeballing is accurate enough.

⅓-to-⅔ ratio. Using the same technique, you divide the paper into thirds and choose one of the lines for the center of interest. Since there is no reason to be exact, you can get used to the idea by simply eyeballing the distance or using your fingers to measure.

Look back and forth between the main subject you chose and your paper. Use your finger and try finding the placement spots that you just learned. Try any other placements that you think you might like. Pretend you are drawing the object with your finger. Decide where you are going to place your main subject, and notice that this will be your center of interest. You can accentuate this subject as your center of interest even more later, when you decide details such as texture, contrast, and color.

2. PLACEMENT OF OTHER CENTERS OF INTEREST. *Continue looking back and forth from your subject to your paper, and imagine what kind of environment or background you want to use.* Keep in mind the style you have chosen as you do your imagining and make your decisions fit the plan.

You may need to consider the availability of your reference materials. Here are some examples of the kinds of considerations that influence the placement of secondary centers of interest:

1. Do you want your main subject in a realistic setting, or do you want a background filled with abstract design or textures? If you decide to draw the subject in one style, do you want to keep that motif through the whole picture or integrate other styles?

2. If it is an animal, do you want your subject in the jungle, in a complex design of black squares, in a desert scene, or sitting on a box in a circus ring? What birds or animals or foliage do you want in your picture with it?

3. If your subject is a still-life object, do you want to draw it alone on a woven mat, to add other articles, or to break it up into pieces and abstract it a little?

4. If your subject is a bird of paradise flower, do you want to put it in a vase with other flowers and leaves, draw it on a piece of colored paper from several different angles, or lay it across a favorite sun hat you also want to draw?

5. If your subject is a classic vintage car, do you want to draw it in front of a Victorian house, put it on a pedestal in a showroom, or put it on a country road?

PLACEMENT OF YOUR MAIN SUBJECT
Where the main subject is placed in a composition will directly affect the drawing's center of interest. These three formulas will help you make your choice.

FIGURE 4.5
Offset from center.

FIGURE 4.6
Using the 1/4 to 3/4 ratio.

FIGURE 4.7
Using the 1/3 to 2/3 ratio.

FIGURE 4.8
Using the 1/3 to 2/3 ratio. As the secondary center of interest, the pine needles appear in a different 1/3 section than the main subject.

FIGURE 4.9
Using the 1/4 to 3/4 ratio. The receding appearance of the poinsettias at another 1/4 point make them a secondary interest.

FIGURE 4.10
Offset from center. The appearance of the secondary center of interest in the opposite offset section gives balance to the composition.

PLACEMENT OF OTHER SUBJECTS
You can use the same composition formulas to decide on placement of secondary subjects of interest.

In Figure 4.8 you see an example of how to place more than one center of interest on a ⅓-to-⅔ ratio. The candle flames on one of the ⅓ lines become the main center of interest, and the two plants to the sides of the candles are within the opposite ⅓ section of the drawing.

Figure 4.9 provides an example of how to place an additional center of interest on a ¼-to-¾ ratio. The large size of the candle and the radiating light create the main center of interest, while the small and receding appearance of the poinsettia flower makes it a secondary center of interest.

In Figure 4.10 you see an example of how to place another center of interest on an offset from the center format. The large and bold poinsettia flowers become the main center of interest, while the small and receding appearance of the candles make it a secondary center of interest. The flames are placed on the opposite offset from the center cross point to balance the proportions of the composition.

Make a decision about the kind of background or surrounding objects you want. Use your finger again to pretend you are drawing, and try different placements of these added ideas. If you need other objects or background reference materials, collect them before you proceed with planning your drawing.

For example, if you have decided to make a still-life arrangement around your subject, collect the other objects and set up the arrangement. If you have decided to put an animal in a jungle, gather up some live tropical plants or get pictures and photos of jungle foliage. Collect materials on other jungle animals, birds, or creatures to add to your drawing.

3. UNDERSTANDING FOREGROUND, MIDGROUND, AND BACK-GROUND. One of the most helpful things in planning a composition is understanding the relationship between these three planes of the drawing. This will encourage you to make a drawing with depth as well as create interest in your work. Children under eight (or older frightened beginners) have a hard time understanding depth perception. They quite often place all the objects in the drawing side by side, in order to avoid the issue of overlapping and receding objects.

In Figure 4.11 the three overlapping planes create a tropical scene. When the example is a landscape scene, it is easy to understand what is meant by foreground, midground, and background. The part that confuses

UNDERSTANDING FOREGROUND, MIDGROUND, AND BACKGROUND
Mastering the relationship of these three planes will create dimension and depth in your compositions.

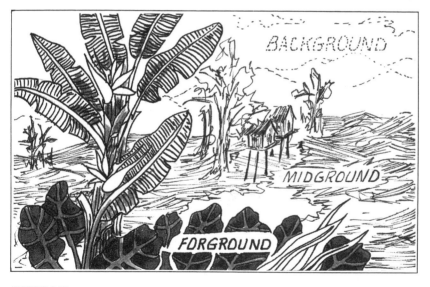

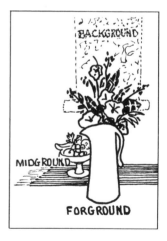

FIGURE 4.11
One way to control overlapping planes in a scene is to draw what is in front first, then lay in each receding section.

FIGURE 4.12
The same principles used to create depth in nature scenes can be applied to still life or design composition.

students is how to draw them. If you *draw what is in front first,* you simplify the problem. Then you can begin laying in each receding section of the scene and put the background in last.

In Figure 4.12 you see a still life divided into foreground, midground, and background. The process of drawing the overlapping objects is done in the same manner as the landscape. *Draw what is in front first,* then set the next layer up higher on the paper. When something is being overlapped, such as the cloth under the bowl of fruit, stop the line when you come to the item that overlaps it (here, the bowl of fruit), jump over, and keep going. This produces the effect of looking behind and farther back into the midground. As things get farther away, they become less pronounced and the edges get fuzzier. To produce the effect of depth you can dull the background colors or darken the shades.

Creating Different Effects

One of the major considerations in planning a composition is how you choose to use the relationships between such factors as size, shape, and color. Since there is no right way to do anything in drawing, there are no firm rules to achieve different effects. Breaking rules is one of the artist's favorite pastimes. The minute you say that a certain thing won't work, some artist will come along and do it. However, there are a few things that can lead to creating different kinds of results. Here are some things to think about before deciding your overall composition.

VARIETY VERSUS SAMENESS. The amount of variety of sameness can be used to create very different effects. In Figure 4.13 you see an example of balancing variety and sameness. The still life is composed of mostly curves and circles with the angularity of the box providing some variety. The objects are a variety of sizes, but they are all the same kind of objects that you would find in a typical still life. In Figure 4.14 the wooden boxes are almost all the same, but the variety in their positions and their different textures create interest. There is also variety in the sizes of the empty spaces, which gives the composition even more interest.

REPETITION VERSUS SINGULARITY. Repetition helps pull a composition together and create harmony, while singularity causes contrast and a center of interest. If you can find a variety of ways to repeat your ideas and then make your main ideas emerge with interest, you can keep the eye trav-

FIGURE 4.13
Balance between variety and sameness is achieved through planning your choices of subject matter, shape, size, color, and texture.

FIGURE 4.14
Repetition can work effectively if the placement of objects is unique and exciting.

eling back and forth between the two. For example, in Figure 4.15 there is a single bird, but the shape of its beak is repeated in the leaves of the tree and plant, the shape of its eye is repeated in the coconuts, the texture of the plant is repeated in the texture of the bird's wing, and the whole tree is repeated in a smaller size.

In Figure 4.16 the idea of scissors is repeated three times, but in very different sizes. You see almost all of one pair of scissors, just the handle of a second, and half the handle of the third. The circular screw is repeated on only two of the three pairs for more interest. The holes in the handles make an oval shape of the empty spaces, where the background texture is repeated several times.

In Figure 4.17, six of the items in the drawing are nicely curved bells and the seventh item is an angular piece of paper. Even though the bell image is repeated over and over, no two bells are alike.

HARMONY AND BALANCE VERSUS INCONGRUITY AND DISORDER.
When you use a lot of repetition you can usually achieve harmony and balance. However, don't judge incongruity or disorder to be negative factors. The point is that you have the control to create any of these effects you wish. If you want chaos or incongruity, create a lot of random variety. If you want harmony, repeat shapes, textures, size, or color in an organized plan.

EXAMPLES OF REPETITION
To achieve interest in your drawings, you can use a variety of ways to repeat your ideas.

FIGURE 4.15
Repeating shape, color, or texture.

FIGURE 4.16
Repeating the same ideas in different sizes.

FIGURE 4.17
Repeating different versions of the same idea.

FIGURE 4.18
You can achieve harmony and balance through organized repetition of shape, size, color, or texture.

FIGURE 4.19
You can achieve incongruity and disorder through the disorganized placement of ideas and shapes.

In Figure 4.18 the repetition of the light fixtures and the fan blades cause a great deal of harmony, while the cord strings are something different and create interest.

The incongruity of the objects themselves are not the only incongruities going on in Figure 4.19. The precision with which the clock face is drawn is totally incongruous to the random scribbling in other parts of the drawing, the empty spaces are a mishmash of shapes that are a bit unsettling, and we may not be sure how the objects relate to one another.

Figures 4.20 and 4.21 are another example of this principle. The two drawings of the eyeglasses use all the same shapes and lines, but with very different effects. Figure 4.20 presents an organized placement of the pieces of glasses, with a repetition of the contour shapes. The slanted lines in the background form a pattern that repeats over and over and pulls the negative spaces into balance with one another. In contrast, the pieces of the glasses in Figure 4.21 cause a very disorderly pattern. They randomly float around in space and don't give enough repetition of shape for us to be able to recognize them as glasses. The incongruity of the pieces leaves a bit of a disorderly feeling.

In light of all this new information, recheck the plan you were making for your project and see whether you want to make any changes. Review the ways to create different effects in your drawing and make some preliminary decisions about what you plan to do. You may want to jot down some more notes before you go on to the last few considerations.

BLACK AND WHITE VERSUS COLOR. Now is a good time to decide whether you want your drawing in black and white or color, because this is also one of the factors that will determine its overall design and composition. This decision will also help you choose the media you are going to use when you get to Step 3. Quite often, people think that their drawing will be more beautiful in color and eliminate the dramatic effects that can be created by using black and white. Here are some variations on the theme of black and white that you can consider before making your choice:

- strictly black and white
- black, white, and a range of grays
- mostly black and white, with a touch of color

Make a decision now about whether you want black and white or color. Even if you choose to do this particular project in black and white, read the

following information about color schemes. It will include some further information about black and white and also familiarize you with how to use black, white, and color as components in planning your composition.

HOT VERSUS COLD COLOR SCHEMES. Many years ago I used to give elaborate lessons about the use of color. Then someone asked me whether I thought this was necessary and even challenged me to see what would happen if I didn't. For an entire year, I didn't say a thing about color. I was amazed to find out that children and teenagers never asked for advice, but came up with beautifully balanced and wonderful color schemes. However, some beginner adults asked for help, so I designed some simple ratios to get them started. These ratios are too simplistic if you decide to go on to painting, for which you need to learn the color wheel and the theories of mixing paint. But with drawing tools there is less ability to mix colors, and these simple ratios are quite adequate to lead you toward selecting color schemes that work.

My goal is not to teach you the complexities of color, but rather to give you an understanding of hot and cold colors and how to use them for different results. You will learn how to use ratios of hot and cold to create a center of interest, how to combine hot and cold for dramatic effects, and how to achieve balance, harmony, or even chaos. Starting by defining every color in the rainbow spectrum as either hot or cold, you will then determine how to add black, white, gray, and brown into the hot-and-cold system, since you will want to include it in your compositional plan.

Hot colors. Think of the colors you see a sunset make in the sky: *red, orange, yellow, pink,* and *reddish purple.* Envisioning the hot sun and the colors the sunset makes reminds you of the hot colors.

Cold colors. Think of the colors you see in an arctic scene, with nothing in it but ice, snow, sky, and the deep waters of the sea: *white, green, blue,* and *bluish purple.* Envisioning such a scene will remind you of the cold colors.

Black, white, and combined colors. *Black* and *white* are not usually referred to as colors, but since we want to use them, we will include them in this simple list. Remembering whether they are hot or cold can be tricky, but this image should help: Imagine that you are on a hike in the desert and you have chosen to wear a black shirt and pants. As the sun beats down on your black clothing, you will be very hot. Imagine magically changing into white clothing, and the coolness will immediately be noticeable. So black is hot and white is cold.

FIGURE 4.20
The organized repetition of the eyeglasses and background lines create harmony in this example.

FIGURE 4.21
In this drawing, the random placement of the pieces of eyeglasses and the background lines create disorder.

FIGURE 4.22
*The direction of the branch and
the bird's beak quickly leads us
out of the drawing.*

Gray is simply a combination of black and white. So *blackish gray* is *hot* and *whitish gray* is *cold,* the degree of heat or coldness depending on the amounts of black or white used in the mixture.

Brown is particularly tricky: it is a formed by combining the opposite colors on the color wheel, which means different shades of brown are made by combining different opposite colors. But since browns end up appearing rather warm, brown will be designated as *warm* for this simplified list.

THE SIMPLIFIED RANGE OF COLORS AS HOT OR COLD. These follow the same order as the rainbow, with black, white, gray, and brown added.

Red = Hot	Reddish Purple = Hot
Orange = Hot	Black = Hot
Yellow = Hot	White = Cold
Green = Cold	Blackish Gray = Hot
Blue = Cold	Whitish Gray = Cold
Bluish Purple = Cold	Brown = Warm

This list is easy to memorize when you remember the sunset, arctic, and desert scenes. Once it has been memorized, you can use the formulas and ratios that you learned in Step 2 and apply them to the composition of your color scheme. For example, you might consider the following:

■ If I use *all* hot or *all* cool colors, will I have enough contrast or center of interest?

■ If I use *all* the hot and cold colors equally, in bright shades, will I be satisfied with a psychedelic effect?

■ If I use *half* hot bright colors and *half* cold bright colors, do I want the tension that might develop between the two?

■ If I use *mostly* hot colors, with a *few* cool ones, where do I want to use the cool ones? What do I want to emphasize with those cool colors, since they will stand out?

■ If I want a hot or warm color scheme, what will happen if I leave more white paper than space I use for colors? (Remember, white is cold, and will therefore counterbalance the warm colors.)

FIGURE 4.23
*Because the vase falls out of the
bottom of the drawing, our
attention goes with it.*

You don't need to select every color in detail now; just decide whether you want a warm or cool color scheme, where you are going to emphasize opposites, and what you are going to do with the empty spaces. For instance, do you want a black-and-white and shaded gray drawing, a line drawing in mostly hot bright colors, a very warm color combination with the main subject in a subdued cool color, or a drawing using nothing but warm brown tones? Decide on the general color scheme that you are going to use, knowing that you can make lots of detail changes along the way.

Visualizing the Mood and Movement

When people say that a drawing is technically accurate but isn't alive (it doesn't have to be a drawing of a live being for that statement to apply), they mean there is no movement or feeling in the drawing. Two things that cause a lot of movement in your drawing are mood and direction. Your goal is to lead the eye through the drawing in such a way that it keeps coming back into the picture and enjoying it even more each time. For example, in Figure 4.22 the direction of the bird and the plant both take the eye to the edges of the paper. Since there are no other repetitive elements in the drawing to bring you back in, you may leave the drawing. In Figure 4.23 the vase looks as though it is falling through the bottom of the paper, and your eye goes off the page with it. If the flowers were tall and more developed, they would bring the eye back in, but their small and unfinished appearance is not strong enough to catch the interest. Furthermore, the background line is so uneventful that it just pulls you out again.

In Figure 4.24, the direction of the birds keeps the eye bouncing back and forth between them. The plants keep bringing you back into the picture as well. The repetition of the berries keeps your eye popping all around and then going back to the bird on the left, as you see a berry in its beak.

The line of the unfinished mat in Figure 4.25 keeps bringing you back into the picture to enjoy the vase of flowers again. The flower on the left that hangs down toward the bowl of fruit also leads you to observe it over again. The angle line in the background is almost like an arrow directing you to observe the vase again. The leaf shapes on the vase are repeated in the flowers, provoking you to look at them again as well.

Make a final check of your composition plan for your project. Think about the aforementioned ideas as you consider the movement of the ele-

FIGURE 4.24
The direction of the birds' beaks and branches keeps our eyes traveling back and forth through the drawing.

FIGURE 4.25
The movement of the lines in the background keeps directing our eyes to re-examine and enjoy the objects in the drawing.

ments in a picture and how they can create a dynamic mood. Make any further changes in your plan that you wish.

STEP 3: PREPARE FOR EXPLORATION

Now that you have everything you need gathered for the project and have made your general decisions about the composition, you are ready to decide what media you are going to use and to begin setting up your space.

Choosing the Materials to Use

As you gain more and more drawing experience, you will have a better sense of the types of media that lend themselves to different styles and subject matter. For now, don't labor over the decision. Recall the various media you used in the projects completed in Chapter 1, and consider how each kind could be used for this project. Here are some general hints on deciding what media might work for different styles of drawing.

Imagine how different choices of media would look with your plan and decide what kinds to use.

Suggested Media for Different Styles of Drawing

1. Loose Styles: charcoal, pastels, Conté crayons

2. Flat Design Styles: markers, ink, colored pencils

3. Contour or Line Drawings: fine-tip and razor-point markers, ink, pencils

4. Shaded Realism: pencils, pastels, Conté crayons, oil pastels

5. Integration of Different Styles: combinations of different media

Gathering and Setting Up the Supplies

You need a quiet time to concentrate as you begin the drawing. Getting up and down to get additional supplies can disrupt your ability to focus and be creative. Bring all the equipment you will need to the drawing space.

Checklist of Things to Remember for Setting Up

1. Scratch paper for planning.

2. If you are using ink, a mat to keep it from leaking through.

3. A couple of pieces of the kind of paper you have decided on.

4. The media supplies you chose.

5. Possible additional items, such as pencil sharpeners, erasers, blending tools, paper towels, water, rulers, or templates.

STEP 4: UTILIZE ROUGH DRAFTS

A rough draft sketch helps you test your imagined ideas in a more tangible way. It helps you gather your thoughts and establish your composition. You may hesitate to discard your first attempt for a plan that you will like better if you immediately start on the final drawing paper.

As you achieve more experience and confidence, you will not always need rough draft sketches, although I suggest you do them every time for now. You will be able to judge the times you need them once you have experienced how they help you.

Sketch a General Plan

Take a piece of scratch paper and make a very loose sketch of the composition you have planned. It doesn't need to be the same size as your plan for the finished drawing; however, if you are still insecure about proportion and scale, it will help you transfer your ideas to the finished drawing if the sketch is the same size. Don't fill in any detail yet. For example, if you were making a sketch of a bird, you would draw its general shape but not the detail of its feathers and markings. *Make any further last-minute changes to your plan.*

Allow Changes in the Plan as You Draw

Now you can do the final drawing and complete the project. Enjoy yourself, and let further changes in your plan occur as you go along. For instance, if

you finish drawing the main subject and decide you want to change your background plan, go ahead with the new idea. I rarely follow the original plan all the way through—it is simply the beginning steps to an adventure.

Remember that this project was to get you into the habit of the project-planning sequence, not to achieve a fantastic drawing. It is more important to quickly repeat the process a couple of times while it is fresh in your memory and not care about the results of the drawing.

Do at least two more projects following this process before you go on to the next chapter. You don't need to select new subject matter; artists often study the same subject in many different ways. Repeating a project with different media and compositional plans can enhance exploration and growth. I suggest that you try different media and drawing styles even if you choose a different subject. Watch for any resistance in repeating the project-planning sequence, or you might miss the best opportunity you have to master the confidence of planning projects.

5

COOKIN' WITH THE FUN STUFF

Have you ever been so involved in an activity that you completely lost track of time? People often have this happen when they draw. At the end of a class, some student inevitably says he or she can't believe two hours have gone by and is disappointed it is time to leave. Such students' enjoyment is so contagious I sometimes find myself staying overtime with them.

When people experience this amount of enjoyment, they are willing to spend many hours doing tedious work. They are also willing to go through the discomfort of overcoming the blocks and fears they may feel about the parts of the process they think of as the "hard stuff," which usually means perspective, proportion, and shading. These three words often have a bad reputation, but they are not as difficult to learn as you might think. They are simply techniques that allow you to create certain effects that most people want to be able to do. When they are mastered, these effects depict realism and are considered the "fun stuff."

Notice I used the words *be able to.* It has been my experience that everybody wants to be able to draw realistically; even professional artists who make their living in fields other than drawing get a longing look in their eyes when they admit they don't know how to draw realistically. Since there seems to be such a strong desire to conquer these techniques, I am going to assume that you, too, would like to be able to. If you are patient with yourself and accept that you can learn to draw realistically, you will learn much quicker than you might imagine.

This chapter will introduce you to the techniques that deal with proportion, positive and negative space, scale, perspective, and shading. It will also help you express your feelings and make adjustments and changes, and it will guide you in how to add contrast and fine detail.

117

EXPRESSING FEELING: FROM YOUR OWN TO THE MOOD OF YOUR DRAWING

You will explore two different ways to focusing on feeling in your drawings: first, expressing your own feelings, and then creating a mood or feeling for the subjects in your drawings.

Expressing Your Own Feelings

The biggest challenge in expressing your feelings is finding out what they are. We live in a time when people are increasingly interested in ways to become aware of their feelings; they are often involved in a courageous search to understand their emotions, desires, and needs.

Although the aim of this book is not to philosophize about these deep issues, they will certainly come up for you as I ask you to tap into your feelings. If you are interested in exploring your deepest feelings through art, I recommend *The Creative Journal for Children, The Creative Journal—A Handbook for Teens,* or *The Picture of Health* (for adults), all of which are by Lucia Capacchione. These books will help you get in touch with your inner feelings and help you know what it is you want to say through your drawings.

Expressing feeling in your drawings not only makes the experience richer for you but also makes the drawings more interesting to the observer. Whatever message or feelings you want to communicate can be expressed through your drawings. When this happens, you experience a kind of intimate relationship with your artwork; it expresses your deepest emotions and feelings. That is why artists become so impassioned with their work. This intimacy is what makes the hours slip by as you become enmeshed in the piece you are working on, and it is what makes the investment of time worth it.

Whenever you have something to say visually, instead of with words, you take on a particular kind of challenge. Your first goal is to be very clear about what you want to say and how you can simplify it into a visual image. Then you work out the way you are going to communicate this through your compositional plan. The same main subject drawn two different ways will convey two completely different messages by the way you arrange the composition and the feelings you put into the subject. For example, you could draw the old town hall with unhappy residents watching a wrecking crew tear it down, or you could draw the old town hall with cheering and celebra-

tion as a construction crew began to remodel it. The following project will stimulate you to express your feelings.

SELF-EXPRESSION PROJECT

Take some time to choose an issue important to you. It might be the joy of surfing, the closeness of sitting with your arm around a friend's shoulder, or the delight in planting a tree. On the other hand, you might want to communicate some disturbing feelings, such as your concern over water pollution or about how hard it is to be alone in old age.

As you consider the various issues you might choose, begin to think of the visual images that you will need to portray your message. Discard ideas that you feel are too vague to draw or that become too complex. Keep narrowing your subject down until you come up with one you feel comfortable drawing.

Plan what media you want to use and the supplies you will need, using the methods you learned in Chapter 4. Gather whatever you will need to do your project. Give yourself up to 2 hours' drawing time, depending on the complexity of what you have decided to draw.

SUPPLIES

Dependent on the subject and style you have chosen

INSTRUCTIONS

As you sit down with the blank paper, try to feel your emotions about the issue you chose. For example, close your eyes and feel what it is like to surf a big wave, experience your frustration or anger as you are confronted with polluted water, or feel the warmth in your heart as you hug a friend. Imagine the kinds of colors and types of lines that depict those feelings for you. Make some sketches to test your ideas, using the samples you gathered for inspiration.

Try to maintain your feelings as you work. They will be transmitted to the drawing and give it a different life than it would have if you drew in an emotionless state.

CREATING A MOOD
Christopher used ideas from
several sources and made
sketches before the final draw-
ing, in order to plan how he
would convey the mood of his
drawing.

Creating a Mood or Feelings for the Subjects in Your Drawings

Your goal is not to convey your personal emotions this time, but simply to give a certain mood to your drawing. For example, in Figure 5.1 the drawing has captured the dejected mood of a boy as he witnesses the aftermath of a forest fire. Figures 5.2 and 5.3 show two different interpretations of an antique car. In Figure 5.2 the artist gave his car a whimsical feeling, as it seems to be broken down at the roadside, whereas in Figure 5.3 the car has a perky look of newness as it sits quietly to be admired.

CREATING A MOOD PROJECT

Choose a subject that interests you and think about the kind of mood you want to create. For example, if you chose a bald eagle, do you want to have it sitting peacefully in a nest, or do you want it flying menacingly in the sky? Look through the samples of things you have been collecting for future projects or find a new subject you want to draw. Decide on the medium you will use and set up the project. You will need around 1 hour and 30 minutes for the project.

SUPPLIES

Dependent on the style and medium you have chosen

INSTRUCTIONS

Try to experience the feelings or mood that you want to create in your drawing. Think about the arrangement of the composition and the kinds of colors and lines that will help create that mood. For instance, if you want a peaceful eagle in the nest, you might have the eagle and nest in the foreground, with a simple light-blue sky and billowy clouds; whereas if you want it menacingly flying in the sky, you might want a dark purplish mountain range in the lower portion of the picture, with the eagle in a dark and rainy sky and lightning bolts streaking through the background.

Do some rough sketches to develop the idea you chose before doing the project.

FIGURE 5.2
Michael Overman — age 11
Broken down antique car.

FIGURE 5.3
George Nelson — age 73
Perky new antique car.

TWO DIFFERENT
INTERPRETATIONS OF
THE SAME SUBJECT
You can convey different feel-
ings, moods, and messages
through your decisions about
how to portray the objects in the
composition, the style of draw-
ing, and the media you choose.

REPRESENTING FORM: PROPORTION, POSITIVE AND NEGATIVE SPACE, AND SCALE

You have been drawing forms since the first project in the book. I suggested that you not worry about proportion and scale until those areas were addressed in more depth. Now that I am going to do so, remember that you are simply taking in new ideas that needn't be difficult. You have had a lot of drawing experience by now and if you allow yourself time to explore, without judgment, you will be successful. You can actually have a lot of fun with this section if you relax and approach the projects as enjoyable games.

Accomplishing Proportion

When you draw an arrangement of flowers or represent objects in abstract forms, you usually don't need to be critical about proportion. However, when you try to draw a realistic version of a human being, a car, an animal, or a group of buildings, proportion is usually more critical to your satisfaction with the drawing.

By proportion, I simply mean a *proper relationship between the parts.* For example, people are not usually satisfied with a drawing in which one

leg of a person is bigger than the other, the neck of a swan is too fat for the size of the body, the front of the car is too long compared to the back, or a building that appears to be a skyscraper is only a little taller than a two-story house.

There are two skills that will help you achieve accurate proportion: *understanding positive and negative space, and noticing the scale of how things relate to one another.* Both of these skills are easy to understand, but they take some practice. You may flounder a little at first, but soon drawing in proportion becomes a natural ability. It doesn't take very long to get to the point where you don't think about it anymore and use your skills confidently.

One of the most important techniques in achieving proportion and scale is to use the principles of positive and negative space.

Understanding Positive and Negative Space

If you have trouble understanding positive and negative space, it may be because of the words that were invented to explain them. I find that if I address the confusion over the terms, people easily understand the concepts and go right on to learn how to use them. I could change the terms, but as they are commonly used in art instruction, it is better to understand what is meant by them and dispel the myth that they are difficult ideas to handle. Here are simple definitions for each:

POSITIVE SPACE: The objects or marks you draw on the paper.

NEGATIVE SPACE: The empty spaces between the objects or marks you draw on the paper.

POSITIVE SPACE. Most people are confused by the term's implication that an object, or the drawn marks representing the object, can be referred to as space. We think of space as empty and therefore negative; thus we react to the term *positive space* as illogical.

One way I have found to help people remember what the term means is to think of the definition in this way: the word *posit* means *to place.* So when you place (or posit) marks in a space on the paper (to represent an object), you are drawing the positive space.

NEGATIVE SPACE. This term is even more confusing in some ways. We are able to think of *space* as *negative* because we think it is *nothingness.* We can even make the transition to think of *negative space* as *empty space.* The confusion comes in, however, when we are told that we have to pay attention to the negative space when we are drawing. The idea of paying attention to nothingness is very foreign to most people. But when you draw, if you pay as much attention to the shapes and sizes of the empty spaces as you do the shapes and sizes of the objects you draw, you will master the best method available to capture proportion and scale.

When you don't pay attention to the negative space, you can draw the pieces of an object with accurate lines and still have a picture out of proportion. For example, look at the picture of the person in Figure 5.4 and notice the shapes of the negative spaces made between the arms and the torso. Even if you drew very nice arms, like the ones in Figure 5.5, you still might not see why they were so out of of proportion; whereas if you paid as much attention to the shape of the negative space, as in Figure 5.6, you would end up with arms that were in proportion.

None of this will really make sense until you experience it.

ACCOMPLISHING PROPORTION
Proportion is the proper relationship between parts. One of the most important techniques to achieve accurate proportions is to use positive and negative space. Positive space refers to the lines you draw to represent the objects and shapes you see. Negative space refers to the empty spaces between the objects and shapes.

By paying as much attention to the shape of the empty spaces as you do to the objects you draw, you can help yourself capture proportion.

FIGURE 5.4
Photograph of a model.

FIGURE 5.5
Notice the different sizes and shapes of the negative space between the two arms and the body in this drawing. The proportion of the left and right arms appears inaccurate.

FIGURE 5.6
In contrast, notice how the spaces between the arms and the body are the same as the ones in the photograph. Now the relative size and proportion of the arms to the body appears normal.

FIGURE 5.7
FINISHED SAMPLE
The black A to the left is the posi-
tive space. If you draw the
shapes of the negative spaces
and blacken them in, you will
end up with a white A like the one
on the right.

FIGURE 5.8
THE JK
Draw the negative spaces that
you see around and between the
JK, blacken them in, and watch
a white JK appear.

POSITIVE AND NEGATIVE SPACE PROJECTS

Figures 5.7 to 5.10 were designed to give you some experience in paying equal attention to positive and negative space as you draw. As you do these exercises, you will find that even if you draw only the negative spaces, the

FIGURE 5.9
THE CORKSCREW

FIGURE 5.10
THE VICTORIAN PORCH CORNER

desired positive object will appear, like magic. This is because the edges of the negative spaces are exactly the same edges as that of the drawn objects. Once you experience this, you will understand the concept. You will need approximately 45 minutes for the exercises above, and 1 hour for the negative-space drawing in instruction #5 on page 127.

FIGURE 5.11
*Example of looking through a
viewfinder to isolate one part of
a scene.*

FIGURE 5.12
*Example of construction of a
view finder.*

SUPPLIES

Photocopies of Figures 5.7 to 5.10 (or blank paper placed next to the book, with blank squares the same size as those in the exercise).

A pencil and eraser

One fine-tipped and one broad-tipped black marking pen

Two or three pieces of 9 × 12″ drawing paper

A piece of 9 × 12″ lightweight cardboard or file-folder manila paper (heavy drawing paper will do, if you don't have any cardboard) to make a view finder

A ruler, a razor blade, and scissors

INSTRUCTIONS

1. Finished sample. Study the sample of the letter A in Figure 5.7. Notice that the black A, on the left, is the posited (or drawn image. In the box to the right the A has become the white negative space. This was achieved by drawing the negative spaces around the A and filling them in with black.

2. The JK. In the empty box to the right of the JK in Figure 5.8, draw the negative spaces that you see between the letters and the edges of the box. Use the pencil first if you wish. If you fill in the spaces with black ink, you will have a white JK appear.

3. The corkscrew. In the empty box to the right of the corkscrew in Figure 5.9, draw the negative spaces that you see between the corkscrew's parts. If you fill them in with black ink, a white corkscrew will appear. Don't worry about perfection; achieving the same kind of corkscrew is all that is important.

4. The victorian porch corner. In the empty box to the right of the Victorian porch, in Figure 5.10, draw the negative spaces that you see between the latticework and railings. Exact duplication is not necessary, but be as

accurate as you can. You may want to use a light pencil line first, then color in the spaces with black ink. Though it is not necessary, you can use a ruler for the slats.

5. Negative space drawing from a three-dimensional object. You are going to look at your subject through a view finder, like the one you see in Figure 5.11. This technique has been used in drawing classes for years. It helps you isolate the object you are going to draw by looking at it through the hole.

You can make the view finder out of lightweight cardboard or manila paper (heavy drawing paper will do if you don't have cardboard, but it will be a little harder to hold upright). It is important that the hole in the viewer be the same relative size as the paper you are going to draw on.

To make the viewer, take the cardboard and draw lines from corner to corner, with a ruler, as in the example in Figure 5.12. With your ruler, draw a rectangle of the same proportions as the size of your paper. It should be around 3 to 4 inches over the center crossing lines. (If you had a square piece of paper, for example, the shape of the hole would be a square instead of a rectangle.) Now take your razor blade or scissors, and cut out the rectangle in the middle. Hold the viewer up and look through it, with one eye closed, and check to see whether the hole is of the same shape as the paper.

Now look at several objects through your view finder. Find an object that has negative spaces in its construction, such as a statue of an animal, with spaces between its legs, as with a kitchen stool, a wooden slatted chair, or a stairwell banister.

Either take the object to your drawing space or clip your paper to your drawing board and go to the object. Sit at a distance at which you can see the portion of the object you want to draw through the view finder, with your arm outstretched. Get into as comfortable a position as possible.

Look through your viewer and study the negative spaces around and through the object. Using the full size of your drawing paper, make a duplicate of what you see. Slowly, draw only the contour lines of the negative spaces one at a time. You can leave the drawing a contour-line drawing, or you can fill in the negative spaces with black or with patterns of lines.

Figures 5.13 to 5.17 are examples of student projects.

6. Repeat. Find another object and repeat the process, while it is fresh in your memory. Remember, the more you practice drawing negative space, the more confident you will become at doing it naturally.

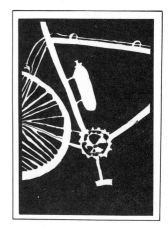

FIGURE 5.13
*Ryan Neuman — age 14
After drawing the negative spaces in a portion of a racing bike, Ryan chose to blacken them in.*

FIGURE 5.14
*Courtney Kleinman — age 12
This negative space drawing of a still life shows how such studies can end up to be lovely, finished pieces.*

FIGURE 5.15
Sarah Finnegan — age 10
By focusing on the spaces
between the wood of the chair,
Sarah blackened in the negative
space.

Noticing Scale

Another way to control proportion is to study the size of one object, or part of an object, in relationship to another. To do this, you can use another old trick. Hold a pencil with your thumb end up against it, with an outstretched arm and one eye closed. When you hold the pencil (or any drawing tool) in this manner, you can use it like a measuring stick. Hold the pencil up and look through one eye at the object, or part of the object, that you want to draw. Use the top of the pencil as one boundary of the measurement and then slide your thumb up and down until the end of your thumbnail marks the place on the pencil as the other end of the measurement. The distance between the top of the pencil and your thumbnail is the measurement. Then hold the pencil against the drawing paper and draw the object, or part of the object, in that measurement. When you use the same measuring technique with other objects in the scene, you will end up with a drawing done in scale.

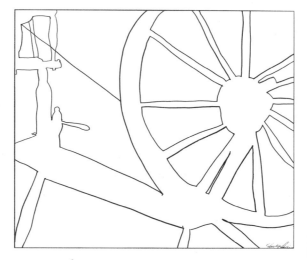

FIGURE 5.16
Stan Harris — adult
Using a view finder, Stan drew
the negative spaces he observed
in the isolated portion of a spin-
ning wheel.

FIGURE 5.17
Sherry Kleinman — adult
Sherry captured the complexity
of the overlapping items in front
of a studio art easel.

In order for the measurements to be consistent with each other, it is important that you *hold your arm at complete arm's length,* with your *elbow locked,* the *same eye closed,* and your *body in the same position.* Figure 5.18 is an example of a student in this posture.

FIGURE 5.18
MEASURING SCALE
Using your drawing tool as a measuring stick, you position your thumb to record the relative size of shapes to each other. This helps you establish proportion and scale.

SCALE PROJECT

You needn't do completed drawings to see how this works. Follow these nine steps with several sketches. Keep in mind that you aren't trying for exactness, but to draw the objects in approximate scale in relationship to one another.

DUPLICATING THE SCALE (OR RELATIVE SIZE) OF ONE OBJECT TO ANOTHER

1. Use any paper and pencil for a quick sketch.

2. Set several objects next to one another.

3. Move back at least 10 feet to draw them.

4. Choose one of the objects to draw first.

5. Hold your pencil at arms length, elbow locked, in front of the object.

6. Close one eye and measure the size of a main part of the object, using your thumbnail to mark the spot on the pencil.

7. Using the pencil like a ruler, place it against the drawing paper to determine the size you will draw it on the paper.

8. Do the same for all the parts of the object to draw the parts in proportion to one another.

9. Now, use the same process to measure the other objects in the scene.

You can practice this technique anytime—all you need is a piece of scratch paper and a pencil. Capturing the relative sizes of buildings, street lamps, telephone poles, structures, or trees to one another is a great way to develop your skill at portraying scale. If you make sketches as often as you can, this too will become a natural ability.

CREATING DIMENSION
By altering the sizes of objects,
overlapping them back into the
picture, and creating contrast
of light and dark, the drawing
takes on a three dimensional
quality and expresses depth.

CREATING DIMENSION: CONTRAST, PERSPECTIVE, AND SHADING

Now that you have learned about representing the proportion and scale of things, you are ready to give them volume, dimension, and depth. The three techniques that will help you accomplish this are (1) *creating contrast,* (2) *using the principles of perspective,* and (3) *adding shading.*

If you are nervous about learning these techniques, do not be intimidated by the words. Again, remember that your attitude is important. If you let your inner critique grab you, it can tie you in knots and make something simple seem overwhelming. These techniques are not any harder than any other skill you have learned. Have fun with them, let yourself practice, and your skill will develop naturally.

Creating Contrast

FIGURE 5.19
Lack of depth and dimension.

You are going to create depth and dimension by *showing the contrast of differences,* such as *large vs. small, bright vs. dull,* and *light vs. dark.* For example, a large bright object will get smaller and duller the farther it is from you. If you were drawing a strawberry patch, the strawberries in the front row would be big red juicy fruit, whereas the ones in the back row would be tiny brown things that may not even be recognizable as strawberries anymore. So you would create depth in the picture by using the contrast of size and brightness.

Study the examples in figures 5.19 and 5.20. The first drawing of the still life looks flat, because the objects do not appear to recede into the distance. The second sample appears to show one object in front of the other, which adds depth to the drawing. Since the objects are round, perspective is not a major factor, and no complex shading was used. The simple use of the contrast of light and dark and large and small create the depth in the picture.

CREATING CONTRAST PROJECT

FIGURE 5.20
Expressing depth and dimension.

As you study Figure 5.20, notice how the objects get smaller and duller, which helps them recede into the background. As your eye reads this progression of light to dark and large to small, the illusion of depth is created in your picture. The farther objects are in the background, the less defined they become. You can create this effect by making the edges of faraway objects fuzzy and vague. Give yourself around 1 hour for the project.

SUPPLIES

A piece of 9 × 12″ drawing paper

An assortment of light to dark drawing pencils (for example, H, 2B, and 6B)

INSTRUCTIONS

1. Find a simple roundish object that is light in color and bring it to your drawing space. Place it on a dark surface, with a dark background behind it.

2. Make a drawing similar to the one in Figure 5.20, in which you draw the object three times. Draw one version of the object in front first. Then overlap the others behind it, by drawing them slightly higher and making each one progressively smaller. Leave the object in front the lightest, and darken each receding one. Make the edges of the farthest one the least crisp. Then add contrast to all three objects by making the surfaces underneath and behind them all darker than the object that they are nearest.

Using the principle of contrast, you have now made a drawing with depth. You will add other factors to these principles as you try more complex drawings. For example, you can add dimension by incorporating objects that have receding lines and lend themselves to perspective. You will create even more realism and volume to your drawings if you also use shading.

Using the Principles of Perspective

Using perspective is simply *using a set of rules that give the illusion of depth and distance.* They were designed to help you draw three-dimensional objects on flat paper. The rules for perspective were invented many years ago and have not changed since.

You can use the rules in a way that involves complex mathematical calculations, rulers, and grids, or you can use them in less exacting ways called "eyeball perspective," "sighting," or "common-sense perspective." I will combine some of the simple calculations with eyeball perspective. This simplified version of the rules will give you satisfactory results without overwhelming you. First, I will define some terms and give you some illustrations of how the basic principles of perspective work.

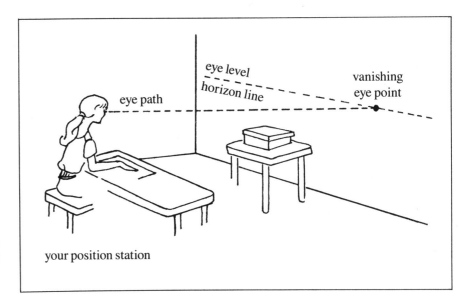

FIGURE 5.21
The spot where your eyes come to rest on the wall or surface behind the objects you are drawing is called the vanishing eye point.

YOUR POSITION (OR STATION POINT). To establish your position, sit in a chair across from the objects drawn, as shown in Figure 5.21, without turning your head to either side. Look straight forward with your eyes at rest; then take note of the spot where your eyes naturally rest, on the wall or surface behind the objects. You can mark the spot with a piece of tape until you are familiar with keeping track of it. Don't move around or shift your weight in the chair, or your sighting won't stay consistent. You need to get comfortable without slouching or tipping your head one way and another.

EYE POINT (OR VANISHING POINT). This is the spot where your eyes come to rest directly in front of you. Looking straight ahead, it is at the end of the *eye path* that follows directly from your eyes. Inside a room it will be on the wall or the farthest object away from you; outdoors it will be on whatever object your eye comes to rest on. In a vacant scene or at the ocean it could be on the horizon line of the land. The eye point is the point at which all receding lines converge when using perspective.

EYE LEVEL (OR HORIZON LINE). Your eye level is an imaginary line that extends to the right and left of your eye point, into infinity. In drawing, it simply is a horizontal line that is parallel to the bottom of your paper and extends from your eye point to the paper's edges.

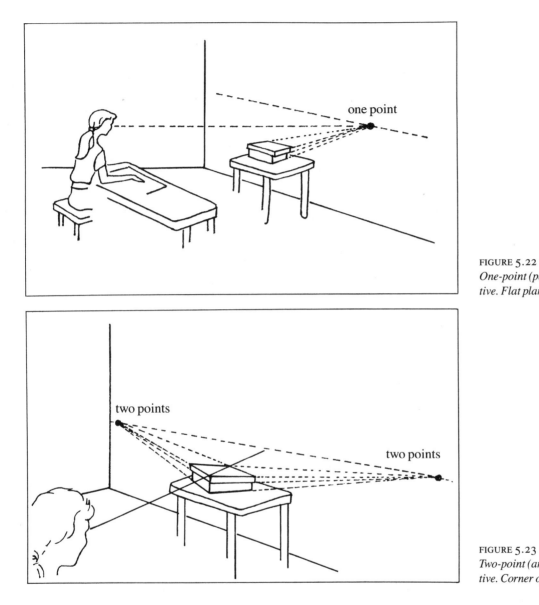

FIGURE 5.22
One-point (parallel) perspective. Flat plane of box faces you.

FIGURE 5.23
Two-point (angular) perspective. Corner of box faces you.

ONE-POINT PERSPECTIVE (OR PARALLEL PERSPECTIVE). In one-point perspective, the flat side of the object that you are going to draw is facing you, as shown in Figure 5.22. You establish the flat side of the object first, then converge all of the receding lines to one *vanishing eye point,* which is directly across from your *station-point position.* If you use light

dotted lines to draw your converging lines, they can be erased at the completion of the drawing.

TWO-POINT PERSPECTIVE (OR ANGULAR PERSPECTIVE). In two-point perspective, the corner of the object that you are going to draw is directly facing you, as shown in Figure 5.23. First you establish the *corner line* and the two *bottom-edge lines* of the object, and then you run the *bottom lines* out of the *eye-level horizon line.* Where each of the two bottom lines meet the *horizon line,* you will establish the *two points.* Then you converge all of the receding lines to these two points.

You will do both one-point and two-point perspective drawings of a basic box in order to understand the principles. Then you will do a couple of exercises for practice: first, you will draw a house by using one-point and two-point perspective; then, you will draw the corner of a room by using eyeball perspective.

BASIC PERSPECTIVE PROJECTS

You will need about 2 hours to do these exercises the first time. It is suggested that you repeat them on a day soon afterward. You will probably need only about 30 to 45 minutes the second time.

SUPPLIES

A fairly large box with a lid

A ruler, pencil, and eraser

Two or three large (at least 18 × 24″) pieces of drawing paper

A drawing board (if a table is not in a convenient location)

The Parallel Box: One-Point Perspective

The easiest thing about one-point perspective is knowing that only the receding lines have to create the illusion of depth. All the lines representing the flat plane facing you (or the front of the box) are drawn just as they are seen. If you make the lines of flat surfaces facing you parallel to the edges of

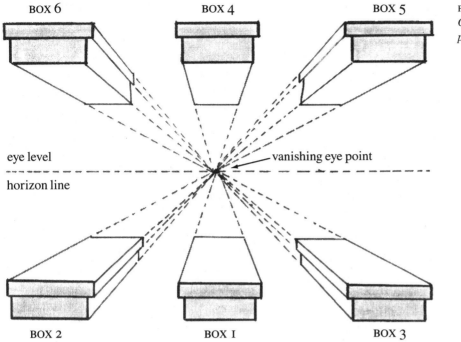

BOX 6 BOX 4 BOX 5

eye level vanishing eye point

horizon line

BOX 2 BOX I BOX 3

FIGURE 5.24
One-point (parallel) boxes project.

the paper, you can control the proportions of an object. Only the receding lines go directly to the vanishing eye point. Study Figure 5.24 and notice how the front side of all the boxes are drawn exactly as they are seen, parallel to the edges of the paper. Then note how all the side lines are drawn at angles that recede to the vanishing eye point. Now you are going to draw the exact same set of boxes, but from observation of the box you have chosen.

INSTRUCTIONS

BOX I

Set the box across from you, on a table that is lower than your eye level. Try to set it in front of a blank wall, with no distractions behind it.

Get comfortable in a chair, at least 10 feet away, with your drawing board on your lap and supplies nearby. Use your ruler as much as you want.

Sit up straight but comfortably, with relaxed eyes. Mark your vanishing eye point on the wall and notice the distance above the box.

BOX I

Step 1

Step 2

Step 3

Step 4

Step 5

Step 6

1. Draw the front side of the box (the flat plane facing you) near the bottom edge of your paper, in the middle. Make the lines parallel to the bottom edge and side edges of the paper. You can use the pencil-and-thumb measurement technique that you learned in measuring scale in order to determine the height and width of the front of the box. Notice how much your lid extends beyond the bottom part of your box and draw that difference.

2. Draw a dotted eye-level horizon line across the full length of your paper, parallel to the bottom edge of your paper.

3. Put a small dot on that horizon line to mark your eye point.

4. Draw a dotted line from the upper right-hand corner of your box to the vanishing eye point on your paper. Draw a dotted line from the upper left-hand corner of your box to the vanishing eye point.

5. Use your pencil and thumb to measure the distance of the back edge of the top of the box from the front edge of the top of the box. Draw a line for the back edge, remembering that it will be parallel to all the other horizontal lines and the bottom edge of the paper.

6. Blacken the lines that form the sides of the top of the lid.

BOX 2
Move your box about 3 feet to the left, but stay in the same station-point position. You will be using the same vanishing eye point for this drawing.

Repeat Step 1 above (drawing the front of Box 2 to the left of Box 1 on your paper).

1. Draw dotted lines from the botton right-hand corner of the box, the bottom right-hand corner of the lid, the upper right-hand corner of the lid, and the upper left-hand corner of the lid to your vanishing eye point.

2. Use your scale measurement technique to determine the length of the lid, and draw the line for the back edge of the lid. Remember that it will be parallel to all the horizontal lines and the bottom edge of the paper.

3. Blacken the vertical lines for the back side ends of the lid and the box. Remember that they will be parallel to all the vertical lines and the vertical sides of the paper. Blacken the receding lines that are the sides of the box and the lid.

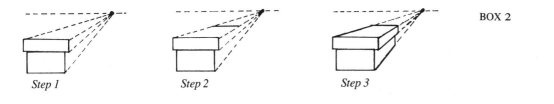

Step 1 *Step 2* *Step 3*

BOX 2

BOX 3

Reverse all the instructions for drawing Box 2, to draw a box on the right.

BOXES 4, 5, AND 6

Arrange to lift your box above the eye-level horizon line and do all the drawings in reverse, near the top edge of the paper. You will use the same eye-level horizon line and keep your same station-point position.

BOX 3

The Angular Box: Two-Point Perspective

Study Figure 5.25, and notice how the corner of the box is in the middle and the receding lines are going back to two points. When a flat side of an object is not flush with your view, and you are facing the corner of it, you need to make only a few changes. This time you will have to establish the two points on the eye-level horizon line, instead of using the vanishing eye point across from your station-point position. As I walk you through this exercise, you will understand the differences.

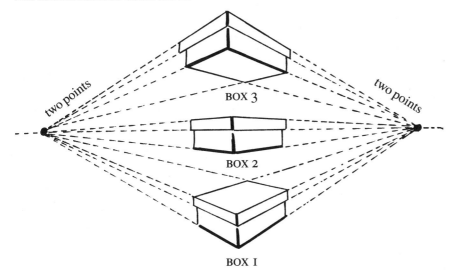

FIGURE 5.25
Two-point (angular) boxes project.

BOX I

INSTRUCTIONS

BOX I

Set the box directly in front of you, with one of its corners facing you. Place it lower than your eye level.

1. Draw a dotted eye-level horizon line through the middle of the entire length of the paper.

Step 1

2. Draw the corner of the box facing you, with a vertical line parallel to the side of the paper, near the bottom middle edge of the paper. Make a small break in the line to also draw the vertical corner of the lid facing you. You can use your pencil and thumb to measure scale.

3. Draw the bottom edges of the box by using your pencil measurements for the length and angle of the slant of the line. You are eyeballing it at this point. If you have a rectangular box instead of a square, one bottom line will be longer than the other.

Step 2

4. Continue those lines with dotted lines, to the right and to the left, all the way to the eye-level horizon line. Where these lines touch the horizon line, make a point. You now have two vanishing points to which all the receding lines will converge.

5. Make dotted lines from the top front and bottom front corners of the lid to the two points.

Step 3

6. Blacken the lines for the sides of the lid and the sides of the box. Remember to make the indentation for the overhanging lid and the lines parallel to the corner of the box and the edges of the paper. The only parts of the box that will be missing are the back edges of the lid.

Step 4

7. Draw a dotted line from the left-hand corner of the lid to the right-hand vanishing point on the horizon line. Draw a dotted line from the right-hand corner of the lid to the left-hand vanishing point on the horizon line. The back corner of the lid is at the point where these two lines cross.

8. Blacken the back edge of the lid.

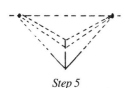

Step 5

BOX 2

Place the box at the same height as your eye level (where you cannot see the top of it), right in the middle of the eye-level horizon line. Repeat all the instructions above, through number 7. You will delete numbers 8 and 9, as you cannot see the top of the lid.

BOX 3

Place the box at a level higher than the horizon line and reverse all the instructions given for drawing Box 1, creating a box bottom in numbers 8 and 9 instead of a lid top.

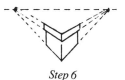

Step 6

With this basic understanding of perspective you can draw just about anything you want. Most buildings offer a combination of one-point and two-point perspective, with some rounded sections. If you are sitting in a furnished room, there may be a combination of round and square objects. Some objects will be parallel and some will be angular. *The secret to making it easy on yourself is to select your station-point position and arrange the objects.* When you understand the principles involved you can move objects around, get rid of objects, and arrange things to meet any challenge for which you feel ready. First choose a position with only one-point perspective, then add some two-point perspective, and finally choose a view that combines both processes. *Remember to sit still and face straight ahead, so that you can keep your view consistent.*

Do the following projects while this information is fresh. Feel free to eliminate objects and complex detail from your scene, as it is almost impossible to represent every little detail. For example, if you are drawing a house, you don't need to duplicate its exact number of windows or porch posts; you simply want to create a house something like it on your paper. Unless you are doing the drawing to remember a particular house, you can eliminate a whole section of it and make your drawing fit the size of the paper or the composition that you want. Of course, the thing that will help you the most is to remind yourself that the exercise is just for practice and that it is unnecessary to be exact.

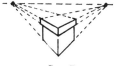

Step 7

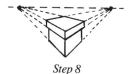

Step 8

BOX 2

BOX 3

BASIC ARCHITECTURAL PROJECTS

You will need about 2 hours for each one of these projects.

SUPPLIES

Drawing board and clip

Two or three pieces of 12 × 14″ to 18 × 24″ drawing paper

A 2B pencil and an eraser

A black razor-tip and regular black felt-tip pen

INSTRUCTIONS

USING PERSPECTIVE TO
DRAW HOUSES
Once you understand the basics
of perspective, you can use eye-
ball perspective to establish the
basic box shapes first. As you
add the detail you can eliminate
and rearrange things to fit the
composition you want.

A HOUSE

Select a house and sit across the street from it. Draw using a light pencil line and erase until you get everything in place. Put a dotted horizontal line through the length of your paper for your eye-level horizon line, and establish your vanishing eye point. You won't have a wall behind it to determine your eye point this time, so you will need to choose a spot on something in the environment to be your guide. Remember to keep you head still and

FIGURE 5.26
Tracy Hoos — age 8

FIGURE 5.27
Brock Essick — age 16

FIGURE 5.28
Dorine Little — adult

your eyes straight in front (at rest) when you establish your vanishing point (or points).

Handle the house just as you did the boxes, drawing its major lines with pencil. Draw all the edges that are like boxes in the house first. Then draw a combination of dotted lines to the points and use eyeballing to put in the detail of windows, doors, posts, and other elements. Eliminate as much detail as you want in order to be comfortable. Each time you repeat this kind of project, you can add a little more detail.

Try your hand at some basic textures of ground or bushes or trees that you see near the edges of the house. Blacken the final drawing with ink and let it dry a good 5 minutes. Then erase all the pencil lines. Kneaded eraser works best for this, as it leaves no crumbling to mix the ink. Figures 5.26 to 5.28 are student examples of this project.

THE CORNER OF A ROOM

You find yourself inside a box when you draw the corner of a room. It gets a bit complex to use two-point perspective from this view, so eyeball perspective is the most practical system to use. Figure 5.29 shows an example of the basic structure you are observing. If you draw the vertical line of the corner first, then eyeball the angle of the slanted lines for the ceiling and floor, you can relate everything else in the room to this basic framework.

Study figures 5.30 to 5.33 before you do your project. Notice how the corner of the room was established by slanting the ceiling lines upward and

COMBINING BASIC RULES AND EYEBALL PERSPECTIVE
Dorine did the lessons on one-point and two-point perspective at the art studio. After drawing the boxes and understanding the basics, she went out into the neighborhood and used eyeball perspective to draw this house. She established the basic drawing at the site, then took photos of the house and a tree she liked on another street, and finished it all up at home. FIGURE 5.42 shows how she later developed the house into a shaded drawing.

FIGURE 5.29
BASIC CORNER OF A ROOM
Notice the slant of the floor lines
and ceiling lines in relationship
to your position station view
point.

FIGURE 5.30
Notice how all vertical lines are
parallel with the corner of the
room.

FIGURE 5.31
Notice how the curtain rod is
parallel to the ceiling line and
the floor molding is parallel to
the floor line.

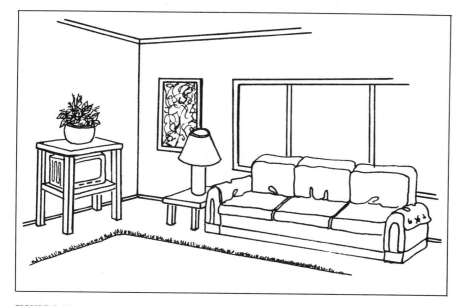

FIGURE 5.32
Notice how the front of the couch is parallel with the floor line behind it. If you start with the right-hand end of the couch out from the wall it establishes the couch in front of the wall.

FIGURE 5.33
Notice how the fireplace and the windows are recessed.

the floor lines downward. Then study how the bottoms of the objects on the floor are parallel with the floor lines, the objects near the ceiling are parallel with the ceiling lines, and the objects in the middle are straight across the middle of the drawing.

The best way to understand how to draw this view of a room is to try it. Select a corner of a room and eliminate all but a few items for your drawing. Find a corner where nothing is hiding the two floor lines as they meet the vertical wall line that establishes the corner. Try to choose a scene with very basic boxlike objects along the walls, such as bookcases, stereo cabinets, or a long rectangular couch, as opposed to overstuffed chairs, kidney-shaped coffee tables, or triangular-shaped sectional pieces. Objects on the wall, such as windows, doors, or pictures provide the best practice for beginners.

Use your ruler as much as you want. Draw with very light pencil line until you get everything in place. You can erase the unwanted lines at the completion of the drawing.

Draw the vertical line for the corner first. Eyeball the angles of the ceiling and floor lines that extend from the corner. Extend those lines out into

FIGURE 5.34
Lindsey Tregurtha — age 9
Perfection is unimportant in
your first explorations using
perspective.

FIGURE 5.35
Ynez Arce — age 16
Eyeball perspective is all you
need for freehand studies.

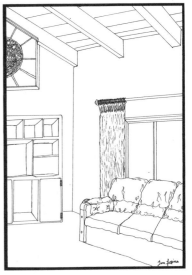

FIGURE 5.36
Tom Lupica — age 22
After doing everything first in
light pencil line, you can finish
up using a rule and ink. This
drawing was done during the
student's first lesson.

the paper as far as you want to draw the scene. Double check the relation of the floor lines to the ceiling lines before you go on.

Draw any items on the walls first. The vertical edges of objects will be parallel to the corner of the room. The top and bottom edges of objects will relate to the slant of the ceiling or floor. For example, the bottom edge of a door will be nearly the same as the floor line, whereas the top edge will become parallel with the slant of the ceiling as it gets closer to the ceiling. Your goal is not perfection, so the eyeball technique is accurate enough.

Next, put in some of the furniture in the room. One major hint about drawing furniture is to draw the back edge or legs next to the wall first and then make a light dotted line out to the front ledge or legs. The front edge of the piece of furniture will be parallel to the wall behind it. Drawing the back edge first avoids the common problem of furniture that suddenly starts penetrating walls.

Have fun with this exercise, and keep studying the examples in figures 5.29 to 5.33 to help you through the rough spots. Figures 5.34 to 5.36 are some first-try examples of this project by other students.

If you still feel a little lost after these exercises, this is typical. It usually takes a bit of practice to make drawing in perspective a natural habit. It's like learning to do tricks on ice skates: you might be able to go around the rink without falling after a few tries, but you would expect to practice a little before you tried to go backward or do crossovers.

Now that you know the basics of drawing just about any object you want to, you can add the last touch of achieving dimension by bringing the magic of *light* and *shading* into play. Understanding the logic of light is what shading is all about.

ADDING SHADING

This is another of the most common blocks to drawing that people have. Most people who don't understand shading have the same story to tell. They talk about how they try to look for the lights and darks, but can't make any sense out of what to look for. What is usually missing is not knowing that there are *consistent patterns to look for,* and that these *patterns are logical if you understand where the light source is coming from.* You won't have any difficulty when you are shown these consistent and logical patterns and how to look for them.

When you are learning to shade, it is important to simplify the set up. The main factors are setting up a project that will exaggerate the light and show you the logic of how the patterns fall. This is one subject that you need to experience in order to understand it.

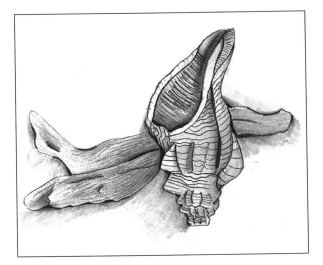

FIGURE 5.37
George Casteneda — age 13
Prior to information on consist-
ent shading.

FIGURE 5.38
George — same week
After basic information on
shading.

ADDING SHADING
One of the most common blocks
to drawing is the fear of shading.
Once you understand the basic
information on how to look for
the regularity of light patterns,
you will be amazed at your
ability to create realism with
shading techniques.

SHADING DRIFTWOOD PROJECT

Study the two student drawings in figures 5.37 and 5.38, which were both done by the same student. He did the first drawing with no prior knowledge of the logic of how light falls on an object. You will notice dark spots randomly appearing in the drawing, on both the tops and bottoms of the objects. You will also notice a heavy black outline around each object to define it. In the second sample, notice that the student eliminated the heavy black edge, and the objects are defined by the contrast in shading. The light source is coming from the upper right-hand corner of the paper and the shadows are consistent with that source. The second drawing achieves a more three-dimensional quality due to the consistent shading and elimination of the black outlined edges.

Both the student and I liked the first drawing very much, and there is nothing wrong with it. But in having learned the techniques of consistent shading, the student now has the option to express himself either way.

Shading is just like proportion and perspective: until you feel that you are able to do it, you may not feel secure about your drawing ability. Shading isn't as tricky as perspective; it just takes the right setup to teach the principles.

The following project will take about 2 hours if you do it in pencil and about 1 hour if you use Conté crayon or charcoal.

SUPPLIES

A piece of driftwood or an interesting tree branch (with bark patterns)

A shell, a piece of coral, a crystal, or a rock

A 9 × 12″ piece of drawing paper

An assortment of light to dark pencils (or Conté crayons or charcoal)

A plastic eraser and a kneaded eraser

A shading stomp (gray rolled paper devise for shading)

A portable bright light that can be shined directly on the setup

INSTRUCTIONS

1. Set the wood and shell or rocks on a smooth surface, away from confusing light sources, such as windows and overhead lights. A dim room is perfect. Then shine the light directly on the arrangement from a little above it and to one side.

2. Make a very light contour drawing of the objects. Notice all the subtle changes along the edges of the objects. This will give your drawing more feeling and realism.

3. Study the light and see how it follows patterns. Note where the lightest and darkest areas are and how they sit in relation to the light source. You probably will have some kind of pattern where the lightest areas are on the tops of the objects, closest to the side where the light is shining, and the darkest areas are on the underside of the objects, away from the side where the light is shining. Some exceptions will be holes and crevices, where the light can't get in and things get darker and darker as the hole or crack gets deeper.

4. Study which objects are lighter or darker than others. You'll start making decisions by asking yourself questions like the following ones. If you can train yourself to think this way, you will have taken the quickest route to success.

Questions That Help You Make Shading Decisions

Where do the darkest darks fall and what are their patterns?

Where do the lightest lights fall and what are their patterns?

How many shades do I see in between?

What is the lightest overall object or surface in the scene?

What is the darkest part of the lightest object?

Is the darkest part of the lightest object still lighter than anything on the next-darkest object?

Is the lightest part of the darkest object still darker than anything on the lightest object?

How can I change the background to be the opposite shade of the object it touches, in order to create contrast and get rid of the lines around the edges that define things?

How can I create contrasting shades at the edges of all the objects, so that I can eliminate the lines around the edges?

When I stand back from my drawing, is everything a similar gray, or is there a range of shades, with dramatic contrasts defining objects?

5. If you still feel a little disoriented about where the light is coming from, you can put a dot near the top of your paper that represents the direction from which the light is shining on the arrangement. You can think of it as a sun, with rays shining across the paper, and it can help you keep track of the direction of the light source. Notice the way this has been done in the exercise sample in Figure 5.39. Study the way the dark and light patterns fall in the sample. Notice how the darkest darks are in the holes and undersides of the objects, and the lightest lights are on the tops of the objects nearest the rays of the light source.

6. Start blocking in the darkest darks. Use the side of the pencil or charcoal, but don't darken any area completely yet. Save your options to go either way as you get closer to completion.

7. Take a piece of scratch paper and make a palette (a smudge) of very thick dark pencil in a square. Rub your shading stomp or finger in it. Then shade with your blackened stomp or finger. This will create the lightest light possible short of the white paper. Use different amounts of pressure to block in the lightest lights.

8. Keep jumping back and forth from the darkest dark to the lightest lights and as many shades in between as you can. Use your stomp or finger to smear or stroke between the two and blend them.

9. Notice the shape of the shadows the objects cast on the surface they are sitting on and how dark they are in relationship to the darkness of the objects. Shade in these shadows and any background that you wish to depict.

10. Leave the white paper for your lightest areas or use your kneaded eraser on the lightest grays to create highlights.

11. If you get too close, you will be unable to see the overall effect. When you hold the drawing away from you or walk away and come back, you will see all kinds of things you didn't notice, so walk away at some point and take a break. When you get back, hold the drawing away from you and see how it reads. This is very important in shading.

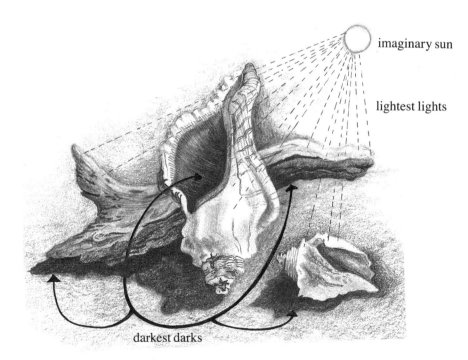

imaginary sun

lightest lights

darkest darks

FIGURE 5.39
UNDERSTANDING THE REGULARITY OF LIGHT PATTERNS
Imagine a sun shining on your paper and how its rays cross the paper. The lightest lights will be where the sun's rays hit the objects. The darkest darks will be on the under sides of the objects, and inside any holes and cracks.

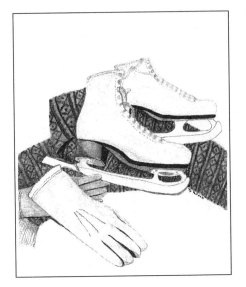

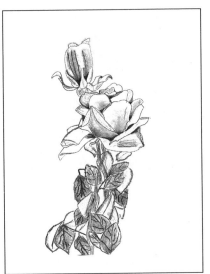

FIGURE 5.40
Tyler Tatsch — age 14
You can make interesting still life
arrangements out of footwear
and accessories that go with them.

FIGURE 5.41
Nicole Burns — age 12
Flowers and plants lend them-
selves nicely to projects in which
you can study shading.

a break. When you get back, hold the drawing away from you and see how it reads. This is very important in shading.

12. At the end, try to get rid of the outlined edges by creating contrasting shades next to one another. The shading next to the darkest edges will be very dark, with a gradual transition of lighter and lighter shading as it goes toward the light source. In general, things behind one another or on undersides will be darker.

If you still feel uncomfortable after completing the project, don't even consider giving up. Everybody feels that way the first few times. While the information is still fresh in your mind, do the additional shading projects that follow. Each attempt will become easier, until you suddenly see differently and the process has become another learned habit.

ADDITIONAL SHADING PROJECTS

Take approximately 1 hour for each of the following projects.

SUPPLIES

Any size drawing paper you feel is appropriate for your choices

Pencil, charcoal, pastel, or Conté crayon, depending on your choice

INSTRUCTIONS

1. Footwear. The drawing of ice skates in Figure 5.40 is only one example of ways to present footwear. Choose some kind of footwear and place it in the same setting as you did the driftwood, with the light to one side.

2. Roses or potted plants. Roses lend themselves to shading well, because of the overlapping patterns of light in the petals. If you can't get a rose, find a plant with many overlapping leaves and draw a branch or two on the paper. Figure 5.41 is a pencil drawing of some roses by a student who was trying this kind of shading for the first time.

3. Architecture. Take one of the perspective drawings that you made and redo it in a shaded version. You can choose to put a dot on your paper to represent the sun as a light source and create the patterns from what you now understand about light logic. Figure 5.42 is a student's result of this process.

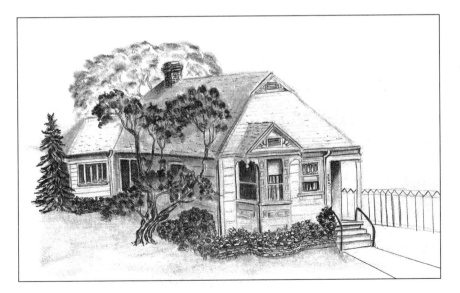

FIGURE 5.42
Dorine Little — adult
Dorine took the drawings she did from the project in FIGURE 5.28 *and redrew it in a shaded and volume style.*

There are two other ideas I want to mention before you go on to explore the endless subjects that you can draw. They have to do with learning how to make changes and how to add finishing touches.

MAKING CHANGES: FLEXIBILITY AND ADJUSTMENTS

The fear of making a so-called mistake is what keeps most people from learning how to draw. Knowing that you can make adjustments and changes will lessen that fear and allow you to enjoy yourself. Being aware that altering things you don't like eliminates the worry and helps you relax.

There is an old saying that mistakes are opportunities in disguise, and I am convinced the saying is true. In fact, it is impossible to define the word *mistake,* since a mistake to one person isn't necessarily one for another. Forget the idea of mistakes and simply notice what you *don't like.*

When you do something that you dislike, you are usually creating a unique problem to solve for which you can come up with a unique solution. Your solutions often make a mundane picture into a uniquely interesting one. Here are a few things to consider instead of crumpling up or throwing out your opportunity for a creative outcome.

Flexibility

When you think you have made a mistake, try to look at it differently. Don't come to a quick conclusion. Even if you are sure there is absolutely nothing you can do to save your drawing, try to be more flexible and positive. Learn to withhold your announcement to the world for a minute. See whether you can stay with the drawing and think of ways to make changes or adjustments. Walk away from the drawing for awhile. When you come back, sit and study the drawing with the attitude that you have many options. If you think you have options, they are more likely to materialize.

Adjustments

You can learn a series of options to change what you don't like. You can organize them into a sequence that promotes ease of solution or time in-

vested. For example, starting over is usually not the most desirable solution. If you think of that one first, you may experience so much frustration that you never get to another choice. Here is a list of considerations that may help you.

FIXING A CRUMPLED OR FOLDED DRAWING

- *Ironing.* Put a towel on the floor and steam iron the back of the drawing. If this doesn't work, you can wet the crease lightly with a damp finger.

- *Spray mounting.* Get some spray-mount glue, a piece of poster board or thick paper, and a piece of scratch paper the size of your drawing. Apply the spray mount heavily on the back of your drawing. Lay the drawing on the poster board, with the scratch paper over it. Take the flat of your hands and start in the middle, spreading out to the edges. Most of the time, the crease will be gone.

ERASING AN UNDESIRABLE MARK, SMEAR, OR SPILL

- *Try several kinds of erasers.* Some work better than others for different problems. For example, there is a typewriter eraser that comes in a peel-down stick that will even erase ink if it isn't too deeply ingrained in the paper. If you get oil spots from greasy fingers on the paper, you can sometimes remove them with baby powder and a toothbrush. Be creative and try several things before giving up.

DEALING WITH DRAWN LINES, SMEARS, OR SPILLS THAT WON'T ERASE

- *Adjust the shape of it.* Children are very creative at making an unwanted line or smudge into something else. For example, many animals that were drawn too fat or too long have been redrawn to the desired shape. Then the extra lines may be turned into lovely twigs of trees, cloud formations, or another row of feathers. When the problem is "too little" or "too short," the solution is even easier: you can simply make the subject bigger and use the extra lines for some kind of pattern or design detail within it. When you are drawing people, the extra lines can become part of the pattern or folds of clothing.

- *Add an object or idea.* When a smudge or smear is in an odd place, you can incorporate it into another object. For example, if you had a leopard on a tree limb and your hand picked up black ink and carried it to

the other side of the paper in the sky area, you could place a bird over the spot. You might add several birds and integrate them into your composition in a way that enhances the drawing.

GETTING RID OF AN UNERASEABLE PORTION OF THE DRAWING

- *Trace the part you want to keep.* If all else fails and you want to start over, you can still retain the original elements of your drawing by tracing them onto a new piece of paper. Take a new sheet of paper and lay it over the drawing. Tape it up to a sunlit window or on a piece of glass with a light behind it. Trace the portion of the drawing you want to keep and eliminate the undesirable portion. If you want to try that part again, you can do it on scratch paper until you are satisfied. Then you can trace that portion into your drawing as well.

- *Cut out the undesirable portion.* You can crop your work (reduce its size by cutting off portions) the way photographers do. Or you can take scissors and cut out a part you want to keep, paste it onto another sheet of paper, and begin to make the drawing into a paper-sculptured format, adding other pieces of drawing in the same fashion. You might even let portions of the drawing be raised from the back surface and create a three-dimensional look. Another alternative is to tear the pieces instead of cutting them with the scissors to give a textured appearance to the sections.

STARTING OVER

- Starting over doesn't have to be a negative experience. Actually, artists often work on a piece several times before it evolves into one of those special ones they love. It can be very enjoyable to watch the drawing change and shift as you start over, sometimes in ways that you hadn't planned at all. Those are the times that you are so glad you had the opportunity to create such desirable changes.

ADDING FINISHING TOUCHES: TEXTURE AND FINE DETAIL

Have you ever heard someone praise an artist because he or she "had an eye for detail"? When you are able to capture fine detail and create beautiful

textures, your drawings come alive with richness. Creating texture and capturing fine detail is not hard; it just takes some time. Patience is the main ingredient necessary to achieving either of these features in your drawing.

People who are called detail freaks thrive on this sort of thing and think nothing of spending thirty or forty hours on a drawing that they might not even like that much. They actually enjoy the process itself. I happen to be one of those people and quite often spend endless hours completing a drawing that is in process for months. I usually have several unfinished drawings around and alternately work on them until they are finished. There is no need to go to this extreme if you don't enjoy detail that much. However, if you would like to use more detail and notice you avoid the process, there are ways to develop your patience. Here are a couple of projects that will help you increase your ability to see fine detail without too large a time investment.

DETAIL PARTS PROJECT

This project will help you notice all the fine detail in an object and see how the parts fit together. You need not create a finished drawing; this is more of an exercise in learning to see. Figure 5.43 is a student example of the project.

Allow about 1 hour for the project.

SUPPLIES

A piece of 9 × 12″ drawing paper

A razor-tip pen

The face of a stack of stereo components, or a complex dashboard of a car

INSTRUCTIONS

1. Sit within a foot or two of the stereo components or the car dashboard.

2. Do a contour-style drawing, focusing on capturing every line and detail of what you are looking at. Don't concern yourself with exact proportion or shading.

CREATING DETAIL AND TEXTURE
Carry a sketchpad and make studies of complex patterns to learn how to see fine details and how parts fit together.

FIGURE 5.43
Ilana Gatti — age 13
A study in the detail of a rack of stereo components.

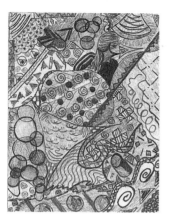

FIGURE 5.44
Cory Madley — age 12
Inspired by studying origami
papers.

3. Start at the top and work your way down. Try to draw everything that you see, including the writing and each knob, screw, button, and line in between sections.

DETAIL PATTERN OR TEXTURE PROJECT

This project is designed to introduce you to seeing the fine detail of patterns and how to create texture. Figure 5.44 is a student example of the project. The student was inspired by studying origami papers and then combining the patterns for her detailed design.

Take 1 hour to do the project.

SUPPLIES

A 5 × 7″ piece of drawing paper, or a piece of similar small size

A set of colored pencils or colored pastel pencils

Colored razor-tip pens

Tombo markers, or any other brand of paintbrush-type felt-tip markers

A piece of cloth or an origami-type paper having a small intricate design

INSTRUCTIONS

1. Use any of the supplies that are appropriate to copy the pattern from the sample. You needn't copy the pattern exactly, but try to make it as detailed and small a pattern as you can.

2. Start the pattern in the middle of the paper, and repeat the same pattern all the way out to the edges.

3. Color the pattern in, staying consistent in the way you chose to design it.

As you go on to the last chapter, you will get a lot more experience exploring the information you learned in this one. There will be only a little more new information when you reach the section on drawing people. Beyond this point I will simply guide you in applying what you have learned so far.

ENDLESS SUBJECTS— ENDLESS RESULTS

Now that you have explored the basics, you are ready to draw any subject. Within each subject are an endless number and combination of topics to choose from. When you consider all the different styles of drawing, the many kinds of media, and the wide variety of compositions available, you could spend a lifetime exploring the results that are possible with one particular topic. If you keep challenging yourself to try new approaches, styles, or ideas, there is no way to get bored or run out of things to draw.

This chapter will reexamine the six general subjects that I suggested you memorize in Chapter 4. They are the same ones you considered for planning projects. I will teach from a few sample topics from each of these six general categories. Here are the six general subjects and the particular topics I have chosen for examples:

SUBJECTS FOR EXPLORATION

1. Beings
 a. The human form
 b. The animal kingdom
 c. Imaginary beings

2. Inanimate Objects
 a. Personal or household items
 b. Industrial items

3. Plants and Flowers
 a. In nature
 b. In still-life arrangements

4. Vehicles
 a. Cars
 b. Boats
 c. Hobby vehicles

5. Landscape or Nature Scenes
 a. Pieces of scenes
 b. Whole compositions of scenes

6. City or Building Scenes
 a. Pieces of scenes
 b. Whole compositions of scenes

FIGURE 6.1
Brent Duke — age 12

FIGURE 6.2
Anna Gutierrez — age 15

*DRAWING WITHOUT
LOOKING AT THE PAPER*
*When you can't control the
results, you let go of your inner
critique and train your eyes to
see the details.*

For each category I will give you some drawing tips, guide you through sample projects, show you student examples, and then encourage you to explore other topics in the category. It is not necessary to take the categories in the same order they appear in the book. You can skip around from topic to topic, as your interest dictates. If you feel that you have exhausted yourself or get stuck, switch to another subject for awhile. Eventually you will find out what you like and what works for you, and you will have learned to draw for yourself.

BEINGS: THE HUMAN FORM, THE ANIMAL KINGDOM, AND IMAGINARY BEINGS

Whether you draw earthly beings or imaginary ones, you need to deal with features of the head area, shape and construction of body parts, and type of body covering or clothing. Here is a strategy that will help you draw any being that you want.

You will learn a system for analyzing body parts, using circles and tubes, that will help you achieve the light sketch (or framework) that I describe in steps 1 through 4. You can also use the five basic elements of shape to analyze the contour edges of the body parts. When you see both of these systems together, you will be amazed at how accurately you can draw any type of being.

As you do the light sketch in steps 1 through 4, you can use a combination of gesture drawing and contour drawing, in a loose style. By making a preliminary sketch in light line, you can continue making changes until you are satisfied with the basic framework. Then you can add the detail features in steps 5 through 7, using a combination of contour line and shading. I will guide you through these steps in the final drawing project that follows.

The key is to grasp the basic general shape of the whole being before you add finishing touches. This strategy helps you avoid such things as drawing beautiful clothing that hangs on an out-of-proportion body, or animal limbs that stick out of a misshapen torso. Starting with the human form, you will be able to use this system to improvise drawing other kinds of beings.

General Approach to Drawing All Beings

PRELIMINARY STUDIES

1. Warm up by drawing without looking at the paper.

2. Explore the volume and feeling with a gesture drawing.

FINAL DRAWING

Step 1. Lightly sketch the general shape of the features of the head area.

Step 2. Lightly sketch the general shape of the torso or body area.

Step 3. Lightly sketch the general shape of the limbs.

Step 4. Make adjustments and capture the general proportions and energy.

Step 5. Add detail features of the face and head area.

Step 6. Add detail features of the body parts.

Step 7. Add details of the body covering or clothing.

FIGURE 6.3
Will Oakland — adult

The Human Form

If you think it is hard to draw people, you need to confront this feeling first. Remind yourself that there may be a simple reason for feeling this way: you probably were never given the kind of information you needed. Give yourself a chance. Allow yourself to go through a normal learning phase, as you would for any new subject. Acknowledge any discomfort you might feel as you study another human being. Your first project is going to be done without looking at the paper, so you needn't even worry about the outcome.

Drawing without Looking at the Paper

Your biggest challenge in this type of study is to let go of any preconceived idea of what you think of as a good drawing. Once you recognize that you can't control the outcome, you will let go of your inner critique and focus on observing and becoming visually aware. The point of this exercise is to train

FIGURE 6.4
Sarah Collard — age 80

Drawing without looking at the paper helps free you to explore feeling in your drawings.

your eyes to see every detail. The drawings in figures 6.1 to 6.4 are examples of what the results might look like. Sometimes they turn out aesthetically pleasing or intriguing, but don't try to make that happen. Concentrate on seeing every line, and let your hand simply follow what your eyes are observing. From now on I will use the initials DWL to talk about drawing without looking.

Drawing-without-Looking Project

You are going to need a friend or relative to model for about 1½ hours for this DWL project, including the gesture drawing and the finished drawing. You will need about 15 minutes of the overall time for this first DWL study.

Supplies

Your portable drawing board

Two 18 × 24″ pieces of newsprint or bond paper

A black regular point felt-tip pen

A piece of Conté crayon or a charcoal pencil

Instructions

Clip the paper to your board and move at least 8 feet away from your model. Use the felt-tip pen for the first study. It doesn't matter what part of the person you start drawing first, but it may help you to start with the features of the face, then the contour edges of the hair, head, and neck, and then down through the body. You can look at your paper to decide where to start, but then look away once your hand starts moving. Even if you are completely lost as to where you are on the paper, don't peek. Use 5 minutes to visually study every line, tiny wrinkle, and crease that you see, while letting your hand duplicate it on the paper. It doesn't matter if the month ends up on top of the nose or the foot is in the hair. The only reason for this project is to teach your eyes to be observant.

After you finish the 5-minute drawing, do another one, using the Conté crayon or charcoal, and notice the difference in feeling and results.

Gesture Drawing

If you have forgotten the procedure for doing a gesture drawing, reread the material in Chapter 1 to refresh your memory. Your goal is to let your hand draw freely, seldom lifting your pen from the paper. You can look at the paper this time, but don't focus on the outcome any more than you did when you were doing the DWL. Simply try to capture the volume of the whole person, without concern for details. The drawings in figures 6.5 to 6.7 are some examples by other students.

GESTURE DRAWING PROJECT

You will need about 10 minutes to do a gesture drawing of your model.

SUPPLIES

A piece of 18 × 24″ newsprint or bond paper
A Conté crayon or a charcoal pencil

INSTRUCTIONS

Use the same pose. Start anywhere on your paper. Make large, sweeping lines to capture the position and general shape of the model, seldom lifting your drawing tool from the paper. Keep your drawing loose.

GESTURE DRAWING
Quickly doing several one- to five-minute sketches is a wonderful way to warm up and study your subject first. They help you capture the overall feeling and mood.

FIGURE 6.5
Art Guiney — age 75

FIGURE 6.6
Barbara White — adult

FIGURE 6.7
Bill Hovland — age 8

Final Drawing

Both of the prior warm-ups were intended to help you loosen up and become more observant. Now you can add some structure, in order to achieve more accuracy in the size, shape, and body proportions. Use the observation skills you gained in DWL and the connection to feeling that you achieved in the gesture drawing, and integrate them into the structure. When you use these techniques together, your drawings will be accurate in proportion and alive with feeling and mood.

The most successful tool I have ever seen in helping a beginner achieve proportion in drawing the human figure is the circle-and-tube system I devised to develop the basic framework of a particular position. This technique involves understanding the human body through its most basic pattern of shapes. If you are interested in a more elemental explanation of this method, you may want to study the section on people in Chapter 5 of my prior book, *Drawing With Children.*

FINAL HUMAN FORM PROJECTS

I suggest that you photocopy figures 6.8, 6.9, 6.18, and 6.19 out of this chapter, so you can study them more easily as you follow the instructions. This way you will also have them handy for your future drawing of humans.

For Steps 1 through 4, I will show you how to use the circle-tube method to establish a preliminary framework that gives you the basic size, position, and proportions of a person. For Steps 5 through 7, I will show you how to use a combination of contour drawing, volume drawing, and shading to develop the details of the person. You can allow the circles and tubes to show through the final drawing or eliminate them as you finish. I will show you some examples of both effects.

Study the front-view framework of the human form in Figure 6.8. Notice how just a few shapes are used to capture the general form. The circles and tubes represent all of the parts except the hands, the feet, and what I call the hip flange.

If you draw the parts in the sequence shown, you can avoid some of the pitfalls of the beginner, which will be explained as we go along.

You will need about 1 hour for this finished drawing.

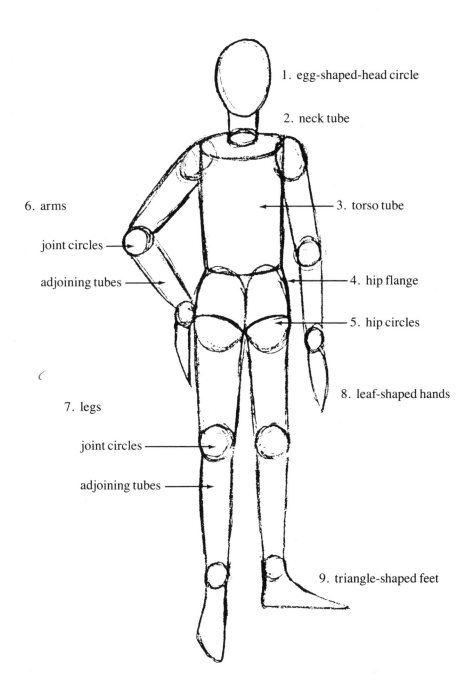

1. egg-shaped-head circle

2. neck tube

6. arms

joint circles

adjoining tubes

3. torso tube

4. hip flange

5. hip circles

8. leaf-shaped hands

7. legs

joint circles

adjoining tubes

9. triangle-shaped feet

FIGURE 6.8
*BASIC CIRCLE AND TUBE
FRAMEWORK OF THE
HUMAN BODY*
*This technique involves seeing
the human body through its most
basic pattern of shapes. If you
draw the parts in the sequence
shown, noting the relationship of
sizes as explained in the lesson,
you will be able to analyze and
represent any position the
human body can take. It helps to
draw the basic proportions of
the position in light line first and
then develop your drawing over
this preliminary framework.*

SUPPLIES

18 × 24″ drawing paper

An H, 2B, and 6B drawing pencil

A kneaded eraser

INSTRUCTIONS

Have your model stand in the same front-view pose as the example in Figure 6.8. It will help for this sketch if your model wears minimal or tight-fitting clothes, such as dance leotards, a bathing suit, or a tank top and shorts.

STEPS I THROUGH 4: USING CIRCLES AND TUBES TO FORM THE BASIC FRAMEWORK

Use your H pencil to start the framework sketch, keeping the line very light so that you can erase or make adjustments. Train yourself to draw the framework in the order below and you will avoid many problems that beginners have with proportion.

1. The Head. Notice how the head is shaped like an egg, with the chin being the point of the egg. Look at your model and, starting near the top of the paper, draw an egg-shaped circle for the head. (Beginners have a tendency to start the head in the middle of the paper and then run out of room for the body.)

2. The Neck. Take your fingers and run them up the sides of your own neck. Notice that the neck tube enters the head at the base of the ears. (Beginners have a tendency to make the neck very narrow, ending up beneath the front curve of the jaw.) Draw the neck tube to fit the size of your model's head.

3. The Torso. Study your model. Notice how wide the torso is compared to the head. Measure the torso width from the base of one armpit to another, not from shoulder edge to shoulder edge. (One of the biggest problems beginners have is to make enormous shoulders and a thick torso. This comes from drawing the shoulders before establishing the size of the torso.) Notice that there are usually about 2 ½ head lengths between your model's chin and waist. Draw the torso tube from the base of the neck to the waistline.

4. The Hip Flange. This shape is like the shape of a man's tight-fitting bathing suit. It establishes the pelvic girdle and crotch line, into which the hips fit. Draw the hip flange before the hip circles, but do so with a very light line. You may have to adjust it as you determine the size of the hips.

5. The Hips. Feel the size of your head with both hands. Then feel one whole hip ball (or circle) with both hands. Notice that each hip ball is at least as big as the size of your head. (Beginners have a tendency to make hips as small as half the size of the head.) The circles you use for hips are more like ovals than the egg shape you used for your head. Draw the oval circles for the hips. Before you go on to the limbs, hold the drawing away from you and examine it for proportions. You will see the relationships better when you aren't so close to it. Make any adjustments or changes and then go on to the arms.

6. The Arms. The biggest secret to getting the arms in proportion is to *draw all the circles (representing the joints of the arms) first,* and then join them together with the tapering tubes. First, feel the shoulder ball with both hands and notice that it is a bit smaller than half the size of your head. Next, feel the elbow ball and notice that it is about half as small as your shoulder. Then feel the wrist ball, which is about half as small as your elbow. If you draw these circles (balls) in this proportion, you will solve most of the problems. (However, notice that the *shoulder circle is inserted into the torso tube* and not sticking out on the sides of it. Again, avoid the enormous football shoulders common to beginners.)

Now study your model closely. Insert the shoulder circles (about half as big as the head you drew) into the torso, noticing about how far out from the ear line they fall. Next, notice where the elbow circles will be in comparison to some other body part, such as the level of the waist, breastbone, or hip. Then notice the shape of the negative space between the body and the elbow joint, and draw the elbow circles where you see them fall (about half as big as the shoulder circles you drew). Now notice where the wrist circles are in comparison to some other body part, such as the waistline, the middle of the hip, or the crotch line. Then draw in the wrist circles where you see them fall (about half as big as the elbow circles that you drew).

Now join the arm circles (or joints of the arms) together, with tubes, and taper the arms appropriately. When you add the detail features of the limbs, you can adjust these mechanical-looking tubes into realistically proportioned arms, with muscle tone and definition.

7. The Legs. You use the same kind of ratios for the legs that you did for the arms. Feel your knee circle, noting that it is a little less than half the size of your hip, and then feel the ankle circle, which is about half the size of the knee. Remember to *draw all the circles (leg joints) first,* and then join them together with tapering tubes. You can make any adjustments for muscle tone and definition in Step 6, studying your particular model's distribution of weight and type of limbs.

8. The Hands. Take the heel of the palm of your hand and place it on your chin, stretching it up to measure your face. Notice that your hand is nearly the same length of your face, from the chin to just a bit below the hairline. (Beginners often draw tiny hands, about half the size of a face.) Measure the size of the face you drew in your sketch of the model (by using your thumb and forefinger) and make a simple leaf shape that size for each hand. Slant the leaf shape in the direction your model has placed his or her hands.

9. The Feet. Take the heel of the palm of your hand and place it on the heel of your foot, stretching the middle finger toward the tip of the big toe. Notice that your foot is even longer than your hand, which means it is a bit longer than your face. (Beginners have a tendency to make feet half that size.) Notice the different kinds of triangular-shaped feet in Figure 6.8, which shows both side and frontal views. Study your model and draw triangular shapes to form the framework of the feet. Measure the size of the face you drew, with your thumb and forefinger, and make any adjustments to get the length of the foot in proportion.

Now look at your drawing from at least two or three feet away. Keep studying the model and your drawing, making any adjustments to correct proportions, before you begin to add the details or darken areas.

STEP 5: ADDING DETAIL FEATURES OF THE FACE AND HEAD

Study Figure 6.9, which focuses on the features of the face and head. These illustrations give you general information on the front-view construction of eyes, nose, and mouth. Every model will have a different version of these features, but I will be guiding you step by step in what to look for.

Don't expect complete satisfaction with your drawing. Most people are very critical about the features of the face and block themselves from learning how to depict them. If you have never drawn faces, develop an appreciation for what it is like to try a brand-new task. For example, try taking the kind of attitude most beginning skiers are forced to adopt. They expect to look ridiculous, laugh at themselves, and have fun as they learn.

general shape

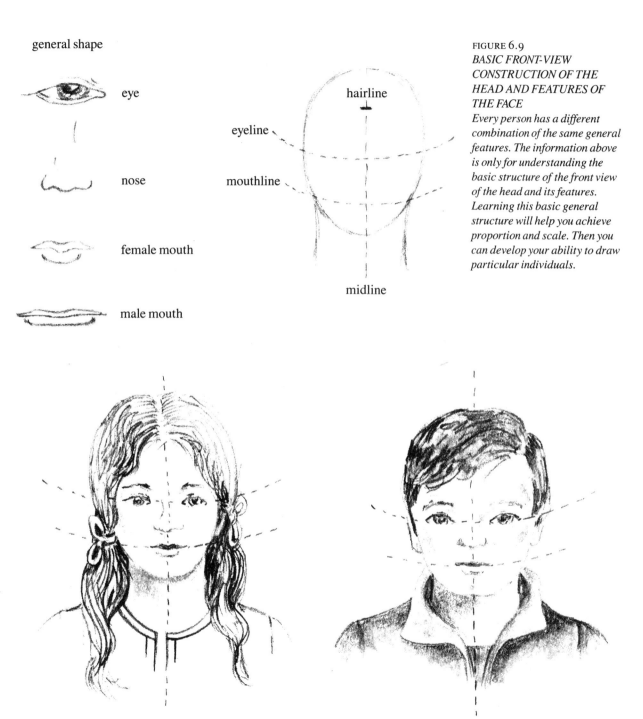

eye

nose

female mouth

male mouth

hairline

eyeline

mouthline

midline

FIGURE 6.9
*BASIC FRONT-VIEW
CONSTRUCTION OF THE
HEAD AND FEATURES OF
THE FACE*
*Every person has a different
combination of the same general
features. The information above
is only for understanding the
basic structure of the front view
of the head and its features.
Learning this basic general
structure will help you achieve
proportion and scale. Then you
can develop your ability to draw
particular individuals.*

Following this step-by-step sequence for awhile will help you get used to proportions:

1. The Mid-line. Notice that the mid-line in Figure 6.9 is where the nose appears in the middle of the face. Make a very light dotted line, where your model's nose falls, right through the egg circle you drew for his or her head.

2. The Hairline. Study your model and make a light mark to show where the hairline starts. If your model has a receding hairline, put the mark where the hairline would ordinarily be. (This is crucial for beginners, who often end up with the eyes high in the forehead. The top of the egg is the crown of the head and quite a bit higher than the front hairline.) Notice how much lower the hairline is in Figure 6.9 than the crown of the head.

3. The Eye Line and Mouth Line. Notice in Figure 6.9 how the eye line and mouth line divide the space between the hairline and the chin line into three parts. Notice how each part gets a little smaller as it goes down from the forehead to the space between the mouth line and the chin. This ratio varies on every model, but in general this guideline will keep you on track.

Look at your model and notice the ratio. Make a light dotted line to establish the eye line and mouth line. Notice that it follows a curved path and wraps around the head, creating the volume of the face. (Most beginners draw eyes and mouths straight across the plane of the face and create a flat-faced look.)

Before you draw your model's eyes, nose, and mouth, study the general shapes of these features in Figure 6.9. These are just examples to show you the basic shapes; I will discuss each one as you look at your model and draw the shapes into your picture.

1. The Eye. Notice the general shape, with a rounded edge on the end near the nose and a pointed edge on the end near the temple. Note the flaps in the skin of the eyelid and how the pupil and iris are formed by a curve hanging from under the eyelid. (Beginners often form the eyeball and iris with full circles, creating a bug-eyed look). Notice that the pupil has a white speck left in it, which is the reflection of light natural to an eye. (This white reflective speck in the eye helps give the people you draw a spark of life.)

Keeping these general principles in mind, study your model and draw his or her individual version of the human eye, eyelids, and eyebrows.

2. The Nose. The secret to drawing the nose is to break the lines that form the bridge and stem. Then draw the tip of the nose and the flanges. Avoid drawing big, dark nostril holes. (Artists usually tend to deemphasize the

nostril holes to avoid exaggerated openings that may remind you of a pig.) Draw your model's nose, noticing the size in relationship to the eyes and mouth.

3. The Mouth. Run your fingers from the corners of your mouth up toward the eyes, and notice that your mouth is about as long as the distance from the middle of one eye to that of the other. This is true for most people. (Beginners often have a lot of trouble, making the mouth either much too short or much too long.) Draw the mid-line of the mouth first. Notice that it has a lot of bends and curves to it. The mid-line is very important to the feelings and expression of the person. Study your model carefully and try to get that mid-line to represent his or her structure of the mouth. Then notice the shape of the line across the top of the upper lip and whether the upper lip is wider than the bottom or visa versa. Notice the shape of the line along the bottom edge of the lower lip, whether the top lip is longer than the bottom, and whether the corners of the mouth turn up or down or meet at a point. Keep the lines light and make adjustments until you are satisfied.

4. The Ears. Run your fingers from the corners of your mouth out to the sides of your head; notice that they run into the bottom of your ears. Then run your fingers from the corners of your eyes to the sides of your head and notice how they run into the tops of your ears. (One tip for drawing ears is to reduce their size a bit to allow for the flatness of the paper, which makes the ears look large. Covering the tops of the ears with some hair helps them from appearing too large.) Draw any portion of your model's ears that you see, keeping the above tips in mind.

5. Hair. Notice any parts in the hair, thick curl lines, sections that go in different directions, or large waves. Use contour lines to sketch in these sections first. Use darker lines than the color of the hair to establish the flow and style of the hair; then color in with the lighter shades. This will help you achieve definition of the hair. For example, if you are making black hair, you will lose the definition if you draw it in black and then color and shade it with black. To avoid this, you can use dark black for the lines and grayish black to color in, or you can use brown or gray for the lines and black between. Whatever effect you devise, the point is to maintain lines of hair flow, rather than a black blob of hair. When shading in the hair, if you let any white paper show through you lose the dimension, since no one has hair with holes through it.

Make the hair extend beyond the egg you drew for the head, especially at the crown of the head. (Beginners tend to make flat-headed people, by

*DIFFERENT
INTERPRETATIONS AND
STYLES OF DRAWING THE
FRONT VIEW OF THE FACE*
*In these drawings, the students
took the basic information on
how to construct the head and
features and used it to develop
their own style and way of
depicting the person who was
posing as the live model.*

FIGURE 6.10
Daisuke Chew — age 12

FIGURE 6.11
Estee Cohen — adult

FIGURE 6.12
Kathy Porter — age 16

FIGURE 6.13
Joel Axelrod — adult

FIGURE 6.14
ADDING DETAIL
Eliminate the features of the face
and realistic hands while you
study the body position and the
details of clothing.

FIGURE 6.15
Lauren Wayman — age 10
Lauren drew the circle and tube
framework with pencil. Then
she used ink to darken the main
shape and add the clothing.
After the ink dried she erased
the pencil framework.

putting the hair right along the egg line. Even hair that is short and combed close to the head is really raised quite a bit from the skin on the skull.)

STEPS 6 AND 7: ADDING DETAIL FEATURES OF THE BODY PARTS
The circle-and-tube framework that you have drawn is like a skeleton on which you will build the body. It established the proportions and size of your model. Obviously, if you left the body in this shape, your person would look like a robot. The reason you used very light line is so that you can now draw over that skeleton with a looser and more expressive type of drawing, without worrying about proportions. You can now combine the gesture drawing and contour drawing you learned in Chapter 1 to develop the muscle definition of the limbs, smooth out the rounded edges of the body, and dress the person in the clothing and accessories he or she is wearing. If your

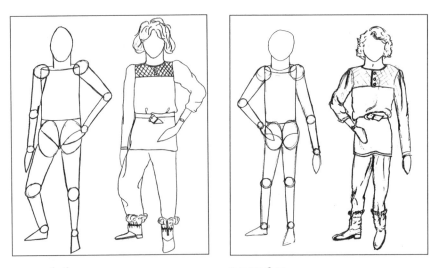

FIGURE 6.16
Cara Drake — age 15

FIGURE 6.17
Erin Conforti — age 17

model is nude, you can develop the volume of the body, with the definition of the muscle tone and the subtleties of the person's mood and energy. Figures 6.10 to 6.13 show some student examples of the frontal view of the face.

Figure 6.14 is a basic drawing of how to overlay clothing onto a body. Study your model and begin to overlay the clothing and form the contour edges of the body onto your framework. Then use any techniques of shading or filling in to give your figure dimension and reality. Figures 6.15 to 6.17 are student examples of this project.

Other Poses

Figure 6.18 shows some other views of the human body in circle-and-tube form. Notice how the circles of the hips begin to overlap one another when the body is seen from a side view and how the circles and tubes of the limbs begin to overlap other body parts when the pose becomes more complex or twisted.

Figure 6.19 shows some other views of the features of the face. Notice in A, B, and C how the neck tube slants into the egg differently, as the head is turned to the side or seen from the back. Notice in A, C, and D how the eyes and mouth are structured differently in three-quarter and profile side views. Notice in B how the mouth, nose, and left eye are hidden from view and the right eye is barely seen. Notice in D how the crown of the head is full and round at the back of the egg when it is a profile view.

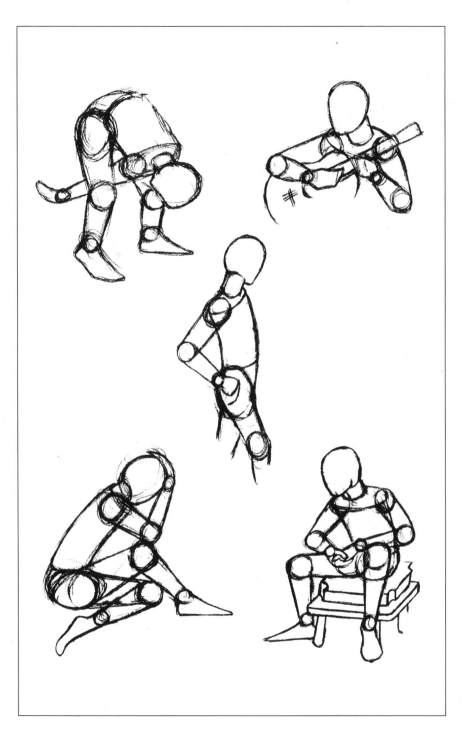

FIGURE 6.18
EXAMPLES OF USING THE CIRCLE AND TUBE METHOD WITH OTHER VIEWS OF THE BODY
Notice how the circles and tubes overlap each other as the pose becomes more complex.

FIGURE 6.19
OTHER VIEWS OF THE HEAD AND FEATURES OF THE FACE
Notice how the neck tube slants into the egg-shaped circle of the head, as the head turns to the side or back. The general shape of the features change as the head rotates to the 3/4 and pro-file view.

View A

View B

View C

View D

FIGURE 6.20
John Christianson — adult

FIGURE 6.21
Janice Purnell — adult

DIFFERENT VIEWS AND
STYLES OF DRAWING THE
SAME POSE
Notice how different artists inter-
pret the basic information and
create their own sensitive way of
drawing the same model.

Figures 6.20 and 6.21 are student examples of two different styles and views of the same pose. Figure 6.20 is an abstract contour of a three-quarter view, and Figure 6.21 is a realistic volume drawing of a complete profile.

Figures 6.22 to 6.25 show some student examples of drawings from other poses. Some show the circle-tube method peeking through the finished drawing, whereas others show how it looks when the artist has erased the circle-and-tube framework from the finished drawing.

OTHER POSES PROJECTS

You can draw people from live models, use photographs, or use photocopies of illustrations or paintings. The following exercises will give you a variety of experiences for future options.

SUPPLIES

Any medium that you choose

INSTRUCTIONS

1. Live Models. Do at least five different drawings. Make arrangements for friends to pose for you, and draw them doing a variety of things. For instance, find out when friends practice the piano, do their homework, recline in a favorite chair and read, play computer games, or work at the sewing machine. Allow about 1 hour for each one of the poses. Do some in pencil, some in Conté crayon, some in charcoal, and some in colored pastel to find out which media you like to use for life drawing.

2. From Photos, Photocopies of Paintings, or Other Illustrative Materials. Do at least five different drawings. Find photographs or illustrations of people in magazines, and use the circle-and-tube process to establish a framework before doing a finished drawing. Use different media and explore what you like. If you have heard that it isn't acceptable to draw from photos or illustrations, remember that many famous painters use photographs.

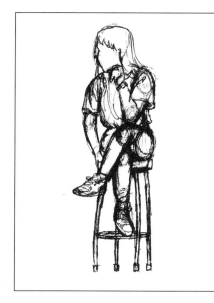

FIGURE 6.22
Joe Chacon — age 16

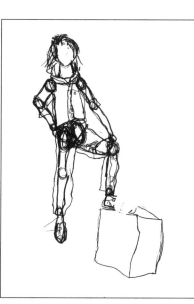

FIGURE 6.23
Bethany Goodman — age 9

*EXAMPLES OF USING THE
CIRCLE AND TUBE METHOD
WITH OTHER POSES THAN
THE SIMPLE FRONT VIEW*
All of these examples were done
by students who used the method
for the first time. They show how
quickly you can gain accuracy in
proportion. Notice the circles
and tubes through the detail in
some of the pieces.

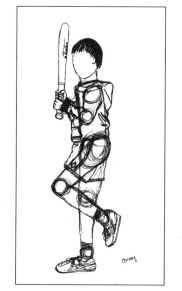

FIGURE 6.24
Chrissy Schindel — age 12

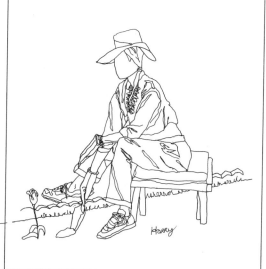

FIGURE 6.25
Harry Stein — age 83

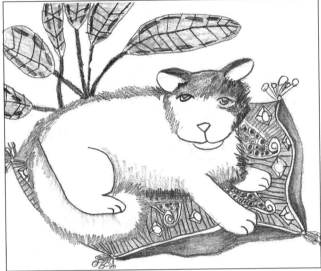

FIGURE 6.26
Becky Kaufman — age 8

FIGURE 6.27
Sean Neprud — age 11

The Animal Kingdom

DRAWING MAMMALS
Following the instructions in this lesson will help you draw any creature from the animal kingdom. These examples are by two students at their first lesson.

It would take another book to deal with how to draw all the creatures in the animal kingdom—from mammals, to birds, to fish, to insects, to reptiles, to crustaceans. However, you can usually follow the same drawing outline that you used with humans. In general, you still draw a head area, body parts, and body coverings. You can approach any animal by following this same sequence of drawing its parts.

When you draw the head area, it is useful to start with the eyes and other features of the face. Then, use a modified circle-and-tube method to establish the general shape of the head and body parts to achieve your basic framework. Some body parts, such as birds' beaks, antlers, and fins, do not lend themselves to this method, but you can use the five elements of shape to analyze any form.

Felt-tip, razor-tip, and Tombo brush markers are among the favorite media for drawing animals and their exotic environments. Although you can't erase with markers and can't make adjustments as easily as with pencils, there are ways to handle changes. For example, you can use a light pencil line to draw the basic framework, then go over the framework in the final

application of media. Erase all the pencil markings before you color in with inks so that your pencil lines aren't set into the paper. Then color in with different kinds of markers. You might want to use a few pencil lines for background ideas, but usually you can risk working directly with the markers.

The following projects give you some general tips about drawing different species and some student examples of the kinds of projects you might design for yourself. Of course, one of the important factors is the need to gather plenty of background information on the surroundings in which you want to place your animal.

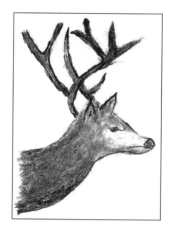

FIGURE 6.28
Annie Ziegler — age 9

ANIMAL PROJECTS

I have chosen mammals and birds for the project examples, but you can draw anything from the animal kingdom. The general instructions I give in the examples will work for any creature you choose. *Do at least two or three drawings before you go on to the section on imaginary beings.*

SUPPLIES

Any media you choose

INSTRUCTIONS

1. Mammals. You can't miss if you start with the eyes, nose, mouth, and neck, while building the shape of the head structure, with contour-line and circle-and-tube construction. Most bodies can be constructed with some kind of tube for the body torso and circles for hips and shoulder flanges. Limbs can be constructed with some kind of circle-and-tube method, paying attention to which way the tubes slant and the relationship of the size of the joints to one another. Using your knowledge about positive and negative spaces between limbs is very helpful. If your mammal is a whale or a porpoise, it would be more beneficial to use a contour-line construction of the overall shape, since there obviously would be no body parts that apply to the circle-and-tube type of system. Don't hesitate to use photos and illustrations of your favorite animals if a live animal isn't available. The student examples in figures 6.26 to 6.29 were done following these guidelines.

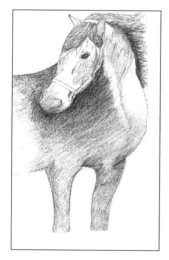

FIGURE 6.29
Sharon Devon — age 11

*Most birds are easy to draw
if you follow a step by step
sequence of drawing body parts.
Start with the eye, then draw the
beak, the head, and general
shape of the wings and body.
Then develop the detail on top
of your basic framework.*

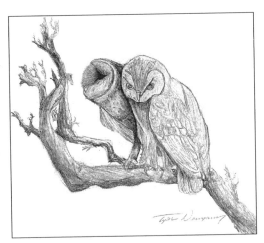

FIGURE 6.30
Tyler Neumann — age 12

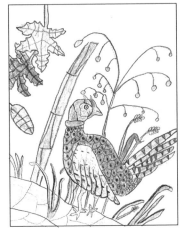

FIGURE 6.31
Ross Roemar — age 11

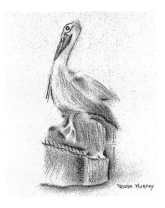

FIGURE 6.32
Freida Murphy — adult

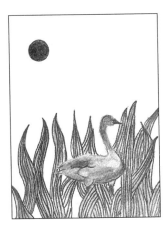

FIGURE 6.33
Michelle Richards — age 13

2. Birds. Most birds are easy to piece together if you draw the eye first, then the beak, the shape of the head, the body, the wings, the legs and feet, and finally the tail. When body parts overlap one another, such as wings over bodies, just *draw what is in front first.* When you want to draw birds in flight, it is usually difficult to work completely from your imagination. You will probably need a live model or a photo of one, as every bird has a distinctly different wing span and pattern to its feathers and body construction. Of course, you can abstract or change colors as much as you wish. I have seen students draw whole new species of birds by using their imaginations and combining things they observe. Figures 6.30 to 6.33 show student examples of some drawings of birds.

As you approach any creature from the animal kingdom, just go slowly and piece your drawing together, bit by bit. Remember that you don't have to be completely satisfied with your results. Artists commonly try something several times before they get it the way they want. It's worth the effort for one of your favorite animals.

Imaginary Beings

Imaginary beings are fun to draw, and they bring out your creative streak. To create any type being, whether humanoid, animal-like, or a combination thereof, you can continue using circles and tubes for body parts, contour lines for edges, and the five elements for construction of shapes. If you are

FIGURE 6.34
Kate Rheinstein — age 10

FIGURE 6.35
Marisa Kirschenbaum — age 11

DRAGONS
For those creatures you don't see around, use your imagination and create your own.

FIGURE 6.36
Babs Freitas — adult

not sure of what you might do, review the student examples of dragons in figures 6.34 to 6.37 and angels in figures 6.38 to 6.41. You might start a file of ideas for imaginary beings, then create some of your own.

IMAGINARY BEINGS PROJECT

There is an endless possibility of styles and media, so challenge yourself, be creative, and have fun.

SUPPLIES

Any you choose, but markers are fluid and colorful

INSTRUCTIONS

Completely let yourself go. Since there are no such creatures, you can explore in any direction your imagination takes you.

FIGURE 6.37
Blanche Fuller — age 84

FIGURE 6.38
Lindsey Robinson — age 13

FIGURE 6.39
Russell Rogers — adult

DRAWING IMAGINARY BEINGS

Lindsey's and Russell's angels were different interpretations of a large clay statue. Sheila worked from pictures of angels, and Jansen created his angel for a special project.

FIGURE 6.40
Sheila Saunders — adult

FIGURE 6.41
Jansen Yee — age 13

FIGURE 6.42
Raj Shukia — age 13

FIGURE 6.43
Nicole Spiegel — age 8

INANIMATE OBJECTS

By inanimate object, I am referring to anything not considered alive or able to move around. Finding subjects to draw in this category can be one of your most creative challenges. If you think you are getting bored with drawing, this category will throw you into a whole new realm of choices.

Some of the most exciting drawings have come from seldom-explored subjects. Figures 6.42 to 6.47 show some student examples of these subjects. You can find a great deal of satisfaction in drawing items that are part of your personal world. Be creative, and find a composition and medium that will lend itself to your subject.

DRAWING FROM YOUR HOBBY
Choose things from your personal interests and use them for subjects of study. You may feel a stronger connection to objects that mean something to you and find yourself drawing them with more awareness.

INANIMATE OBJECTS PROJECTS

Don't limit yourself to stereotyped images of an artistic subject. One of the ways you can break out of this narrow view is to force yourself to make up projects on the spot, using any ordinary everyday object from your bedroom, kitchen, living room, garage, or office.

DRAWING PERSONAL ITEMS
Don't limit your opportunities by drawing only common subjects that are thought of as "artistic." You can enjoy drawing literally anything you find in your personal environment.

FIGURE 6.44
Benjamin Illgen — age 14

FIGURE 6.45
Karishma Patel — age 10

DRAWING INDUSTRIAL OR COMMERCIAL ITEMS
Draw everyday objects around you for practice. Both of these drawings were done at the students' first lesson.

SUPPLIES

Any supplies to match the project you plan

INSTRUCTIONS

Choose one or two of the topics in each of the following categories and make up drawing projects for yourself.

1. Personal items
 something inside your purse
 something inside your closet
 something in your pocket
 something in your desk drawer
 something on top of your dresser

2. An item related to hobbies
 sports equipment
 musical instruments
 gardening equipment
 collector's items

3. Household items
 something from the kitchen
 an appliance or piece of media equipment
 a piece of furniture, a sculpture, or a decorator accessory

4. Office or factory items
 office equipment or machinery
 industrial machinery

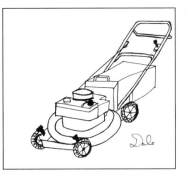

FIGURE 6.46
Dale Boteler — age 25

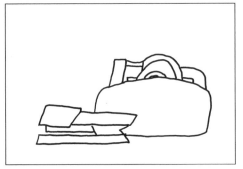

FIGURE 6.47
Devin Weaver — age 7

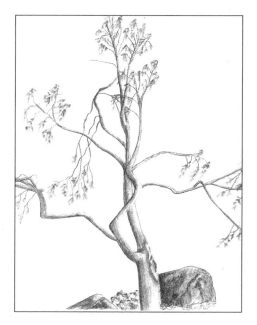

FIGURE 6.48
Rebecque Raigoza — age 19
Drawing an entire plant.

FIGURE 6.49
Felice Willat — adult
Isolating a section of a plant.

PLANTS AND FLOWERS IN NATURE OR IN STILL-LIFE ARRANGEMENTS

Plants, vegetables, fruits, and flowers have traditionally been favorite subjects of artists. Since perspective and proportion aren't as critical in the plant world, you can take more liberties with your creations and achieve more consistent satisfaction. You can draw right from nature, or you can arrange your subjects into still-life arrangements on a table or other flat surface. Remember that drawing what is in front first will help you with overlapping.

DRAWING PLANTS AND FLOWERS IN NATURE
Instead of drawing an entire scene, isolate a particular plant, draw only a section of it, or take pieces of different plants and arrange them into abstract compositions.

Plants and Flowers Projects

Drawing foliage in nature is quite different from drawing it in still-life arrangements.

FIGURE 6.50
Debbie Kaufman — age 9
This girl arranged pieces of
nature and plants by letting them
trail off the edges of the paper.

IN NATURE. *Don't try to draw every leaf and twig you see, or you will become overwhelmed.* All you need to do is establish the kind of branches, leaves, or flowers and place them wherever you want in your composition. You can draw the entire plant, such as the tree by the student in Figure 6.48; run your subject from the edge of your paper, as the students did in figures 6.49 and 6.50; or fill the whole frame, as the student did in Figure 6.51.

IN NATURE PROJECT

When you draw plants or flowers growing in nature, you usually have to isolate them from the whole landscape scene. The view finder that you made in Chapter 5 will enable you to look at a scene and decide which part you want to draw. You can also look at a particular plant and decide which part of it to draw. Then you can take the liberty to rearrange or delete the other parts.

SUPPLIES

Any you choose, but oil pastels lend themselves nicely to plants

FIGURE 6.51
Stephanie DuPont — age 11
An example of arranging pieces
of plants and nature into an
abstract composition.

INSTRUCTIONS

Select one or two topics from each of the following categories, and do a project of your own creation.

- **Tree:** A whole tree without leaves, a tree with full leaves, a flowering tree, a tropical tree, a tree laden with fruit, etc.
- **A Plant:** A cactus, a large-leaf tropical plant, a vinelike plant, a bush, and so forth.
- **Vegetables and Fruit:** Any types of vegetables or fruit, either hanging in trees, growing on stalks, or coming up from the ground. You can isolate a single branch, draw the whole plant, or draw a portion of the plant.
- **Flowers:** Draw from an endless list of wild or domesticated species. You can draw them in bunches, isolate them on the page, or mix them together in abstract arrangements.

IN STILL LIFE. Whenever you make still-life arrangements of plants, flowers, or fruit, you may want to add some other objects to the scene, such as a vase to hold the flowers, a ceramic pot for the plants, a bowl for the fruit, or a piece of sculpture. You can design your composition to be an exact copy of the arrangement or create a composition from several ideas and objects. For example, Kindred's drawing on the cover of the book was accomplished by cutting some bird of paradise flowers and arranging them in a vase with other dried flowers, putting the vase on the wooden stand, taking a piece of favorite fabric and laying it around a pillow, adding some tassels to the pillow from the imagination, looking at photographs of cats, and building the color scheme by looking at paintings by Gauguin. Figures 6.52 to 6.55 are a variety of student compositions created from still-life arrangements.

STILL-LIFE PROJECTS

Find some flowers or plants and decide what other objects you want to use with them in an arrangement. Don't be limited by the typical kinds of arrangements you have seen. Let your creative juices flow, and design a project that includes objects you love.

SUPPLIES

Any you choose, but colored pastels or charcoal lend themselves to still life

INSTRUCTIONS

Design one or two projects from each of the following categories, using a different kind of medium and composition for each plan.

- A vase of flowers, alone.
- A potted plant, alone.
- A plate or bowl of fruit, alone.
- Any of the above, with other inanimate objects.

DRAWING PLANTS AND FLOWERS FROM STILL-LIFE ARRANGEMENTS

You can arrange still-life objects to create different moods and inspire either realistic or abstract interpretations. Notice how the combinations of objects in these drawings complement each other.

FIGURE 6.52
Monica Banks — age 16

FIGURE 6.53
Akemi Hayashi — age 11

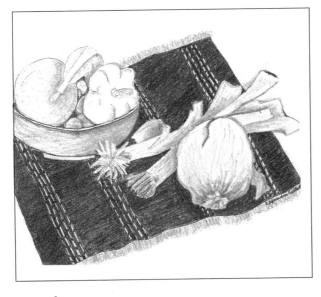

FIGURE 6.54
Alexandra Salkeld — age 13

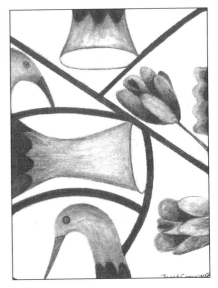

FIGURE 6.55
Janet Consolver — age 12

VEHICLES

Many people love to draw the contraptions that we have invented for travel. You simply need to choose which one you are interested in, develop ideas about the environment and background, and plan your project.

The main drawing techniques that will help you are (a) *using your knowledge of the 5 elements of shape* and (b) *paying attention to the positive and negative space.* Analyze the types of lines that make up the individual parts, and notice the relationships of the negative spaces between the parts. You may choose to draw with simple contour lines or use volume and shading, depending on the medium you use. Figures 6.56 to 6.61 show some student examples of vehicle projects.

VEHICLE PROJECTS

In drawing the main subject (or vehicle), it helps to select the central part of the object and draw it first, such as the frame and wheelbase of a car, the main body of an airplane, or the hull of a boat. Then, slowly piece together the detail parts that are attached. You can use illustrations, photographs, models, toys, or the real thing to provide the details.

SUPPLIES

Any you choose, but pencil or ink lends itself well to vehicles

DRAWING VEHICLES
There is an endless variety of vehicles we have invented for travel. Use illustrations, photographs, models, toys, or the real thing to provide you with inspiration and visual information.

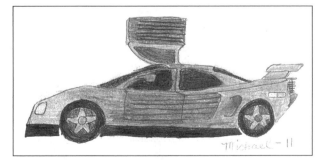

FIGURE 6.56
Michael Hass — age 11

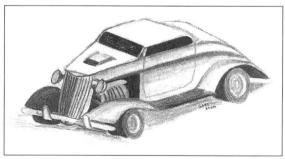

FIGURE 6.57
Gary Scott — age 16

You can make the vehicle the main subject or use several of them as secondary subjects in a scene. When you draw hobby-type vehicles, try to feel their energy and motion while you are drawing.

FIGURE 6.58
Ian Fullmer — age 10

FIGURE 6.59
Charlotte Dusinberre — age 88

FIGURE 6.60
Jake Wyman — age 13

FIGURE 6.61
Arianne Waer — age 11

INSTRUCTIONS

Design one or two projects from each of the following categories, using different drawing styles and media.

When drawing some vehicles, you may want to incorporate the persons operating or using them. If you aren't sure how to handle the action sometimes required, go to where you can observe the activity or get illustrations and photos. Use the circle-and-tube method to capture the pose and then add your detail. This method is very efficient when you are trying to draw people moving. As you become accustomed to using it, you will be able to catch the motion and proportion more and more easily.

- **Cars:** Current model, classic model, or imaginary design.
- **Boats:** Ocean liner, clipper ship, military ship, sailboat, motorboat, dinghy, rowboat, canoe, or imaginary design.
- **Airplanes:** Jet liner, private jet, military plane, twin-engine plane, private propellor plane, antique model, sail plane, or imaginary design.
- **Spacecrafts:** From space programs or imaginary design.
- **Hobby vehicles:** Hang glider, hot-air balloon, wind surfer, surfboard, bicycle, motorcycle, unicycle, or imaginary design.

FIGURE 6.62
DRAWING FOLIAGE
There are many ways to interpret
ground covers, plants, bushes
and trees. The key is simply to
capture the kind of pattern you
see. Making sketches and studies
in a drawing tablet will allow
you to explore and develop your
own style.

LANDSCAPE OR NATURE SCENE

There is usually an overwhelming amount of information in most landscape or nature scenes. Since your eye sees a vast panoramic view, it is difficult to narrow things down to a manageable composition. Using your viewfinder is very helpful; it achieves the same effect as looking through the lens of a camera.

I combine sitting at the scene, taking photos for finishing up later, and using pictures of the main subjects to study their detail or patterns. I suggest that you use some kind of process to eliminate and rearrange things. For example, if you are drawing a desert scene with hundreds of cacti and twenty different kinds of ground cover, you could choose just a few of the elements and develop your own composition.

Finding something in the scene to use as your center of interest is a helpful starting point. For example, if I saw an expansive scene of rolling hills, with farms and barns, I would select one particular farm or barn as the main subject. Then I would build the composition around it. If there were twenty different kinds of trees and bushes around the house, I would insert a few that I like into the picture to suit my plan.

When it comes to drawing foliage, there is an endless number of ways to interpret any particular ground cover, bush, plant, or tree. The key is sim-

ply to capture the kind of pattern you see. For instance, notice the kinds of textures and patterns of colors in such things as wheat fields, blackberry bushes, and cattail swamps. Each has a distinctive pattern and texture that becomes apparent when you look at the whole instead of each individual part. Figure 6.62 shows some examples of this.

One way that you can develop the ability to see these patterns is to focus your eyes softly on your subject. Let your eyelids half close and your eyes become unfocused. Then take a piece of scratch paper and play around with different ways of capturing those patterns before you commit yourself to the finished drawing.

One of my favorite books on drawing foliage is *How to Draw Trees,* by Henry C. Pitz. This excellent book describes the kinds of patterns in plants as well as on the ground. I suggest that you study books like this before going out to draw a whole scene and that you do a lot of sketching before tackling finished drawings. Use books, photos, other drawings, and live scenes to practice individual pieces of scenes before trying to put them all together.

LANDSCAPE OR NATURE SCENE PROJECTS

The first project is to encourage you to practice drawing various pieces of nature scenes, and the second is intended to help you develop a whole scene. You probably will need many outings before you begin to develop the kind of results you would like. It usually takes quite a bit of exposure to learn your own unique way of handling the intricacies of landscape.

Allow at least 3 hours for each outing, and prepare yourself to be comfortable in the kinds of conditions you might experience. Nothing can spoil an outing more rapidly than the physical discomforts of being hungry or thirsty, being improperly dressed for changing weather, being confronted by animals you weren't ready for, or walking with improper footwear.

SUPPLIES

A backpack or shoulder bag to hold art supplies, snacks, water, and so forth

A sketchbook, with a large clip to hold the pages together (in case of wind)

A plastic resealable sandwich bag for pencils, pens, erasers, pencil sharpeners, and so forth

Appropriate clothing and walking shoes

Optional—A camera to take snapshots for further studies at home

INSTRUCTIONS

Sketch pieces of a scene, as described below, before developing an entire scene.

SKETCHING PIECES OF SCENES

Find a spot you like. Taking one piece of the scene at a time, play around with developing techniques to capture the patterns and textures of the subjects. Make loose sketches anywhere on the page, letting your pen or pencil jump around the paper. Use different kinds of media to draw the same thing, and see which medium lends itself to achieving a result you like. Figures 6.63 and 6.64 are pages from the kind of study in two students' sketch pads.

When you run out of room, turn to the next page and continue drawing pieces of the scene. If you have a camera with you, take some snapshots of that scene. You may use them later to develop one of your finished drawings.

When you feel that you have exhausted your ideas, walk somewhere else and try pieces of a new scene. Don't even try to make a finished drawing during the first few trips; use them to build the basic information that you

FIGURE 6.63
Sage Essick — age 18

FIGURE 6.64
Thomas Walker — age 8

SKETCHING PIECES OF SCENES
Before tackling a scene, study its parts in a random fashion on the pages of your sketch pad.

need. Study photographs and books on drawing landscape and seascapes in several sessions at home.

Take at least three outdoor trips, and do at least three sessions at home, with books and photos, before you decide to develop a whole scene.

Developing a Whole Scene

Prepare for your outing and supplies as in the last project. Select a location that has a clear main subject—for example, a particular tree, a group of boulders, or a large flowering bush. Plan a composition, using that main subject as your center of interest. Then choose particular pieces of the scene to make secondary centers of interest. You would seldom try to draw everything that you observe in a scene. Eliminate as much as you want and rearrange things to fit your composition. This is the key to making a drawing work without becoming overwhelmed.

Develop a foreground, a midground, and a background, as in Chapter 4. As you add each section of foliage or each background idea, you may want to do some rough sketches to decide what kind of pattern will achieve the effect you want.

If you have a camera, it is quite often practical to finish your drawing from your photos. Sometimes weather or time doesn't allow you to stay outside as long as you would like. Don't expect complete satisfaction with every try. If you make the trip itself enjoyable, you won't place heavy expectations on your drawing results. When you get home, you can always start over and rearrange things even further. Figures 6.65 and 6.66 are student examples of this project.

CITY OR BUILDING SCENE

When you draw scenes of buildings, you can become overwhelmed with all the detail and overlapping information. Your ability to eliminate and rearrange are what will make the job more manageable. For example, if you are drawing a Victorian house, you don't need to put in every window and detail piece of gingerbread; the secret is to duplicate the style of the house you are looking at, not to achieve photorealism. Unless you are recording for history or want the challenge of an exact drawing, you need not draw as if you were a camera.

FIGURE 6.65
Holly Swartz — age 21

FIGURE 6.66
Jo Ann Finley — age 12

*DEVELOPING A WHOLE
LANDSCAPE OR NATURE
SCENE
A whole scene in nature can be
overwhelming. The key to suc-
cess is to eliminate as much as
you want and to rearrange items
to fit your composition.*

If you are drawing from a realistic scene, as opposed to graphic infor-
mation, you may need more time than weather or light will permit. In this
case you can use snapshots to finish your drawing at home.

CITY OR BUILDING SCENE PROJECTS

In the first project you will learn how to develop a small part of a scene; in
the second, you will explore developing a whole scene. Drawings made
from looking at a whole scene can be very complex and challenging, so give
yourself freedom to learn. Let go of your expectations at first, and allow
yourself several outings of exploration. Each outing usually takes about 3
hours, so prepare youself to be comfortable in the kinds of conditions you
might encounter.

SUPPLIES

A backpack or shoulder bag to hold art supplies, snacks, water, etc.

A sketchbook, with a large clip to hold the pages together (in case of wind)

FIGURE 6.67
Mimi Toro — age 9
Before you draw a building it
helps to do a sketch of the basic
box-like perspective of its shape.

FIGURE 6.68
Judy Schaff — adult
Before you try to add all the
details to a structure, make
studies of isolated sections.

A plastic resealable sandwich bag for pencils, pens, erasers, pencil sharpeners, etc.

Appropriate clothing and walking shoes

Optional—A camera to take snapshots for further studies at home

INSTRUCTIONS

SKETCHING PIECES OF SCENES

Find a building scene you like, and use your viewfinder to isolate it. Draw lightly with pencil in your sketchbook, and erase as much as you want. Make a rough sketch of the general shape of the building by using the perspective techniques you learned in Chapter 5. Imagine the whole building is like a series of boxes and draw its overall shape. Don't finish the drawing now; simply practice general shape. Figure 6.67 is a student example of this kind of sketch.

Go to another page in your sketchbook. Choose a very small portion of the building, such as the upper left corner of a roof or a particular window.

Make a very detailed sketch of that portion, noticing its various pieces and how they fit together. Try different textures and patterns with your pencil to capture the kind of materials used in the building. Let the edges of the section fade out into nothingness. On the same page, select another section of the building and explore drawing it. Keep choosing different pieces of the building, going to another page when you run out of room. Figures 6.68 to 6.72 show several pages from different students' sketchbooks of these kinds of detail and texture exploration.

Now select some other element in the scene and follow the same procedure. Make a general perspective drawing of the shapes and scales of the different elements. For example, do another perspective box drawing of a building, with a rough sketch of trees, other buildings, and telephone poles. Use your thumb-on-the-pencil measurement technique, from Chapter 5, to compare the relationship of the objects to one another. Don't put in any detail now. This study is just to get the general scale of the objects in relation to one another and the basic proportion and perspective. Figure 6.73 is a student drawing of this type.

Now, choose a portion of a scene and make a detailed drawing of the scale of objects to one another. For example, draw a street lamp as it over-

FIGURE 6.69
Mary McCracken — adult

FIGURE 6.70
Anne Lawrenson — age 11

SKETCHING PIECES OF BUILDINGS
These pages from several students' sketch books show how they made detailed studies of portions of buildings.

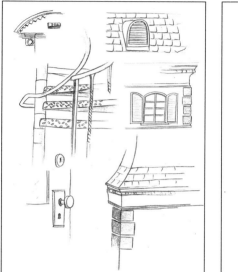

FIGURE 6.71
Babs Freitas — adult

FIGURE 6.72
Patricia Faria — adult

laps the corner of a house, or an upper portion of a telephone pole as it over-laps the smokestack of a factory. Figure 6.74 is an example of this kind of sketch. If you have a camera, take some snapshots of your scene. Keep drawing portions of scenes until you feel satisfied, then move on to another scene or view.

Use illustrations and photos from books to make similar studies at home. Use the same techniques as you did outside, remembering to do general drawings of perspective and scale and detailed sketches of pieces of the buildings and scenes.

Explore at least three outdoor trips in nature and three indoor sessions with pictures before you decide to develop a whole scene. Explore different drawing media to see what works for you.

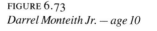

FIGURE 6.73
Darrel Monteith Jr. — age 10

BASIC BOX STUDY OF SCALE
Understanding the relative scale of the structures in a building scene can be done in a basic box sketch first.

DEVELOPING A WHOLE SCENE
Prepare for your outing in the same manner as you did in the prior project. Select a scene with a building you like for a main subject. It may even be a location of which you did prior sketches. Choose what media and drawing style you want to use, and make a few preliminary sketches of the whole

composition. Eliminate as much as you want and rearrange elements to fit your composition.

Develop a foreground, a midground, and a background, as you did in Chapter 4. First, make the general framework of the main buildings in proportion and scale to one another, using eyeball perspective. Then, using light line, add the other objects in the scene and evaluate the scale. Occasionally stepping back a few feet from your drawing will help you determine proportion and scale.

Now, lay the detail into your framework, darkening the drawing as you become more and more satisfied with the whole composition. If you are making a volume-shaded drawing, begin to lay in the light patterns. When you are outdoors in natural light, you can follow the patterns you see. Starting with the darkest darks and alternating with the lightest lights can be helpful to the beginner. If you have a camera, take some snapshots of your scene so you can continue working on it at home. Figures 6.75 to 6.77 are some student examples of this project in different drawing styles. Some were made at the site and others from photographs.

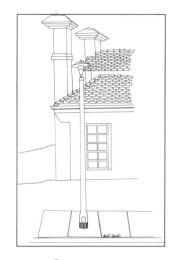

FIGURE 6.74
Rachel Broth — age 14

DETAIL STUDY OF SCALE
Before you do a finished drawing of a building scene, you can do a detailed study of the relative scale of the structures in a portion of the scene.

ENDLESS EXPLORATIONS ON YOUR OWN

You have now absorbed a vast amount of information and drawing experience. If you follow the instructions to plan projects in all the styles and sub-

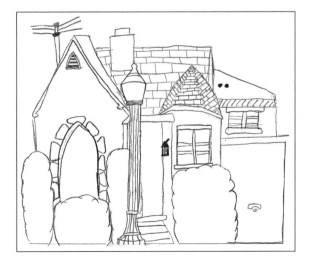

FIGURE 6.75
Kyla Ginsberg — age 11

DRAWING A WHOLE BUILDING SCENE
Remember that you can eliminate or rearrange as much as you like to get a scene that you like.

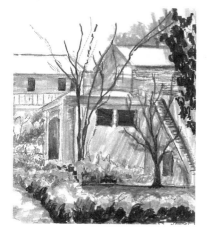

FIGURE 6.76
Dorothy Soule — age 93

FIGURE 6.77
John Little — age 21

jects mentioned, you could be drawing nonstop for an entire lifetime. There is no end to the opportunities that keep presenting themselves. You have expanded your options to an endless array of styles, combinations of media, and topics for subjects.

As you move forward, forget all prior expectations you may have had, and learn to draw for yourself. You have been exposed to the basic structure of drawing and the freedom to do it your own way. With all that in mind, you are now truly free to explore on your own.

If you get stuck for ideas, you can always go back to the lists of suggestions. I encourage you to keep trying new things until you hit on the combinations that you like the most. I personally find there is no end to discovering new and exciting ways to draw. One of the major motivations I have in finishing this book is to get back to the many drawing projects that I have sitting around waiting for me and to some new ideas and media I want to try.

Take advantage of times that lend themselves to drawing. If you are going on a day trip or a vacation, or if you know you will be on a plane for hours or will be sitting waiting for an appointment, take along your sketchbook and bag of supplies. Don't hesitate to draw the same things over; this will build your memory bank and hone your skills.

As the years go by, I am endlessly amazed at the number of people who have always wanted to draw and didn't think they could. I am continually impressed with how quickly they achieve the success they hope for. My joy in life is the desire that you will become one of them.

NOTES TO TEACHERS

People from many professions correspond with me. They explain how they are using my drawing method and invite me to work with them. I have come to realize that the schoolroom teacher is only one of the many roles in which people are involved in educating or transforming others through drawing. For example, optometrists are drawing with patients to improve their vision, mental-health workers are drawing with clients to help them heal their childhood traumas, special-education teachers are using drawing to help learning-handicapped students, health-care professionals are using the method to provide a quality activity to hospital patients, probation attendants are helping inmates cope with their confinement through drawing, and geriatric attendants are teaching the elderly how to fill their free time with an activity that makes them feel alive and vital again.

In the twelve years since I developed the drawing method, I have taught a wide variety of students. I have experienced teaching in both private and public school systems. Yet now I realize that I also was a teacher for the twenty previous years. As an artist I used drawing as a teaching tool in the other career fields I pursued. During the past three decades I have been fortunate enough to work with all the different groups of students I will be discussing with you.

As a play therapist and counselor in a psychiatric clinic, I was able to use art as a vehicle for communication; as a probation officer in maximum-security institutions, I conducted art workshops with delinquent teens in after-school programs; as an artist, I was hired to teach drawing to pre-schoolers; the California Arts Council funded grants in schools for me to work with learning-handicapped students. These special-education schools exposed me to working with a variety of slow learners, ranging from kindergarten age through twelfth grade. One of the schools served learning-

disabled students who were severely emotionally disturbed, and another served teenage gang youth. After my method became established in regular school systems, I was asked to use it in several public elementary school programs. One of the contracts was very important to the discovery that the method could be used in conjunction with teaching English as a Second Language. Another contract helped me understand how to use the method with visually impaired and physically handicapped students. As the founder of Monart Drawing Schools I have worked with hundreds of students, from preschoolers to their elderly grandparents.

Drawing is a beneficial tool, whether you plan to use it in a regular classroom or in some other setting. The projects and ideas in the book can be adapted to a wide range of participants and used for a variety of reasons. First, I will share some information that applies to all teaching situations, followed by some general information on how to use the method with different kinds of students, class sizes, and types of environment. Then I will give you some hints on working with students of various age levels.

TIPS FOR ALL TEACHERS

LEVEL OF EXPECTATION. I have watched teachers with different expectation levels achieve completely different results with the method. It is almost as if the students rise or fall to a teacher's expectation level. This may be true even when the teachers follows the lesson plan in exactly the same manner. For example, I have watched teachers who feel children are incapable of being still and quiet struggle with maintaining order in the classroom. As a result, the children's work is often disorganized and incomplete. If, however, the teacher is one who believes children are very happy to concentrate and get engaged in their work, the same children will magically become relaxed and produce more creative and completed drawings. If a teacher uses a whiny and sweetly condescending voice, believing that the students are fragile and need overprotection, the students regress in their ability to function. Such students become very immature, continually asking the teacher to do things for them and drawing below their capabilities. If the teacher takes on an authoritarian attitude, in the belief that the students have to be controlled, the classroom can become a war of wills. Again, if I change the teacher to one with higher expectations, the children will stop the acting out and function at a much happier and more mature level.

If you are not sure of how you sound and look to others, I suggest you tape yourself teaching. Home video is the most revealing vehicle, but a cas-

sette tape of your voice is just fine. As you listen to or watch the tape, try to imagine yourself talking to one of your best friends or a colleague in the same tone or posture. Imagine how you might react to someone using the same voice inflections and teaching style. This is one of the most helpful ways in which to see what kind of tone you are setting. After many years, I still do this periodically myself.

TEACHING A SUBJECT WITH NO RIGHT ANSWER. This is one of the biggest challenges to a seasoned teacher. We are conditioned to learning environments that help us achieve accuracy, remember correct information, or learn certain ways of doing things. It takes practice to remember that you are not trying to get your students to draw in a particular way. Focus on helping your students *draw for themselves,* and continually remind them that drawing is different from many others subjects they learn. Encourage them by pointing out there is no wrong way to do things. If at all possible give pass-or-fail grading, instead of letter or number ratings, and base the grade on consistency of participation rather than finished results. This will help you avoid arbitrary comparisons and promote creative exploration.

VARIETY OF RESULTS. This is the second biggest challenge in guiding others to draw. At the end of each drawing session, take time to personally note how much variety was achieved from the lesson. This habit will help you notice whether you are giving too much direction and encourage you to allow for more freedom of interpretation. One of the traps you can fall into is trying to protect students from any possibility of not liking their result. If you can't stand to watch them struggle with solutions, you may be tempted to make the lesson very structured and guide them every step of the way. It may make it easier for you and your students both, but they are being robbed of the need to solve problems and the capability to make independent creative decisions. As educators, this is a major problem we have to address. Because drawing is such a visual subject, you can easily monitor yourself. Simply notice the variety of expression and make appropriate adjustments in your teaching. If you see that the students' results are too similar, back away from the detailed way you might be modeling the instructions. If you notice that the students are lost and unable to achieve any satisfactory results, give them a little more structure and guidance.

STRUCTURE VERSUS FREEDOM. Understanding the difference between teaching *general principles* and *detail information* will help you achieve independent results from your students. You want to use enough

structure for success and yet enough freedom for a variety of creative results. When you plan a lesson, focus on general information of shapes and how they connect with one another. Teach the students to start with some central part of the subject, get them to use the 5 basic elements of shape to analyze the general shape of the parts, teach them to notice the relationship of proportion and positive and negative space, and then let them use their imagination in interpreting that information. In the beginning you can model the way these pieces fit together, but after a few lessons let students try it on their own. You can alternate guided and unguided lessons until they achieve independent confidence, giving them more or less structure depending on the complexity of the project. Your main goal is to teach the basics and then slowly wean students away from any dependency on you.

You can display a variety of three-dimensional objects, photographs, or other finished drawings around the room for inspiration, but any demonstration you provide needs to be very general and incomplete. You can show students how a particular shape is composed without modeling an exact way to draw it. One of the things that will help you achieve this is to draw very large and sloppily, explaining to students that you aren't trying to achieve a finished drawing; you are just demonstrating the basic general parts and giving them the freedom to put the pieces together in their own way.

Use a large piece of paper in the front of the class or a piece of scratch paper next to the student to do any demonstrations. Never draw on students' papers to show them something. The single most bitter complaint I hear from people who stopped drawing is that their teacher drew on their picture to explain something. They note that they were too intimidated to say anything but were seething inside with anger during the experience.

The older your students, the sooner they will be able to function on their own. However, as they become more independent, it is unrealistic to expect them to draw totally from their imaginations. No matter how long students have been drawing, they need visual stimulation. In the field of realistic drawing, even the most skilled artists need live objects and graphic materials to observe the subjects they want to draw.

You may be hesitant to use illustrative materials or photographs, because you have heard it was harmful to a student's overall development. However, there have been many studies that prove the concern is unwarranted. For example, Dr. Margaret Dowell, an Art Educator from Frederick, Maryland, recently published research on this topic in the National Art Education Association's journal, *Studies in Art Education.* Her research study

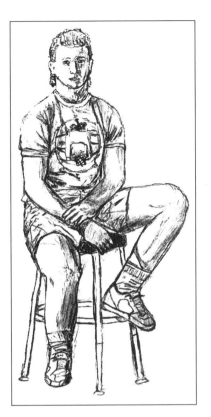

FIGURE A.I
Darryl Lamberth — age 14
Highest rated student trained
from photocopies of masters.

FIGURE A.2
Peter Septoff — age 15
Highest rated student trained
from photographs.

FIGURE A.3
Jennifer Wright — age 14
Highest rated student trained
from live models.

showed that students who had been trained to draw the human body from photographs or photocopies of master works were as technically proficient in areas such as proportion, foreshortening, and value than students who had been trained exclusively from observation of live models. Figures A.I to A.3 are examples of the student works in her study. The three examples—final test results from drawing the same live model—were chosen by impartial judging of the highest-rated students in each of the three categories. The drawing deemed to be the least technically proficient was by the student who had learned exclusively from live models.

The conclusion from the overall findings of the study was the suggestion that *classroom instructors utilize both two- and three-dimensional vi-*

RESEARCH STUDY
The drawing deemed to be the least proficient was by the student who had learned exclusively from live models. Encourage your students to learn from many forms of inspiration.

suals during representational drawing instruction. That means you can stop worrying and allow students to learn from copying photographs, using other graphics and drawings, and studying live models. If you encourage students to learn from many different forms of inspiration, they tend to become more creatively expressive and confident in skill level.

WAYS TO SAVE MONEY ON SUPPLIES. The cost of art materials has become a real problem for most teachers. If you cannot afford the list of supplies suggested in "How to Use This Book," you need to improvise. Your drawing program will collapse for lack of supplies unless you have a practical plan. For example, a school district can rarely afford supplies for every classroom in a school, so setting up mobile art carts has been one way to cut down on expenses. Depending on the size of your school and classes, you can make a few carts and share the supplies on some kind of regularly scheduled basis. Here are some suggestions on what to include.

Markers. Crayola markers (one set per every two students) are in the most practical price range for a large school, but the pictures drawn with them will fade. Berol Prismacolors are on the approved nontoxic list and will not fade. The most important colors to buy are light blues for water and sky and a variety of greens and browns for foliage. If you can't afford complete sets, you can supplement them with the cheaper kinds of markers.

Pencils. The regular #2 school pencils are adequate to create satisfactory pencil drawings. However, the students will not be satisfied with pencil drawings unless you teach them how to do some shaded and realistic styles. Of course, if your school can afford gradated drawing pencils, they will be able to achieve more depth in tones. If so, I find an H, a 2- or 3B, and a 5- or 6B provides a pretty good range. Kneaded erasers will outlast those on the end of a pencil and are more efficient.

Pastels. When you are doing any kind of loose or three-dimensional colored drawings, pastels are less expensive and more appropriate than markers. Other advantages are the ability to make adjustments with erasures, to blend colors, and to develop depth and shading.

Paper. If you can afford drawing paper, compare the cheaper brands. If drawing paper is too expensive, you can use white construction paper. Local printers may be quite happy to donate their leftover paper to you for a tax write-off. I have had a consistent supply of paper, which is far more expensive than I could afford for school use, by making excursions to printing companies. The donations are usually of very large sheets, however, so I have to either take the time to cut sheets on the paper cutter or pay a bookbinding company to cut it for me—the cost of which is still far lower than that of buying paper.

DIFFERENT TYPES OF STUDENTS

ART STUDENTS. Some art teachers think that I am suggesting they replace their methods with one I have devised. What I am suggesting instead is that you simply add some of these ideas to what you already do. I strongly believe that integrating the best from all the different drawing methods will make us all better art teachers. Art educators have given me feedback that the basic structure of the guidelines for a noncompetitive environment are very useful additions to their curriculum. Many say that realistic drawing is the one subject they felt uncomfortable to teach and that many of their students feel a lack of confidence in their drawing skills. They report that they found no conflict in adding my lessons to their repertoire and that it has helped many of their students find the confidence they were seeking.

REGULAR PUBLIC OR PRIVATE SCHOOL STUDENTS. Prior to knowing about Monart, many elementary school teachers told me they were asked to delete drawing from the curriculum. They report this happened in conjunction with the popularity of self-esteem programs. They say that so many children were unsuccessful at drawing that the school boards felt the subject should be avoided. I was unaware of this policy when I began using drawing programs in the schools. Since teachers are now showing success with their entire class, the policy is changing. Schools are clamoring for art again, aware that it is a process that can be used to teach basic skills. When you provide students with the kind of structure I am suggesting, you not only can count on everybody being successful but on art being one of the best tools you have to raise self-esteem. When people perform a task that they are sure they can't accomplish, they are usually very willing to try in other areas they fear.

At the moment, the major thrust of drug-prevention programs is to raise self-esteem and provide students with activities they are motivated to enjoy and learn through. The drawing program is being funded by drug-prevention dollars in many school districts, because the teachers find it a program that works.

You may already feel overwhelmed by your busy schedule and may not be able to imagine adding another subject to your curriculum. The good news is that you can teach any of the basic skills through the arts. Since students are highly motivated to draw, you have them *all* on board for once. Literature-based reading programs are finding the drawing method a natural complement to reading, story telling, word recognition, and creative writing skills. Science lessons provide a natural vehicle for drawing, since

you can draw any of the subjects you are studying. When covering units on other cultures and history, you can engage the students by drawing artifacts and objects from earlier time periods and exotic places. Even math can become fun when you decide to do such things as study the relationship of fractions through planning the composition of a picture.

LANGUAGE STUDENTS AND STUDENTS WITH LANGUAGE BARRIERS. At a time when immigration is bringing us bilingual students from around the world, language acquisition departments of major universities provide interesting statistics about using drawing to teach language. Over fifty years ago it was concluded that you could recognize vocabulary and pick up language eight times faster while drawing. The unfortunate problem is that language teachers feel so inadequate about drawing themselves that they don't know how to use drawing as a teaching tool.

While teaching on a contract in the East Los Angeles area, I was suddenly exposed to this exciting new aspect of the drawing program. East Los Angeles is an area that attracts a bilingual population from many cultures. The Monart instructor who assisted me on this contract spoke many languages fluently and got along in several others. We were aware of the many Hispanic students in the district and were working with several on a one-to-one basis. One day when we had finished teaching a large group, the teacher came to us in amazement and asked us whether we were aware there was an entire table of non–English-speaking Vietnamese refugees in the back of the room. She said they had been enrolled for weeks and were in a state of culture shock. She explained how they had been unable to follow regular class work and just sat there quietly day after day. On this day, they had done everything we were talking about and ended up with lovely drawings. We had no idea that they couldn't understand a word we had said.

My colleague saw the implications. She left Monart, enrolled in U.C.L.A.'s language department, and wrote her thesis on teaching ESL through the Monart drawing method. She educated me in how to instruct language teachers to use drawing and preschool teachers to access primary language skills and reading readiness through drawing. She taught me the power of using drawing to naturally access language.

In teaching language, you can use the same drawing method you use for drawing classes and focus the lesson on certain groups of ideas and words. For example, if you teach lessons in which you draw animals, the vocabulary for body parts is grasped. If you make exaggerated gestures in relationship to the equipment and process, the words relating to directions,

colors, and equipment are picked up naturally. This method is so visual that students can grasp what you are communicating without understanding the exact words. The magical part is that they learn the language naturally, just the way a baby learns its first language. Students begin to recognize the same words over and over during the lessons. They relate to what they visually observe going on and have visual images to remember the words that were used to accompany the parts of the drawing process and the things that they drew. As they hear these recognizable words in the context of sentences, they learn language through conversations that are accompanied by visual images and remembered experiences.

LEARNING-HANDICAPPED OR SPECIAL-EDUCATION STUDENTS. The years in which I used the drawing method with the so-called learning handicapped taught me some invaluable lessons. I came to suspect that many of these children who were labeled slow learners were possibly very bright but used their minds in a way that does not adapt easily to the manner in which we traditionally teach subjects in school. I began to avoid reading academic records in order to avoid preconceived notions about what to expect. The feedback from administration was exciting: students were doing things that were considered impossible for them to achieve. In using this drawing method, I suggest that you drop all expectation levels when you deal with children who have been labeled Learning Disabled. You may be pleasantly surprised.

However, succeeding with these students didn't come easy. I never had to muster up so much patience. I could work with only three or four students at a time, and the experience still pushed me beyond my limits. Sometimes it took a year for me to achieve results similar to what could be accomplished in a week with regular kids. But the point is that it happened, when everyone was pretty sure it couldn't.

Some of the children I worked with were borderline autistic or severely disoriented. Children who couldn't talk at all when I met them began to communicate with me and acknowledge contact. I wasn't surprised that at about the same time they could finally draw, they began their first attempts at reading.

EMOTIONALLY DISTURBED STUDENTS. If you use the same drawing method with emotionally disturbed students as with so-called normal students, you shouldn't find much difference in results. Of course, if a student happens to be upset at the time of the lesson, you will simply have to deal

with the disturbance the way you usually do. When a patient is having a crisis or acting out, drawing can be one of the best tools you have to calm that person down and get him or her stabilized again.

I strongly caution you against analyzing students' drawings for psychological reasons. Unless you are an art therapist, this can be very dangerous. For example, a preschool child who had painted a beautifully colorful picture of flowers suddenly dipped into the black paint and completely covered the painting. I watched the staff have a heated discussion about the possible reasons. They had the child diagnosed as disturbed and were ready to check his body for bruises and interrogate him about abuse. The director knew the dangers of analyzing art and angrily reprimanded the staff for their actions. She communicated with the boy and asked him to tell her about the wonderful black drawing. The child beamed with pride as he explained that he had seen a magic show the night before and had figured out he could make his drawing disappear by covering it with black paint. You can use a drawing session to get some dialogue started or simply to let a patient vent his or her feelings, but analyzing the content of the drawing isn't appropriate.

PHYSICALLY SICK OR HANDICAPPED STUDENTS. Your drawing sessions with these students will need to be geared to their particular set of physical problems. For example, if you are working with a palsied elderly person, encourage large gesture-type drawings, with a loose, colorful style. If you are working with a bedridden person, set up a lap board and make the supplies easy to access. A person who has lost his or her hands can draw using a tool called a wand that clamps around the drawing implement and can be held in the mouth. There are also many skilled artists who have learned to draw and paint by holding the implement with their foot. If you are working with visually impaired students, let them rest their face almost on the surface of the drawing.

I don't need to explain the benefits of giving a sick or handicapped person the gift of drawing. In short, it can give them the feeling that they have a reason to get up in the morning and look forward to the day.

DIFFERENT ENVIRONMENTS AND CLASS SIZES

ONE TO ONE. When you work with one student, I suggest you sit next to him or her and develop a warm interchange. Have a piece of paper of your

own to show them some ideas and suggestions, and just be there for support. You can have some quiet conversation, but also make sure there are some totally quiet times when the student can concentrate and get lost in a drawing. Once students gain their confidence, you may find yourself with much spare time in which to do some drawing of your own. There is something very special about drawing together in silent concentration. It can build a close relationship and you can learn from each other.

SMALL GROUPS. If there are only four or five students, it works nicely to sit at one big table with them. Demonstrate most of your information on a large pad of paper or a drawing board. It is best to prop up a drawing board next to you or have a large pad on an easel, so that you can get up once in awhile and walk around to work with each student individually. Sitting with your students makes you more accessible and encourages interaction. However, watch out for too much social conversation. Students need long periods of silence for their focus and concentration to become engaged. It is a little harder to maintain when you are sitting with them, because you are more prone to social interaction yourself.

LARGE GROUPS. When you can't all fit at one table, you need to establish a demonstration area on a nearby wall and teach in a classroom-type setting. If you don't have a bare wall, you can use a white board, paste paper on a chalkboard with tape, or use a conference-style chart pack on an easel. I suggest you do not demonstrate on a chalkboard, as something gets lost in the translation when you use white line on a dark surface. If you have over twenty students in a classroom, be sure to use at least $18 \times 24''$ paper for your demonstration and a thick-line dark colored pen. It is very frustrating for students in the back to be unable to see what you are showing them.

Keeping the focus in large groups is your big challenge. Clear out all personal belongings and clutter from the tables. This also makes it easier to move people who are socializing and creating distractions. I let a new group know in the beginning that I will be moving people around to minimize noise and distractions, so that they get used to it and don't have to be embarrassed or shocked. I find this goes very smoothly if I give a warning first, then just pick up a student's drawing and take it to another location, asking the person in that location to switch with the disrupting student. The distractor simply has to go where his or her drawing has moved.

It is very important to remember the eye-relaxation exercises and the warm-up sheets. One warning about sudden bedlam: if everything is very peaceful and there is suddenly a burst of talking and noise, it is quite often

due to stress instead of socializing. Before you start toward disciplinary measures, note what you just asked students to do and find out whether it ended up in results they are dissatisfied with. For example, I can almost predict there will be a burst of talking when a group of beginners try to draw two sides of a vase. The proportions aren't perfect and their inner critique rises up to protest. Since they are more familiar with talking themselves out of a tight spot than seeing themselves out of one, the students abandon ship and start frantically talking to the nearest listener. A sense of humor helps pull them out: simply acknowledge what happened with a smile and a good laugh. Then you can give some suggestions for adjustments and reassurance that things don't have to be perfect. Remind students that they would have to become a photographer instead of an artist if they wanted photorealism. You can always repeat the eye-relaxation or breathing exercises whenever the group loses focus or gets rowdy.

As your groups get larger, it becomes more difficult to give students individual attention. Checking everyone's progress in the beginning stages is the most critical point at which to avoid problems. After the first couple of instructions, I take a tour around the room to make sure no one is lost. This helps me avoid noticing a problem halfway into the project. For example, it is a shame to notice too late that a wonderful drawing has been done on a piece of photocopy paper or that a student who is drawing an elephant has put the eyes so close to the edge of the paper that he or she won't have room for the trunk.

Don't forget that learning from others is important. Art students always study one another's work, but usually when no one notices. I find that it is freeing to not only give them permission to examine the work of classmates but also to build this practice right into the lesson. For example, halfway into the lesson you can have everybody walk around the room to observe how different people are doing things. However, *total silence* is a must to avoid a terrible mess of comparisons and fear of critical comments. Compliments are just as problematic, because they set up the climate for students to want them or to become afraid that they won't get them. The purpose of the observation has nothing to do with critique; it is to help the students learn what they like and ways to achieve it. You need to remind them of that purpose and establish the silence before any kind of sharing session begins.

DIFFERENT AGE LEVELS

EIGHT TO TEN. This is the critical age when your students begin to discern the difference between early childhood symbolic drawing and more

realistic styles. It is extremely important to talk openly about the differences and help them appreciate both styles. You will have some students in your class who are unconcerned about realism and want to continue drawing in symbolic styles, so be sure to provide time for free drawing as well as structured lessons in realistic styles. Watch for disparaging comments by students who have dropped the symbolic styles, and take time to correct the misunderstanding. Let all the students know that you don't agree with such judgments, and model an appreciation for both styles of drawing. When you have an art show or an open-house display, it may help to include many different styles—from abstract, to symbolic, to realistic.

There is nothing in this book that I have not used with eight- and nine-year-olds, but it is unrealistic to think that they will all feel immediately comfortable. I tell students that learning to draw is something like learning to ride a bike: their drawings will be a bit shaky for awhile until they can finally take off the training wheels. With this kind of understanding, they are usually willing to try. If you have a few students who aren't ready, you can alternate your lessons with more basic projects from *Drawing With Children*.

TEN TO TWELVE. There are still a few students at this age who are having fun drawing in symbolic and stick-figure styles. Until they naturally graduate from these early childhood drawing styles, it is very important that you allow them the time and respected space to do so. However, they need a little more protection from possible criticism from their peers. This is a wonderful age at which to have some art history sessions, in which students are taught to appreciate different styles of drawing.

The main difference between this group and the prior one is the amount of time they need the training wheels. However, they start having a new set of problems as the distractions of prepubescense begins, and it becomes harder and harder for you to hold their focus. Be aware of the boy–girl split in the room, and establish seating arrangements that will help students concentrate.

TEENS. If you are working with this age group, you already know how peer pressure will affect everything you do. Refusal to draw at all is at its highest peak. In a subject they aren't sure of, it is too risky for students to receive criticism. Sometimes none of my prior advice works, at which point you need to get creative. For example, I once worked in a special school with a student body of about sixty. The students had been expelled from the entire Los Angeles system, but their parents demanded they receive an education. Most of them were gang affiliated and all of them had been designated

as "at risk." In the first week of the program, only two of the sixty really wanted to draw. Obviously, I had to come up with some new motivating techniques. Oddly enough, allowing students not to draw was part of the plan; the other part was what motivated them to finally try. The end result was an art exhibit in a major bank on Sunset Boulevard, where all sixty students' work was represented. The plan I devised works for individuals in a class as well as it does for a group.

When you hear the absolute statement "I don't want to draw," don't argue or judge it. Accept it in a matter-of-fact way, but immediately set the ground rules. You might tell a student: "I don't want you to draw if you don't want to, but I'll need you to cooperate with me in return. I'll need you to do something quiet, where you won't need my attention or distract anyone else. You have the choice to read some of these art books, make designs with these templates and rulers, or read something else. If you want a grade in art, you can do any kind of doodling you want on the paper. As long as you are participating, you will pass. If you change your mind about drawing with me, I will try to help you draw any subject you choose."

I don't use this approach as a trick; I really wouldn't protest if someone followed the agreement for an entire year. However, it never has lasted very long. When the nonparticipants observe how easy and fun drawing is for those who try, the number of participants grows each week. The major key seems to be the availability of templates, which encourage participation. The other secret is being willing to draw what students want. I had fun learning how to draw 1950 Chevy low-rider cars and the like.

I have one more rule that helps this method work: I have some exceptions to drawing what students want. If the requests are in the realm of violent, satanic, or gross images, refuse them without judgments. I tell students that I notice how they already know how to draw those particular images, since they do so over and over, and that in drawing them I wouldn't be teaching them anything new. I reserve the drawing lessons for learning to draw other things they are interested in. Once they get to draw what they want, students also accept my choices. I have watched groups of street-wise tough guys quietly enjoying drawing a still life or a fluffy kitten another classmate chose as a subject. However, I have never found teens to be satisfied with a steady flow of still-life arrangements or live models; they want to draw animals, cars, boats, and other things they are interested in too.

The younger teenagers need a few weeks of the kind of training wheels I talked about with the eight-year-olds, but the older ones function about the same as adults. To help the transition to aspects of the more complex work,

such as perspective and shading, keep interspersing the lessons with some flat two-dimensional or stylized kinds of drawing. The enjoyment and success that students experience will keep their confidence up and their interest higher.

TERRIFIED ADULTS. Starting off with flat two-dimensional–type drawings is the single most important tip I have to offer. The majority of terrified adults that I teach in Monart Schools have enrolled in another drawing class somewhere and dropped out. The humiliation they felt still burns on their faces as they tell me the same story, over and over: they walked into an immediate assignment about shading or perspective and dreaded the critique. By the humiliation of the second or third critique they never went back. The interesting thing is that these students usually need only two or three weeks of drawing in a flat style before they gain the confidence to handle such techniques as shading and perspective. It seems that the acceptance they achieve while they explore two dimensions gives them a high degree of willingness to explore three.

Unless an adult is aspiring to be an artist, he or she will have no more interest in constantly drawing still lifes than teenagers do. Adults love drawing jungle animals, birds, and bold designs with bright-colored marking pens. I think that all those who never got to draw as children want to make up for the lost years.

A NOTE FOR ALL

No matter whom you are drawing with, I hope you learn to have fun. I believe that if we can tap into the inner child and fill our souls with pleasure, we can look upon one another with more appreciation. It seems our world needs more of that. I have watched students express warmth and appreciation for one another while they draw together. It is my wish to draw with each of you in spirit, as you draw together.

BIBLIOGRAPHY

Briggs, John. *Fire in the Crucible.* Los Angeles: J. P. Tarcher, 1988.

Brookes, Mona. *Drawing With Children.* Los Angeles: J. P. Tarcher, 1986.

Capacchione, Lucia. *The Creative Journal for Children.* Boston: Shambhala, 1989.

———. *The Picture of Health.* Santa Monica: Hay House, 1990.

Chaet, Bernard. *An Artist's Notebook.* New York: Holt, Rinehart and Winston, 1979.

Cornell, Judith, Ph.D. *Drawing the Light from Within.* New York: Prentice-Hall Press, 1990.

Dodson, Bert. *Keys to Drawing.* Chicago: North Light Books, 1985.

Edwards, Betty. *Drawing on the Right Side of the Brain.* Los Angeles: J. P. Tarcher, 1979.

Ernst, Bruno. *The Magic Mirror of M. C. Escher.* New York: Ballantine Books, 1976.

Ernst, James A. *Drawing the Line.* New York: Reinhold, 1962.

Ferguson, Marilyn. *Brain Mind Bulletin.* Los Angeles: BMB, 1985–1990.

Gardner, Howard. *Artful Scribbles.* New York: Basic Books, 1980.

Guptill, Arthur. *Drawing with Pen and Ink.* New York: Van Nostrand Reinhold Co., 1961.

Heizer, Robert, and Baumhoff, Martin. *Prehistoric Rock Art.* Berkeley and Los Angeles: University of California Press, 1962.

Howard, Kathleen. *Metropolitan Museum of Art Guide.* New York: Metropolitan Museum of Art, 1983.

Huffington, Arianna Stassinopoulus. *Picasso, Creator and Destroyer.* New York: Avon, 1988.

Laidman, Hugh. *How to Make Abstract Painting.* New York: Viking Press, 1961.

Lewis, David. *Pencil Drawing Techniques.* New York: Watson-Guptill Publications, 1984.

Lohan, Frank J. *Pen and Ink Techniques.* Chicago: Contemporary Books, Inc., 1978.

Lowenfeld, Viktor, and Brittain, W. Lambert. *Creative and Mental Growth.* New York: Macmillan Co., 1947.

Luckiesh, M. *Visual Illusions.* New York: Dover Publications, 1965.

Milani, Myrna, and Smith, Brian. *The Principles of Energy.* New Hampshire: Fainshaw Press, 1985.

Nicolaides, Kimon. *The Natural Way to Draw.* Boston: Houghton Mifflin, 1941.

Pitz, Henry. *How to Draw Trees.* New York: Watson-Guptill, 1956.

Sachs, Paul. *Modern Prints and Drawings.* New York: Alfred A. Knopf, 1954.

Smith, Ray. *How to Draw and Paint What You See.* New York: Alfred A. Knopf, 1984.

Sperry, Vicci. *The Art Experience.* Boston: Boston Book and Art Shop, 1986.

Woods, Michael. *Life Drawing.* New York: Dover Publications, 1987.

INDEX